REASON TO SING

An inspiring journey overcoming trauma, abuse & betrayal

Kelita Haverland

Published by Heart & Soul Music, September, 2024
ISBN Paperback: 9781927049075
ISBN Ebook: 9781927049082
ISBN Audio book: 9781927049099

Copyright © 2024 by Kelita Haverland
All rights reserved. No part of this publication may be reproduced, stored in or introduced into a retrieval system, or transmitted, in any form, or by any means (electronic, mechanical, photocopying, recording or otherwise) without the prior written permission of the publisher. This book is sold subject to the condition that it shall not, by way of trade or otherwise, be lent, resold, hired out, or otherwise circulated without the publisher's prior consent in any form of binding or cover other than that in which it is published and without a similar condition including this condition being imposed on the subsequent purchaser.

Editor: Vickie van Dyke
Typeset: Greg Salisbury - Red Tuque Books
Book Cover Design: Greg Salisbury - Red Tuque Books
Portrait Photographer: Kelly Savalle

Permissions:

"Here I Am Wholly Available" Lyrics composed by Chris Bowater
Copyright Sovereign Lifestyle Music Ltd. Used by permission
sovereignmusic@aol.com
"Unusual Child", "Must Have Been From Heaven" Lyrics composed by Kelita Haverland
Copyright Heart & Soul Music. Used by permission
info@kelita.com
All Biblical scripture references are King James version, Public Domain

To Gord, Keldon & Kelly
You are my pillars of strength and I love and adore you beyond measure.

"*Deep inside, our integrity sings to us whether we are listening or not. It is a note that only we can hear. Eventually, when life makes us ready to listen, it will help us to find our way home.*"

Rachel Naomi Remen

Author's Notes

Disclaimer

I've chosen to share the stories of my life as I remember them. While I've endeavored to be as accurate as possible, there may be instances where I've condensed time or reconstructed dialogue from memory. Memories can shift and evolve over time, so some details may be clearer than others. However, I've strived to capture the essence of my experiences as faithfully as I recall them. To the extent that I've made errors in this account, they are mine alone.

Content guidance

This memoir depicts true accounts of incest, suicide, drug abuse, emotional abuse and adultery. Please read with care.

Preface

Welcome to "Reason to Sing." Your decision to share this personal journey with me fills me with deep gratitude.

In the pages ahead, you'll *navigate the highs and lows, struggles and triumphs* that have shaped my life. I hope mine is a story of resilience, an odyssey through the shadows of trauma, abuse and betrayal, seeking strength and redemption.

Within the narrative are references to original songs I have written and curated to mirror the emotions and themes of specific chapters. These songs were birthed from these very stories, offering a unique glimpse into the heart of my experiences. I encourage you to listen to these songs, available in their entirety on the accompanying CD entitled "Reason to Sing" on your favorite streaming platforms. You can also access them for free, along with all of my other music, on my YouTube channel, Kelitalive. www.youtube.com/user/kelitalive

These songs are the soundtrack of my life, deepening our understanding as we journey this path together.

I'd like to believe that "Reason to Sing" is more than just a memoir—it's a testament to the resilience of the human spirit. My hope is that within these pages, you'll find solace, inspiration and perhaps, your own reason to sing.

With love & gratitude,
Kelita

Contents

Copyright ... II
Dedication ... III
Author's Notes ... IV
Preface .. V
Prologue ... X

Part ONE - Trauma, Tragedy & Trials

Jimmy and Me - Deep Dark Secret 1
Scared of the Dark .. 4
Daddy and the Homestead .. 8
Mr. Piano ... 13
Pickled Pieces .. 19
The Great Escape .. 27
Premonition ... 38
The Red Roses .. 45
Sweet Release - Caged Bird 50
Little Miss Starlet ... 55
And Now This .. 64
Mommy Comes Home .. 68
My Big Brother ... 71
Jimmy's Hideaway .. 74
Drugstore Cowboy - Naked Soul 84
Vilda Pearl .. 91
The Conversion .. 98
The Caddy ... 102
No Good-Bye - Deep Need 105
Mean Mike .. 109
Tousled Sheets .. 113
Western James Dean - Unusual Child 118

Mad Crush - Bring Love Home ..124
Stardom Awaits ..133

PART TWO - Music, Marriage & Misbehavior

Cheap Blue Blanket..136
Drug Daze...145
Trouble in Paradise..151
Music Biz ...156
Too Hot To Handle..162
The Naked Truth - Breakin' Down167
Secret Love - In the Shade of the Willow Tree................171
The Major Affair ..176
Good-Bye April - Good-Bye April...................................180
Hot Summer! ...187
Out of Control ...199
Finally ..206

PART THREE: Trust, Treachery & Truth

No More Secrets - The Strong One211
No Big Deal ...218
Nashville or Bust ...221
The Crash?...233
The Return - When You Rewrote My Heart235
Searching for God - My Sweet Lord240
Change of Life ...248
Rejected - Change My Man..256
Double Denial - My Faith ..267
The Confession...278
The Separation - What Kind of Love...............................286
Homecoming - Because of Love300

Answered Prayers - Miracles ..308
Testimony - Must Have Been From Heaven......................317

Epilogue - Reason to Sing..325
Acknowledgments ..348
Author Biography..351
Book Club Questions ...352

Prologue

The small plane lurches unexpectedly, causing my tiny plastic glass of water to explode all over my blouse. Great. More turbulence. Exactly what I need in my life.

At least I'm not drinking red wine.

I wish I was drinking red wine. Any wine. I'm a bundle of jangling nerves and this bumpy flight isn't helping. Deep breathing isn't helping. Wine wouldn't help either. There is no help for me.

I attempt to mop up the wet mess with the equally tiny napkin the flight attendant served with my peanuts. It doesn't do much good. The plane plunges yet again. I close my eyes tightly, as if shutting off the view will end the turmoil.

Unlikely.

I have just escaped from a disastrous hurricane in Nashville, and I'm heading home to a potentially bigger cyclone in Toronto. There have been a lot of storms in my life. More than most, I figure. And I have weathered them all. And somehow, miraculously, survived. But all that past craziness happened *to* me. I didn't get a vote. So much unbelievable stuff just happened. But this is new. Yes, this is different. This was all caused by me. Me.

My fault. My choice. My dumb decision. And now I will have to face the music, and that once-beautiful music may well come to a deafening end.

What was I thinking? How could I have been so reckless?

The empty water glass cracks in my hand as I choke back a sob. In less than half an hour this stupid plane will land. That is if we don't crash first. A part of me would rather suffer this airborne pandemonium forever than confront the chaos surely waiting for me at home.

Please fasten your seatbelts, says the voice from the cockpit. *This landing may be a little rough.*

My hands are shaking as I click the buckle into place. It's not the landing I am worried about. It's what happens *after* we land that has me terrified.

Have I completely screwed up my life?

PART ONE
Trauma, Tragedy & Trials

Chapter One
Jimmy and Me

Jimmy, I can't breathe! You're too heavy. You're hurting me. I can't breathe. Why are you doing this? What are you doing to me? Jimmy, you're hurting me. I can't breathe.

I don't know what you're doing. I can't understand any of it. What are we doing here? Why are you hurting me? What did I do? I trust you. I've always trusted you, Jimmy. You're not like the other boys. Frankie and Billy are always bullying me. Not you. You're different. You're my very favourite brother. I know I'm special to you. Even though you're so much older than me, you treat me like a princess.

When I tried on my brand-new pink and white checkered flannel nightie, the one I got for my 5th birthday, you said I was pretty. You said I was sexy. What does that mean? I don't know what that word sexy means. Does it mean you love me most? Does it mean I'm your favourite too? You made me feel so special and I know you love me. The other boys don't love me as much. But you do.

So why are you doing this? Why are you hurting me? Jimmy, please stop. You're way too heavy. I just want you to get off me. I can't breathe anymore.

I don't like hiding back here in the trees. Why are we here? We're too far away from the house. There's nothing back here, only the rusty old farm machinery. And this icky mattress on the ground. Why is this outside? It's gross. It's stinky and wet, and all lumpy. And it has horrible brown stains. Why does it smell like old pee? I didn't pee, honestly I didn't! Why do I have to lie on it? And there's something digging into my back. It's hurting me.

You're too big. Jimmy. You're way too tall. You're crushing me. You're hurting me so much. You can't lie on top of me like this. You have to get off me. You're going to kill me!

Why aren't you listening to me? Why won't you tell me what's going on? Why is everything so quiet? I don't want to cry but I can't help it. Please don't cover my mouth.

I don't want to touch you. I hate when you force me to touch you. Please don't make me touch you. There. Especially, not there. Your skin feels so soft and smooth, just like a baby's. But you're not a baby, Jimmy. Why are you making me do this? Why are you breathing so heavy? Why is this taking so long this time?

Jimmy please, stop groaning! Don't hurt me.

Oh. There it is. That warm sticky mess all over my belly. I hate that smell. It makes me gag. I feel sick. Get off me!

Finally! You're listening to me. It's over. It's finally over. I am so glad it's over. I can breathe. I can finally breathe now. Thank God, it's over. Thank God, I can finally breathe again. Now I'm cold. So very cold. It's so icky and wet. Get this stuff off me. Hurry. Please Jimmy, get this stuff off me.

Oh no. Not the poplar leaves again. The poplar leaves hurt me almost as much as you do. They scratch my skin. They feel awful. I used to like the poplar leaves. The way they smelled. Now I don't like them anymore. At least all the mess is gone.

Chapter One

I'm still sticky in some places. I hate this part.

But I know you'll be nice to me now. You will pick me up off this stinky mattress and help me put on my shirt and fix my hair. You will smile at me. You will take my hand. And together we will walk back to the house.

Me and Jimmy. Jimmy and me. On a beautiful warm sunny day.

Deep Dark Secret 🎵

Chapter Two

Scared of the Dark

Ever so slowly, the large mahogany casket drops down from my bedroom ceiling. It settles beside my bed, as if wanting to join me beneath the blankets. I grab for more of the tangled mess of covers. I am frozen with fear as I feel the bitter chill engulf the room. Suddenly, the lid begins to open. And there she is - Grandma. Dead Grandma, lying on the satiny cream-coloured pillows in her black dress with the pearl buttons. Her chubby hands holding a white carnation, folded neatly and resting on her fat belly. Her necklace of white pearls is wrapped around her wrinkly neck like a noose. I see the dark mole at the corner of her mouth. I used to try and touch it. Then she would pretend she was going to bite me. But she never did. It was just a little game we played. Her skin is so white. I know it's Grandma, but she doesn't look like I remember. Or like I want to remember.

Without any warning … WHOOSH! … I am sucked into the coffin and stuffed beside her dead body. I try to holler but the words won't come. Nothing comes out. Nothing at all. I can't scream and I can't yell. No one can hear me even though my mind is shrieking. "Oh, my God, no! No! Grandma don't take me. Please don't take me away. I need out! Let me out of here!"

It's too late.

There is a deafening THUD! The heavy coffin lid crashes down on top of Grandma and me. Hard, like an ancient vault being sealed for another thousand years. And then quicker,

Chapter Two

much faster than its entrance, WHOOSH! ... the casket rockets us through the ceiling.

I am shaking my head and flailing my arms, desperately trying to break out of this deadly prison. All I see is darkness. Nothingness. Only black. Am I dead?

The sound of my own screams wakes me. Frantically kicking off the covers, I sit up. A cold sweat sends shivers to my pounding heart. It is beating wildly, as if I am being chased. I catch my breath in ragged gulps and slowly let out a huge sigh of relief.

It's just that same old awful nightmare. It's just Grandma, coming back to haunt me. What a terrible way to remember her. Why can't I just remember the yummy sugar cookies she gave us? Or her big squishy body with lumpy rolls of fat, hugging me?

When Grandma died, my little sister, Vian, and I were at the funeral. They made us look at her lying in her coffin. We didn't want to look at her dead body, but we had no choice. I was already 6 but Vian was only 3, so it was pretty scary.

Sometimes I have another nightmare. It's scary too. But that one is with Jesus. I can see his long dark hair, sandals and white flowing robes. He slowly walks toward me with his arms reaching out. He looks so handsome. Like that picture. The one that's in the little white church where Grandma and Grandpa used to go. I am standing close to the edge of a very tall cliff. I take baby steps backwards, as Jesus comes closer. And then a little closer. I keep stepping back, one foot behind the other, unsure of what is happening. Jesus gets closer and closer. One more step. Two more steps. Three steps then I lose my balance and I tumble backwards over the edge of the cliff. I howl with terror as my body crashes. But I always wake up just before hitting the ground.

Maybe I have the nightmares because of seeing Grandma when she was dead. Or maybe, because of the time we had to see Grandpa when he was dying in the hospital.

That time, Mommy and Daddy got us out of bed in the middle of the night. We had to put on our matching red velvet dresses and black patent-leather shoes. We were still half asleep when we left the farm and drove to the hospital. When we got there, Grandpa's skin looked ghostly as he lay in the bed. He was hooked up to all kinds of machines. They were making funny clicking noises and he had green tubes coming from his nose. And there was something white and crusty all around his mouth. Daddy held Vian and me, and one by one, he leaned us over the hospital bed. Then we had to give Grandpa a kiss on the cheek. He had that old-man smell. The closer I got to him the more I could hear horrible rattling sounds. I had no idea where they were coming from. I loved Grandpa but I hated seeing him like that. After we left that night, Grandpa died.

Ever since Grandma and Grandpa died, Vian and I have both been afraid of the dark. Vian is even more frightened than me, though. She's three years younger, so her bedtime is earlier than mine. But every night, I know she stays awake, waiting for me to come. When I crawl in beside her, I can feel her warm hand reach over to grab a piece of my nightie. I love my little sister. I take good care of her. Knowing that she counts on me to keep her safe helps me to feel just a little less scared of the dark.

Chapter Two

Sandbox memories. Making mud
pies with my little sister Vian.

Vian and I in our matching outfits
sharing a sweet moment.

Chapter Three

Daddy and The Homestead

"It doesn't matter what a person looks like on the outside, it's what's on the inside, right here, that really matters."

Daddy points to my heart and then gives Vian and me each a big bear-hug. We drape ourselves over him on the fancy chesterfield. I grab the small black comb out of his front shirt pocket and start running it through his hair. We love playing hairdresser with Daddy because he lets us do whatever we want. He's got thick black hair with lots of Brylcreem in it. It's oily and sticky but I like the way it smells. My little sister and I giggle like crazy as we style his hair in funny ways. Daddy doesn't mind at all. He is always happy to make his girls happy.

We play another favourite game called "Where's the Penny." Daddy takes a penny and hides it in one of his hands. Then he puts both hands behind his back, and we try to guess which hand it's in. After we finish, the three of us snuggle up together and stare out the large picture window. It faces the #2 Highway. We count every single car and truck driving by. I feel safe when I'm so close to Daddy. I just love him so much.

Daddy was born in Archie, Missouri, in the United States. His full name is Americus Ivan Ohler, but everyone just calls him Ivan, thank goodness. Americus is such a big word, and besides, it just sounds so - American! When he was very little, in 1915, Grandma and Grandpa brought him and my two aunties to Canada. They settled on the family farm, which is eighty miles south-east of Calgary, in southern Alberta. Later, my daddy became a Canadian citizen.

Chapter Three

The homestead where he grew up is the house where we all live. It's nothing fancy, painted white with green trim. Two storeys tall, three bedrooms, a kitchen and a living room. There's a tiny new bathroom with a bathtub and a flushing toilet. Before I was born everyone had to use the stinky outhouse. We still use it when we're playing outside. I hate it. I don't like to wipe my bum with the magazines. They're stiff and they hurt.

My three brothers, Jimmy, Frankie and Billy, used to have to bathe in the big silver metal wash tub. We don't have enough water on our farm so we need to haul it from our cousin's farm a few miles away. I love going with Daddy in the big water truck because I really love to see my cousins. I like to play house with them and help Aunty Liz give baby Lana a bath in the pink plastic tub. She even lets me put on the baby powder. It smells so sweet!

Because we don't have a lot of water, we only get one bath per week. Mommy runs two baths for the seven of us. We can never have very much water in the tub. I'm lucky because Vian and I always get to go first.

Outside of the bathroom is one sink. Above it is a medicine chest with a mirror on it. It's too tall for me to see but my big brothers always fight over it. They have to comb their hair and pop their icky zits every day before the school bus comes.

Every winter morning, Daddy heaps coal into the black potbellied furnace in our kitchen. Then Vian and I rush in, carrying our clothes for the day. We dress so fast in front of the stove. If not our skin freezes instantly!

When it starts to get really cold outside, our bed is moved into my parents' bedroom. Vian and I sleep together. My very favourite thing about winter is sleeping in Mommy and Daddy's room. It's the only reason I look forward to winter. Just for that. I love it so much! It means we can all be together. Cozy and warm.

The second bedroom upstairs is called the 'the spare room. This is the fanciest room in the house. It stays empty for most of the year except when Grannie or other company comes to visit.

I love Grannie's visits because she spoils us! She showers us with love and lots of food! She always brings a carload full of home-made pies. Rhubarb and sour cream raisin are my favourites. Oh, and butter tarts with walnuts. She brings so many loaves of white bread, they take up the whole back seat. Then there are the treats - Wagon Wheels, Cracker Jack popcorn, toasted coconut marshmallows and black licorice Twizzlers.

I sometimes wonder why my three older brothers never get to sleep in the spare room. They sleep in a tiny bedroom down in the basement. Two bunk beds, next to where the coal is stored. I call it the dungeon. One time I just about died down there when one of them tried to suffocate me with a pillow. It's a horrible room and I don't like spending any time down there.

My three brothers are actually my half-brothers. You see, Mommy was married to another man before she met Daddy, so the boys have a different father than Vian and me. Well, they did have a different father. He died before I was born. From some sickness called suicide. Mommy told me he used to get drunk and leave her and the boys alone all weekend without any money. And sometimes he would hurt her and give her bruises. That made me feel sad for Mommy. I don't know what sickness that is, but I don't like that he was mean. My Daddy would never hurt Mommy.

I'm always scared when I have to go down to that eerie basement. There's no banister on the stairs and the only light is from a single dangling bulb with a long string attached to it. And it's at the bottom of the stairs. With every single creaking

step, I am so scared the alien monster will come slithering through the slats. Then he'll reach up and wrap himself around my ankles. He'll drag me back to his den and who knows what he'll do to me? Ewww, it gives me the chills just thinking about it.

I always jump up to grab the string as soon as I reach the bottom of the staircase. I can't wait to get that light on. My brothers tell me that this is where the Boogie Man lives. I believe them.

I hate that basement so much. I only go down when Mommy sends me into the cold cellar. It's another small, dingy room, filled with large gunny sacks and wooden barrels that store potatoes, onions, and carrots. There are wooden racks stacked with mason jars of Mommy's homemade peaches, pears, jams and jellies, pickled beets and yucky pink meat. Gross! The pink meat is for emergencies, when unexpected company comes, and she needs something fast to make for dinner.

Mommy loves cooking for company. She's used to feeding the hired hands who work during the busy summer harvest season. We have a large beef cattle ranch and a very big vegetable garden. There's always plenty of food.

My favourite thing about our house is our big verandah. That's where Daddy smokes his pipe on warm summer nights. I love the way it smells. When he blows out a big puff of smoke, it looks like a miniature cloud all around him. We love to gaze up at the stars and try to find the Big Dipper and the North Star. We can hear the croaking sounds of frogs and the howling echoes of the coyotes off in the distance. Those are special times with Daddy.

Our western style family photo: Daddy (Vian) me, Billy, Jimmy, Frankie and Mommy

Photo Credit : Paul Anderson

Both these photos were taken before we rode in the local Claresholm parade. It was called the Family Ride.

Photo Credit: Paul Anderson

Chapter Four

Mr. Piano

Today is so bright and sunny. I love the colour of blue in the sky. I can't wait to go outside and play. I put on my red jacket. I look inside my black gumboots and turn them upside down before I put them on. One time I stepped inside and I felt a big lump. When I took it off, a mouse ran out. That was awful! I hate dirty old mice! There are so many on the farm.

I'm really happy to see the first signs of spring. The little green shoots with the pretty purple petals are starting to peek through the ground. This means we can finally say good-bye to another long winter. It's still chilly but I can't wait to get out on my bike. What a perfect day for a ride.

I cycle out to the gravel road bordering our property. I can hear my three brothers off in the distance, arguing over the bikes. Soon they're following me and getting closer. I stop to brace myself and hold tightly onto my handles. They whiz past me, nearly knocking me over. But I am still trying really hard to catch up with them.

I continue to pedal madly. They don't pay much attention to me. They're older. Billy is four years older than me. He's 10. Frankie is 14 and Jimmy is 16. My sister is still little, so I play a lot by myself. I visit all the cats and new baby kittens out in the barn. Sometimes Billy and I ride our Shetland pony, Peanuts. He's really fat and doesn't like us riding on him.

This past winter, Mommy and Daddy bought the farm down the road. We always drove by the old boarded-up house. Now it's ours. I know that's where the boys are going. I

overheard them whispering. They're not supposed to go near there. Daddy said, "That house is strictly out of bounds to you boys. Period!"

It feels like it's taken me forever, but I finally pull my bike up to the back porch. I was right. Their bikes are all here. But I don't see them anywhere.

I walk around to the other side of the house. It doesn't look like it's been taken care of in a long time. The wood is so battered and worn, you can hardly tell it was ever painted. I have to step really high to walk over the old branches that have fallen. All the prickly shrubs are overgrown and there are lots of dead vines covering the front door.

But wait! Two scruffy old boards are dangling on the frame. It's definitely not locked anymore! Uh oh, the boys have broken in. I see just a little bit of an opening. They're going to be in deep trouble. They're not supposed to be in there!

What should I do? Should I go against what Daddy said? Or should I just go in? I take two seconds to make my decision. I go in.

Although it is a beautiful, sunny day, it's very dark inside. The damp, musty smell hits me right away. This place must not have been lived in for a very long time. The dirty linoleum floor looks ancient and worn. I think it's yellow and black squares, but I can't really tell, it's so dark. I feel all the yucky old mouse poo on the bottom of my rubber boots. A broken rocking chair is missing its seat and I can see a missing arm lying on the floor. There's so much dust! Layers of spooky old spider webs hang in every corner. And there's some of that long and sticky brown flypaper hanging from the ceiling. It's covered in dead flies. This house is creepy.

I step into the kitchen and snoop inside the cupboard drawers. They're heavy and stiff and hard to open. More icky

Chapter Four

mouse droppings everywhere. There's a chipped teacup with a yellow rose on it and two bent silver spoons.

I hear laughing upstairs. The creaky floorboards are moving from my brother's weight. All the dust is floating down into my face. It's making my nose itch and making me cough.

I know I should leave the kitchen, but something makes me turn back around. It's just a feeling. What's back there? I can see there is another door. How did I miss that? I take hold of the heavy cast-iron doorknob and turn it carefully, with an ever so slight hesitation. I gently push the door open and peer around the corner. The sunlight streaming in through the cracks of the boarded-up window is heavenly. Everything is moving in slow motion. It's like I'm unlocking an ancient magical treasure. My eyes adjust to the warm light and I see something incredible. A rosy blush burns my cheeks and my eyes light up.

"It's a piano!" I softly whisper under my breath. "Wow!"

I am so surprised. Oh, how exciting! My body shivers as I step through the doorway and enter this enchanted room.

"I wonder if this was the music room?" The piano is covered in layers of dirty pigeon poop and even more dust. "I'm so sorry they left you behind, dear old Mr. Piano." I touch him gingerly. "And nobody's been here to take care of you. I'm just going to open you up."

I reach for the lid and gently pry it open. "Look at your pretty black and white keys. I think they're called ebony and ivory. You're so beautiful. I wonder how long it's been since you've been played, dear Mr. Piano."

My tiny fingers touch the keys and I begin to plunk away. Some of them are very stiff and barely move. Others don't make any sound at all. I begin to perform my imaginary masterpiece. The sounds echo throughout the room. As I play, I feel so happy inside. This will be my little secret.

Once I'm back home, I'm not sure if I should tell Mommy about my newly found treasure. What if she gets mad at me for going inside the forbidden house? But I'm too excited to keep my secret. The boys will be in a lot of trouble and won't be happy with me. But I decide to spill the beans.

"Mommy, promise you won't be mad if I tell you something?"

She doesn't look up from the pile of towels she is folding. "Well, I guess that all depends on what you're going to tell me."

I gulp down a deep breath. "Well … you know that old farmhouse at the end of the road? The one we're not supposed to go near? I … um … well, you see I followed the boys down there and they went inside. So, I did too. And Mommy, you'll never guess what I found there?"

"What did you find?" She looks up from the towels and glares at me.

"I found an old piano. I mean a really, really old piano!" I am far too excited to be scared. "It's all covered in bird poop but I know it's really beautiful underneath."

She stares at me silently. I keep going. "And I played it, Mommy. I loved playing it. It sounded so amazing. Can we go look at it? Please?"

A tiny smile crosses her lips. "A piano? Really? Hmmmm. I don't know, Kelita. We'll see."

Does she not believe me?

"Yes, Mommy. A PIANO!"

I am starting to feel sad. What if she doesn't believe me?

Thank goodness she does.

We make our way down to the old house, through the boarded-up door, cobwebs and over the mouse droppings. I lead her to my dear old Mr. Piano.

"Well, this certainly is a beautiful old piano, isn't it?" she says with delight in her voice.

Chapter Four

"I just knew you would love it, Mommy. I knew you would!" I am as happy as Christmas morning.

Mommy tells Daddy and soon after, the heavy instrument is hauled out of the dilapidated farmhouse. And nobody gets into trouble, not even the boys!

We deliver Mr. Piano to Mr. Turley, in Carmangay. That's the closest town to our farm. He is going to repair and refinish it. I wait for what seems like forever, with all the patience I can muster. Finally, after many months pass and I have all but given up hope, Mr. Piano arrives. He is completely cleaned up and refinished. He looks so different. All shiny and spotless like he's wearing his Sunday best.

Mr. Turley is very proud. "The wood is burled mahogany. The castors are made of solid ivory and there are only six octaves instead of eight. You see these holes on either side of the music stand? They were once used to attach candlestick holders. There wasn't any electricity back when this piano was first played!" He puffs out even more. "I've been able to trace the serial number all the way back to London, England, to a Mr. Mason of Newcastle who purchased it in 1847."

My mother is beaming. "This is all very exciting. Thank you for tracking down the history for us." Mr. Turley bows ever so slightly. Mommy continues, "You did an incredible job bringing it back to life. And how does it sound? Much better than before, I imagine?"

Mr. Turley responds with hesitation. "The piano, apart from the cabinet, is still in very bad shape. I'm sorry Vilda, but the sounding board is not any good. It would take a lot of money to completely rebuild it. And even then, you'd never be guaranteed it would stay in tune."

My heart sinks. Even though I don't completely understand, this doesn't sound good to me.

"I'm afraid this will always be more of a conversational piece than an instrument to be played." Mr. Turley looks sad but resigned. So does Mommy.

I gaze down at the black and white keys and gently run my fingers over them. Quietly I whisper, "I am so sad that I won't be able to play you for real, my dear Mr. Piano. But I think you're very special and I'm so happy Mommy has decided for you to stay."

I stare up at my mother, hope flooding my eyes. "One day we will get a piano, right Mommy? A real one so I can play."

"Yes, Honey," she answers gently, patting the top of my head. "One day, I promise."

Chapter Five

Pickled Pieces

I have so many incredibly happy memories of Daddy. And I have so many incredibly sad ones too.

I know how much he loves me. It's a great big kind of love. It doesn't matter how big I grow, I still want to crawl up on his lap and wrap my arms around his neck. Then I shower him with lots of fat hugs and kisses.

Whenever Daddy gets sad, I feel sad too. Then I love him even more.

Like when Grandma died, Daddy was hunched over at our kitchen table. I know he was trying to hide it but I could see him crying into his hands. I heard him crying in his bedroom too. Daddy was sad for a very long time when Grandma died. That's when my heart really hurt.

Sometimes, he has to go to the hospital. Mommy says he's sick and needs to go away for awhile. But Daddy doesn't look sick. He doesn't lie in bed when we see him. He doesn't have to wear a hospital gown. I don't understand.

When we get to the hospital, Mommy meets him at the elevator. Then we sit in a small room and have a visit. When we're finished, he goes up the elevator all by himself. I hate the long drive back home. I am always sad when Daddy isn't with us. I don't like when he has to stay in the hospital.

My Auntie Frances is in the hospital sometimes too. She has cancer. When Mommy goes to see her, she has to drive all the way up to Edmonton. That's a really long drive. While she's away, Daddy looks after us. There are times he gets really sad and then he cries again.

Right now, my Auntie Frances is really, really sick. Today Mommy left in a big hurry to go and see her. Daddy is taking care of us. Vian and I have skating lessons in town at the rink and then, after lessons we get to skate just for fun. Daddy drops us off but doesn't stay and watch. We are on our own until he comes back to pick us up. I can see him standing at the end of the rink, waiting for us to come off the ice. I grab my sister's hand.

"Come on, Vian, let's go. Daddy's here." I'm excited. Hopefully he will buy us a treat.

As we skate closer to the boards, I can see something is very wrong with him. His hair is messy and he is crying. "Your Auntie Frances has passed away," he whispers through his tears. "She's gone now. She's gone forever."

Daddy is sobbing. His hair keeps falling in his face and even though he reaches up to brush it back, it falls down again.

Vian and I stand, dumbfounded. Dead? She's really dead? Like in heaven now and forever? Neither one of us moves an inch. We just glare at him, waiting for him to tell us what to do.

He finally opens his arms wide to hug us both. We try to steady ourselves on our skates and hang on to him for dear life. We squeeze him as tight as our skinny arms can squeeze.

He is acting so different. My stomach is churning with that old familiar feeling. I don't know what's wrong with him, but I am worried. I can't even think about my Auntie right now, just Daddy. I am panicked and my heart is galloping.

"Ccc'mon ... c ... c ... c'mon, girls, I'll help you off with your skates."

Why is Daddy slurring his words? He's walking funny too. Lopsided. We all wobble over to the bench and I can feel people staring at us. It gives me the creeps.

I know he wants to help us, but he just can't. "It's okay,

Chapter Five

Daddy, I can do it. You just sit down. Right here." I try to be calm and sweet. He slumps onto the bench. Vian starts patting his back. She is trying so very hard to be brave and helpful. "It's okay, Daddy," she murmurs. "Don't cry. Please don't cry."

His hair keeps falling back into his face every time he slumps. He never lets his hair fall like this. "Lemme, lemme me help with your skates," he whispers, trying not to draw attention. "Come on, honey, I want to help you." I sense he knows people are watching us. He can feel their stares too. It doesn't feel good.

"Daddy, it's okay," I sink down next to him. "I can undo our skates. It's really okay. You just sit still right beside me." I'm only 10 but at this moment I feel much older, taking care of my father.

He won't have it. "I am your daddy and I'm gonna take off your skates!" He is bellowing. "You girls mean everything to me and I'm gonna take these off, right here!" His eyes are filled with tears. "Right now, that's what I am going to do. Cause I can do that for you."

He bends over sideways and reaches for our feet. I don't want to make a scene so I let him untie our skates. His eyes are so red. Tears are tumbling down his face. A few drops fall onto my skates. He grabs a hankie from his pocket. My poor daddy!

It's obvious Vian isn't at all sure what's going on. I reach out to squeeze her arm gently. I want so badly to comfort her. As for me, I just want to crawl under this bench. I feel sick.

Finally, we are ready to leave, and it can't be soon enough for me. Daddy is taking way too long to walk to the parking lot. Vian and I hold onto his hands as we slowly make our way to the truck. I cannot wait to get in and fly away from this place. I never want to see those people again as long as I live!

I wish Mommy was here. I need her to make everything

right. I don't want Daddy to be like this anymore. I want him to stop crying. I want him to stand up straight and talk normal. When is she going to come home and take care of us? I am so, so sad my Auntie has died.

But I have to be strong for Daddy right now.

~~~

"I've got some business to take care of and then I'll be right out." Daddy pats Vian's head. "When I'm done, we can go get a treat, okay? You girls wait right here. Stay in the truck."

We will do as we are told. It's not the first time Daddy has visited the gas station at the south end of town. And left us in the truck to amuse ourselves.

I take the lead. I know that if I don't entertain her, my little sister will start acting up. We play the driving game. Take a trip to Hawaii. I let her drive. When we arrive, we swim in the ocean, we walk on the beach and explore the island.

But now, after twenty minutes of imagination, we are both bored and restless. Daddy has been gone for a long time.

"When is he coming back? I'm thirsty," Vian moans in a tired voice.

"Me too." I'm not sure what else to say. *Where is he?*

"When can we go and get our treat?" she whines some more. Vian has had enough.

"I don't know." Time to take some Big Sister action. "Let me go and see if I can find out. You wait right here, okay?"

I jump out of the pickup and quietly sneak into the side door of the garage. It smells like old trucks and oil and gas. I can hear men's voices in the corner, so I follow them. Sneaking a peek into the dingy office, I see a few men sitting around a messy metal desk. They are huddled around a big whiskey

bottle. Daddy is laughing with them. I'm not sure what they're laughing at. It doesn't sound very funny to me.

Daddy notices me peering around the corner. He doesn't seem angry. "I'll be right out, Honey. I won't be long now."

I run back to the truck as fast as I can and hop up into the driver's seat. I feel embarrassed. I didn't want anyone to see me.

Vian stares at me hopefully.

"He said he's coming soon." I cuddle up next to her. "Don't worry … he'll get us a drink in a minute or two."

We wait a bit longer and finally, Daddy comes outside. We see him pop a coin into the drink machine. Kerplunk! Out comes a Pepsi. We're both thirsty and very happy when he hands us the tall bottle.

Our next stop is in front of the Bell Hotel on Main St. Our town of 3,000 people has only one stop light (it's not very big). At least the only hotel is located on a busy street. We get to watch people coming and going. It makes the time go so much faster.

Daddy goes through the door that says, Men Only. I'm not really sure what kind of business Daddy is doing in the hotel, but it looks like we're stuck waiting in the truck again.

Vian and I finish sharing the bottle of Pepsi. And then we wait. And wait some more. Vian is falling asleep on my shoulder as the minutes click by.

Where is Daddy?

After what feels like an hour, he appears, opens the truck door and helps us both hop down. He digs into his pocket and hands us each a dime. With Daddy between us, holding our hands, we walk to the store to buy our favourite goodies.

As soon as we arrive back home Vian and I rush to our bedroom. We can't wait to finish our Pink Elephant popcorn and find that special little prize waiting at the bottom of the

box. I can hear Mommy's voice off in the distance. My ears perk up. She sounds angry. I try to listen.

Ivan, you're not getting that big jar of pickles out of the cupboard. You're in no shape, so please, just forget about them. Go on now - get out of the kitchen!"

No sooner has Mommy left the kitchen, Daddy is back rummaging around in the cupboards. He is not taking no for an answer. He really wants those sweet mixed pickles!

When he finally finds his treasure, he carefully attempts to remove the heavy jar from the top shelf, but loses his balance. SMASH! The giant pickle jar hits the floor. From all over the house we hear the heart-stopping crash and race into the kitchen. Shattered glass, sweet mixed pickles and sticky juice cover the entire kitchen floor! It's an overwhelming sight and I know what is coming next.

My mother is livid. "Ivan - look what you've done! Didn't I tell you? This is exactly what I said was going to happen. That's why I told you NOT to get those pickles out. Just look at this mess. Get out of the kitchen!"

Daddy looks like a pathetic scolded child. But I am the child. Why do I have to witness this? *Oh, please don't let her be so mad. I don't want to be here, right now. I wish I was invisible.*

Mommy does not try to hide her anger. She knows she is now the one in charge of cleaning up this dangerous mess. Daddy keeps repenting and offering to help. He kneels on the floor, desperately trying. He mutters, "I'm sorry," over and over again. His speech is weak and slurred. "I'm s-s-oo s-s-s-sorry. You're right. You're right. I'll clean it up. I'll clean it all up. I'm sooooo stupid – so stupid. I'm so sorry."

Daddy protests and tensions only raise higher. Mommy is fuming! She doesn't want Daddy to help out at all! "Ivan, there's glass everywhere!" she screams. "You're going to cut

## Chapter Five

yourself - now get off the floor and just let me do this. Get out of here. Get out of the kitchen – NOW!"

Daddy is starting to cry and his voice is rattled. "I said I was s-s-s-s-sorry. I'm really sorry, ha-ha-Honey. I'll clean it up. I'll c-c-c-clean it all up. Ya, ya, ya You were r-r-r-right. Yup you w-w-w-were r-r-r-right. I'm sorrrrry."

His words have no impact. "Ivan, leave the mess alone and get the HELL out of the kitchen and I'm not telling you again! Maybe next time you'll listen to me!" She turns her back as she mops up the shattered glass. I stand there silently, wishing they would stop yelling. *Why can't they just kiss and make up?*

Daddy tries to stand then slumps against the kitchen wall, defeated. "Well – maybe there just won't be a next time - maaaaybe not. I can't do anything rrr ... right. I can't do anything right, can I? I'll just get it over. Rr ... right now ... and you won't have to worry about any next time." He is muttering but I can hear him. And understand him. *Am I the only one hearing his whispered threat? Is this for real? Oh Mommy, please don't be so mad.*

I know Daddy has made many threats like this before, but this one is happening right in front of me. And I'm scared. I have heard him behind their closed bedroom door. I have heard their arguments when they think I'm asleep. But this time there is no wall between us. This time I can hear everything.

I look over at Daddy, who is now weeping uncontrollably. Once again he is sitting on the floor in a very sad, pickled mess. I want to go over and comfort him, but something tells me I should just stay put. I feel frozen in fear.

Mommy is not responding at all. She has heard these threats before. She is on her hands and knees, very methodically picking up the broken glass. She doesn't even look up at Daddy, sobbing on the floor.

*How can this be happening? Why won't she say something to stop him?*

I want to call for help. But who?

I want to feel safe. But Mommy and Daddy can't protect me. I don't think they can even see me. I am the invisible 10 year-old child.

I take a deep breath and stare out the window. I will be strong and I will not cry. I have to be strong. I am caught between Mommy and Daddy. I don't want to be caught in the middle but here I am.

Daddy slowly picks himself off the floor. He stands shakily, then leans against the wall. *Should I go to him?*

I can't.

I bend down and help Mommy pick the pieces off the floor. We work together in silence.

*Say something to him, Mommy. Please! Tell him it's okay. Tell Daddy you know it was an accident. Say something. PLEASE MOMMY PLEASE, say something!*

Nothing. The quiet is all-consuming. We hear Daddy staggering down the hall. Mommy remains still. No expression. But I know her mind is churning furiously. There is a war raging inside her. All her thoughts are trapped behind a giant steel door.

But they're not. They are strong and, like the pickle juice, I can feel them spilling out everywhere.

What if this is a mess that is impossible to fix?

Chapter Six

# The Great Escape

Once Mr. Grainger is certain everybody is on the bus, he closes the heavy door. A strong smell of egg salad slams me in the nose. Somebody must have saved their lunch for the ride home.

Mr. Grainger is not only our bus driver, but he is also the local undertaker. I think he's the most handsome of all the drivers. He really doesn't look like an undertaker, but I know that's what he does. It is kind of creepy. Every morning he picks us up at 8:30, then goes and works with dead people. And every afternoon he picks us up at 3:30 for the drive home, after working with dead people. It's the same routine, day in and day out. I sure hope he never mixes us up!

As soon as we arrive at our laneway, I notice our Mercury Marquis in the driveway with its doors wide open. It's a big boat of a car. I am surprised to see several suitcases in the trunk and clothes still hanging on their hangers in the windows. There's a box of Cheerios on the back seat and pillows, towels and bedding on the floor. One of Vian's favourite dolls is lying on the dashboard.

*What's going on?*

This car is jammed to the roof! I have no idea what is happening. Or why. Nobody told us we were going on a trip.

Mommy is standing in the doorway. She looks deadly serious. There is no hug or kiss. She shoos us away from the house, toward the car. "Okay kids, I need you to all turn back around and get into the car. If you have to go to the bathroom, make it quick. Then right back out and into the car!" Her voice is strong and stern.

"What? What are you talking about?" I ask timidly, half in shock.

Billy barks back at me. "Just do what Mom says, Kelita."

*Huh? What does he know that I don't?*

"I don't understand. What are we doing?" I pester further.

Vian is even more confused. "Mommy? Where are we going?" My little sister is almost in tears.

"Do you need to go to the bathroom or not?" Mommy glares at us both, her voice emotionless.

"But I don't understand. Where are we going?" I am relentless. And afraid.

"Right now, I just need you to do as I ask," she commands. "Quickly. Please, hand me all your books."

I dump my armful into her hands. My pencil case falls to the ground and all the coloured pencils roll out. I dive to pick them up.

"Don't worry about those, I'll get them." Mommy gathers the crayons and continues to issue orders. "Kelita, you go and use the bathroom down the hall. Vian, you can use the one here. Billy, I need you to help me with that laundry basket. It's going in the trunk." My mother is on a mission!

As I sit on the toilet, half-panicked and half-frozen, I remember our conversation from last night. She was speaking quietly as she washed dishes.

"Kelita, I need you to bring home all of your books from school tomorrow. Bring all of your supplies as well. You'll need to go to your sister's home room and help her do the same." She sounded matter of fact. But I was confused.

"I don't understand. Why do you need to see our books?"

"I just want to see everything you've been working on, that's all." She wasn't looking at me. Just cleaning up the after-dinner dishes like usual.

## Chapter Six

"But why do you need all our supplies?" This didn't make any sense at all.

"Just do as I ask, please, Honey. I want to see everything that's in your desks." Her tone was suddenly much nicer. But still firm.

And now a day later, we're being rushed out of the house like it's on fire!

We squish ourselves into the overstuffed car. Billy sits in the back and Vian and I cram into the front with Mommy. Everything feels frantic and my nerves are beginning to rattle.

"Mommy, there's not enough room for me!" There is too much stuff everywhere. Vian is almost on Mommy's lap!

"Then you'll just have to make room. I need you to hurry up!" She spits the words sharply. "Kelita, please! Just push those blankets on the floor and close the door. Slide over closer to me, Vian!"

My sister and I are squished in like sardines. We both have pillows on our laps and Vian is holding onto her doll tightly. *I hope Mommy packed something for me to play with too.*

We still have no idea where we're going. But our mother obviously does. We pull out of the driveway going way too fast, and hit the highway heading north on the #2. No one says a word. The only sound is the whirring of the wheels on the pavement, over and over, droning on as our home fades farther into the distance.

I close my eyes and focus on the thumping of my heart. Nothing about this feels right. Why isn't Mommy explaining anything? And where is Daddy?

A sudden memory jolts me into high alert. Something I saw in the kitchen. When I was rushing back outside from the bathroom, I noticed a thick white envelope on the table. It was addressed to Daddy, in Mommy's handwriting. It just said 'Ivan'.

*What is in that letter?*

"Where's Daddy?" I break the deathly silence. "Why isn't Daddy coming with us?"

"He can't come with us." She doesn't take her eyes off the road. "He has to look after the ranch."

"But how long are we going for? And where exactly are we going?" I keep trying.

"I want Daddy to come with us!" Vian pouts.

Billy pipes up from the back. "Just let her drive. Be quiet, okay?"

*He knows something. I can tell.*

We drive on in silence, afraid to upset Mommy. But I think I am even more afraid to find out the truth. The truth about why Daddy isn't with us. I knew that he was going off to a cattle sale today. He was standing by his truck when the school bus pulled up, all decked out in his tan cowboy hat, denim shirt and pressed jeans. His brown cowboy boots were scuffed and muddy. He wasn't wearing the new ones. Those are only for special occasions.

He had come right over to us for a good-bye hug. "Have fun at school and be good for your teachers," he said. "I'll be home in time for supper. I love you girls." Then he hopped into his shiny red and white Ford pickup and waited until we were safely on the bus. It was all so normal. So regular. We all waved goodbye like every other day.

Now, just a few hours later, the four of us are piled into our car without Daddy and we don't have any idea where we are going. Or why.

I am hating this day and everything about it. Are we running away from Daddy? Is it because of his drinking? Because of his threats? It's not that bad, is it?

Could it be because of what Daddy said about Mommy and Mike?

## Chapter Six

Mike and his wife are friends my parents met through the cattle business. We have visited their ranch outside of Calgary many times. Sometimes even for dinner. I love the noodle casseroles his wife makes. That's the best thing about going to their place. They come to our ranch often too.

They have three kids, two girls and one boy. They are a lot older than Vian and me but we both like their youngest daughter, Deanna. She is a teenager! She will happily entertain us up in her bedroom while our parents talk about buying, selling and breeding cattle. BORING!

But now, on this crazy day that makes no sense at all, I remember Daddy's words about Deanna's father, Mike. I knew Daddy had been drinking alcohol, but I was still shocked when he slurred, "Mommy doesn't love me anymore. I know she loves Mike. She's with him right now. That's why she's in Calgary. Your mother doesn't love me anymore."

I didn't know what to say to him. His words were so hard to understand. "Don't cry, Daddy," I tried my best to console him. "I am sure you're just imagining this."

Maybe. Maybe not. There was a tiny place deep inside of me that believed him. And I had good reason. One time, Mike and his wife had stayed over at our house. When they were leaving, Mike went back inside to fetch something from the guestroom. Mommy went back too, to help him. I'm not sure why but I followed them in (they didn't see me). And I saw them embracing. Not just friendly hugging. Really embracing, like actors in the movies.

But that was then, and this is now and who really knows the truth? The road keeps rumbling underneath us, as we chew up mile after mile.

*Poor Daddy. What if he was right?*

Then I think about my mother and what she once confessed to me.

"Your father has been receiving all these letters from someone he met when he was away in the hospital." Daddy had gone to the States for treatment and was away for a long time, that's all I knew. Mommy held out a handful of letters to prove her point. "Just look at them all!" I could tell she was hurt. And she was angry too.

After that she started making more trips into the big city. And as soon as she was gone, Daddy would dive into his secret drinks. I never saw him pour the vodka, not once. But all of a sudden, he would become withdrawn and sad. Then came the crying. That's when I would get scared. I couldn't wait for Mommy to come back home. For everything to be normal again.

Today is not normal. Today is confusing and upsetting. It feels like we are running away. We are leaving our beautiful new home, our school, all our friends and our ranch. But worst of all we are leaving Daddy. I'm only 11 years old. I still need my Daddy!

Nearly two hours later I can see the big city on the horizon as we come over the last hill. This part of the drive has always been my favourite. There are beautiful sprawling ranch houses with freshly painted white fences. I see horses playing with their colts and red and brown cattle spotting the fields. When we get closer to the city limits, the traffic gets heavier. Today the highway is super busy (at least busy for us country folk). We pass the gigantic grain elevator in Midnapore and then turn off the main road. Mommy seems to know where she's going as she navigates a maze of smaller streets. We enter one last avenue lined with two-storey townhouses and Mommy pulls the car up to the curb and parks.

"Okay, kids. Let's get out and everyone help unpack, okay?" She searches in her purse as she heads towards #12. Standing

## Chapter Six

under the stoop, she finally finds what she is looking for. The key. She opens the door and walks in.

*What? What is this place? Who lives here? Why are we here?*

"Is this where we're going to be staying?" I ask Billy, as he loads a pile of clothes over his arms.

"Yup," he replies curtly. Billy is always a person of few words.

Vian climbs over me to get out of the car. She and Billy start carrying things into the townhouse. I can't move. I am completely lost in thought. *Are we really coming here to live? And if it is true, why didn't we even get to say good-bye to anyone?*

It's all happening way too fast. My head is spinning and my tummy feels upset. An unusual sadness has overwhelmed me. I wish I could throw up! I want this feeling to be out of me. I just want to turn around and drive back home.

"Kelita, aren't you coming?" Vian asks me, excitement in her voice as she grabs her pillow from the front seat. *She doesn't have any idea, my poor, dear sister. She thinks this is all a big adventure.*

"I'm coming. I'm coming." I grab one of the smaller suitcases from the trunk and slowly make my way to the front door. Inhaling deeply, I step inside and survey the living room.

*Well, there's not much in here.*

I drop the suitcase as Vian grabs my hand and leads me upstairs to see our bedroom. I am shocked. Beyond-belief stunned.

"What's *that* bed doing here? I point to the ancient saggy mattress, perched on a rickety wooden frame. "And that ugly dresser?"

Vian just shakes her head. Maybe she doesn't remember?

"This is all our old yucky furniture!" I am totally disgusted. "I wonder how it got here?"

My mind is racing. I am beginning to understand. Over

the past few months, I noticed pieces of furniture missing, mostly from my brothers' bedrooms in the basement. Our new home has much more space so a lot of the older furniture from our previous farmhouse was in storage downstairs. Jimmy and Frankie don't live at home anymore. Just Billy and us girls. I guess my mother figured nobody would miss a few old beds and some ancient dressers. When I did ask her about the missing things, she told me she was having them "antiqued." It made sense. I never had a clue.

I wonder how long she has been planning this move. Is it weeks or is it months?

I slump down onto the floor, out of energy and hope. Billy rifles through the Yellow Pages for a place to order pizza. That brings a smile to my lips. It's actually the best part of the whole day. Pizza for dinner!

I feel a bit better with pepperoni in my belly. Vian and I crawl into our new-old, lumpy bed. It has been a very long and stressful day. I want my own bed back. In our own house. The one with Daddy in it. But what can I do?

"That light is so bright. Can we turn it off?" Vian is crabby. She must be exhausted.

"No," I sigh. "Those are the streetlights. I'm afraid we can't turn those off."

"But it's shining right into our room!" She is almost crying.

"I know it is. Just close your eyes and try to go to sleep." I'm not sure what else to say. This is all new for me too. "Turn over and I'll cuddle you, okay?"

I snuggle into my little sister's back and wrap my arm around her. We feel safer this way. I love her so. I know she doesn't understand. Not like I do. I must protect her.

Without any curtains or blinds, I have a hard time getting

## Chapter Six

to sleep. But it has more to do with my deep sadness than the city lights. I can't look out and see the stars, like at home, in the country. I won't get to see my friends out in the schoolyard anymore. I won't have piano lessons, or choir or the girl's club I belonged to. Or our swing set. Horses to ride whenever I want. So many things will be missing. But it's Daddy I worry about the most. *What about him?*

My sweet Daddy is the last thing on my mind as I finally drift off.

~~~

It takes some time (and some tears) but now that we're all enrolled in our new schools (Billy in Grade 9, Vian in Grade 2 and me in Grade 6), I am starting to feel an underlying wonderment about this new city life. There is, as strange as it may seem, a small hint of excitement that I have a hard time admitting to myself. My cousin Rhonda Lee lives here in Calgary and now we're closer to one another. She is most definitely a city girl. I remember her visiting with us on the farm. She was very frightened of silly old harmless dragonflies (I know, they look way more dangerous than they are). She is also terrified of cows. I am not kidding – cows!

But now I am joining Rhonda Lee on her turf - the big city. No dragonflies and no scary cows but oh, so much to learn!

The thing I love the most about living at "Village on the Green" (the name of our townhouse complex) is all the kids! On the farm, Vian and I only had each other to play with. But here, there are kids everywhere. We spend hours playing hide-and-go-seek. I'm getting to know every tree and shrub on these grounds.

Freedom - ah yes, freedom. We are most definitely

experiencing a new kind of liberty. We live within walking distance of a strip mall which includes a corner store. And you know what that means? Candy and chips and chocolate and more candy!

So here we are with new friends and cousins and candies at our fingertips and life is feeling okay. I miss Daddy for sure, but I have to admit, there are benefits!

And that is when the doorbell rings.

"Somebody's at the door!" Billy yells from his bedroom.

"Can somebody please answer it?" I holler back, expecting my friend Lisa. I'm still brushing my hair. A girl has to look good in the big city.

"It's alright, I've got it," Mommy answers. She's been extra nice to us since we moved.

I hear a man's voice. It catches me by surprise. Because I know that voice. I *without a doubt* know that voice. I run down the stairs to confirm my suspicions and when I do, I stop in my tracks and then back slowly up the staircase.

There has been no warning at all but there he is, standing at our front door like he owns the place. Mommy looks so happy to see him. I feel embarrassed witnessing her girlish flirtations. With *him*? I just cannot understand it.

What should I say? What should I think? I find myself speechless. All I can hear are Daddy's drunken words stumbling out of his heart. *Mommy doesn't love me anymore. She loves Mike.*

It was true! What he had been telling me, was right. Mommy really doesn't love Daddy anymore.

I inch my way back upstairs and stand as if in a trance, gazing out from my bedroom window. It's a beautiful spring night. My mother is driving off with this man. This man who is married to another woman. This man who said he was my

father's friend. This man who I saw embrace my mother in a way that was just plain wrong!

The deep betrayal burns inside me. It keeps company with the angry little girl who is fighting to survive. And the sad and loyal daughter who misses her daddy so desperately.

I let go a silent scream as I dry my tears on the new curtains. It is time to run outside and greet my friends. I need to hide from my own shame and humiliation. From this horrendous ache in my soul. But mostly, I need to hide from the devastating pain I feel for my dear sweet, abandoned Daddy.

Chapter Seven

Premonition

The nights are much cooler. The poplar trees are no longer green. Their yellow and brown leaves have started to scatter. Walking home from school today, I hear the crispy crunching under my feet. When I inhale that distinct autumn scent, a profound memory washes over me. I'm not quite sure what it is. Six months have passed since our great escape from the ranch. Six months of becoming a city girl and running away from Daddy.

As soon as I get home, I open my mother's bedroom door to find her leaning over her small white suitcase. It is laid out on the bed and, inside the shiny blue lining, her clothes are neatly folded. She is packing.

"Hi, Mommy, do you have to go somewhere?"

"Hi, Honey. Yes, I do have to go away for a few days. You girls are going to your aunt's. You'll have fun with Rhonda Lee. I think there's even a hike she wants to take you on."

"Where are you going?" I ask cautiously.

"Denver. There's a cattle sale there."

"What about Billy?"

"Your brother's going to stay here on his own." Doesn't sound like she wants to talk very much.

My brother Billy is older. I guess he can take care of himself. Going to my aunt's would be so boring for him anyhow.

My parents have always done a lot of travelling for their cattle business. Vian and I usually have to stay somewhere, or someone stays with us. Since being here in the city, Mommy

Chapter Seven

hasn't travelled very much. Daddy usually goes on his own now. He just got back from France not too long ago. My parents have helped to bring the first Charolais cattle from France into Canada. They are the large white cows known for their beef. In fact, Daddy used to be the President of the Canadian Charolais Association. When he came back from his trip, he brought Vian and I some French perfume and very special gold earrings. We also received a beautiful silk scarf of Paris with pretty pictures and French writing on it.

I'll miss my mother but going to my aunt and uncle's is always a treat. Besides seeing my cousin Rhonda Lee, I love staying in their fancy house. It's beautifully decorated and always sparkling clean. We take our shoes off as soon as we go in. Our feet sink deep into the fluffy new carpet and its fresh scent fills the air. The living and dining room are decorated in just two colours - beige and pink. Expensive figurines and vases are all encased in glass. The oval-shaped coffee and end tables have golden legs. All are delicately adorned with miniature teacups, saucers and tiny teapots. There are petit points of Pinky and Blue Boy in fancy white wooden frames hanging over the white stone fireplace.

I always wonder if anyone ever actually sits in the living room. It's like a showroom. I love it. Auntie Lucille's décor is so different than our mother's. Ours is western. We have wagon wheel lamps over the dining room table, horseshoe ashtray stands and Naugahyde furniture. We also have a buffalo head hanging in our basement, along with its matching hide on the floor. Wolverine, coyote and cow hides too!

After Mommy drops us off, Vian and I quickly settle into our aunt's palace. After supper (or I should say dinner, because that's what city folk call the last meal of the day), my aunt and uncle read in the den while Rhonda Lee and I play a

fun game of "Clue." My younger cousin Greg is playing with Vian.

The phone rings.

Uncle Don gets up to answer and my eyes are glued to him as he walks into the kitchen. Not sure why. My spidey sense is tingling. I overhear his voice and listen closely to his tone. Something has happened. My antennae are up - way up. I sense something is very wrong at the other end of the line.

I am pretty good at interpreting conversations behind closed doors. Even though I am only 11, it has been a way of life for me for a very long time. Before we left Daddy, I always listened at the master bedroom door. Somehow it made me feel safer if I knew what my parents were talking about. I'd be up until the wee hours, but it was worth it.

Now, I listen to telephone conversations between Mommy and that man. I feel like a spy. Yes, she is still seeing, him. Even though it hurts me, the more I know, the better. Or maybe not. I'm not sure. Maybe I'm just torturing myself even more. But still, I always try to eavesdrop.

The call ends. It's short. My aunt and uncle are whispering in the kitchen. Something definitely doesn't feel right to me. Not at all. When they walk back into the den, I'm totally expecting them to tell me something horrible. But they don't. They just sit down and pick up their newspapers like everything is fine. Maybe I'm wrong? Maybe everything is fine?

In bed I toss and turn, trying to get comfortable, but I can't sleep. Even though Vian is next to me I feel so alone. The dark shadows cast from the nightlight only add to the crazy thoughts swirling around in my head. I can't turn off the busy-ness in my brain no matter how hard I try. Once again, I am worried.

Morning finally arrives and I drag myself out of bed. Rhonda Lee has invited me to go along on a hike with her

Chapter Seven

Girl Guide troop. I'm not at all hungry but I force myself to have some breakfast, so as not to worry my aunt.

"You alright, Honey?" she asks me tenderly. She can see that I am not my usual cheery self. I can hardly finish the toast and honey. And everyone in my family knows I can eat a lot.

"I'm fine, thank you," I lie.

"Did you have a good sleep?"

"Yes, thank you," I lie again.

I still have a strong feeling that something is very wrong. But my aunt and uncle are acting like everything is normal. I remain silent. I can't dare speak what my mind is imagining.

Maybe the hike will help? Being with a group of strangers doesn't really bother me. I have always been pretty good at fitting in. In fact, since our move to the city, I have lots of new friends. I haven't had any issues adjusting to my new school either. Still, I cannot shake this feeling of dread.

The gnawing in the pit of my stomach keeps growing as we begin our hike. That sixth sense from last night continues to haunt me. It's pouring into today like molten lava from a volcano, smothering every thought. I try to enjoy the hike and the company of the other girls but it's like I'm not really here. There's a heaviness pulling me down. I feel like I'm carrying a thousand pounds on my back.

I don't say anything to Rhonda Lee. I can't put into words what I'm experiencing. Besides, I don't want to worry her, nor do I want to hang a dark cloud over this hike. I am very grateful that she has invited me along.

When the hike is finally finished, we're dropped back at the house. Grannie's car is parked in the driveway. Why is Grannie here? She lives several hours away.

Rhonda Lee and I are greeted with hugs and kisses. I have always loved the feel of Grannie's soft hands. They are gentle

but strong. She smells so good, just like the soap she keeps in the dish in her bathroom.

I act somewhat surprised she is here. But truthfully, I'm not. That spidey sense has grown in leaps and bounds.

"Rhonda Lee and Greg," my aunt addresses her children. "Grannie and I need to have a little bit of alone time with Kelita and Vian." My aunt leads us into the den. "Can you please close the door. We won't be long".

Auntie Lucille sits on the couch and my sister climbs up onto her lap. I sit down beside them, and Grannie sits on the other side of me. I am trembling visibly now as all the worry I've been squashing since last night flows out of my veins. My stomach lurches and then come the sweaty palms and furrowed brow.

"We need to tell you something," Grannie gently prepares us. The voice inside me is howling! *I knew it, I knew it!* As the colour drains from my face, my body goes limp. *I knew there was something wrong.*

"Your Daddy has passed away," Grannie murmurs softly.

Silence. Nothing but a giant black hole sucking me in.

Did she just say what I think she said?

I cannot believe it!

And yet ... I knew.

Grannie continues. "I am so sorry to have to tell you this, girls. So, so sorry." She wraps her arms around me, drawing me close. But I pretend not to hear her. I don't want to hear her. I am NOT listening to her.

She hugs me tighter.

"He passed away yesterday." My aunt has found her voice even though her face is deathly pale. "Your mommy is on her way here and she will arrive very soon, I promise."

I still cannot respond.

Chapter Seven

How? Where? When?

We just saw Daddy last weekend. He was fine. He was so happy to see us and have us stay with him. He was so good this time. Why, why now? My mind races in a million directions.

Grannie keeps trying to console us. "Mommy is flying back from Denver just as soon as she can."

"She wants to get back to be with you," Aunt Lucille chimes in, holding Vian even closer.

"What happened to him, what happened?" My tears have turned into sobs.

Vian gazes up at our aunt, her tiny eyes glistening. "How did he die?" she whispers.

I am terrified to hear the answer. But I think I already know. I knew last night. That call.

There is more talking as shock settles in. The world has stopped spinning. I can't hear any more of their words. Only mumbles and my own groaning, deep down inside. I feel sharp piercing stabs. And dread, like a huge tidal wave is coming for me.

I want to run towards it. Not away. I want it to engulf me. To drown me. I want to die and be with Daddy.

But I don't. I continue to breathe and cry and shake and stare blankly at the wall. When dinner is served, I stifle the nausea that consumes me. It's meatloaf with mashed potatoes and frenched green beans. My aunt is an excellent cook and I love her comfort food. But tonight I cannot eat. Not even one bite. Everyone is quiet around the table. No one knows what to say. The air is thick with discomfort. We all feel it. All I can do is stare at the food on my plate.

"May I please be excused?" I ask politely.

"Yes, of course, Honey," my aunt rises to take my hand. It must be so hard for her, trying desperately to tend to our broken hearts.

Vian joins me and we climb up the stairs together. We need bed. Bed and oblivion. We don't even brush our teeth. It's still early evening but I am completely drained. Tired of crying. Exhausted from the shock. I only want to sleep so I can escape the scorching pain. So that I can forget this new reality.

Once again, it's just the two of us. Me and Vian. All alone in a big bed. I snuggle up and wrap my body around hers. My little sister is only 8. I must take care of her. We find comfort together.

Thank God, we still have one another.

Chapter Eight

The Red Roses

The long car ride has been unbearably stifling. My eyes are puffy and they burn. And my head feels tight like a spinning top that's been wound around and around, ready to be released. I know it's from the crying. And the tension. Tension that won't stop, not even to sleep. Mommy's perfume isn't helping any. I wish she wasn't wearing so much.

It seems like the cemetery is a thousand miles away! I hope we get there soon. I need to get out of this car.

I finally see the sign - Mountain View Cemetery. I don't see any mountains today and the sun remains hidden behind a haze of grey clouds. It's a dull and dreary day. Perfect for the occasion. At least the October air is fresh and crisp.

I step out of the silver limo onto a road covered in tiny dark red stones. My new shoes hurt my feet. But I must smile through all my pain and greet the many people who have traveled all this way just for Daddy. He must have been very well-liked.

As if mandatory, people start lighting up cigarettes. I think of Daddy and his horrible habit - Black Cat Number 7s were always in his shirt pocket.

I blankly watch everyone smoke as we walk toward the gravesite. Vian and I are holding Mommy's hands. Most people won't look at her, but Mommy keeps a prim smile firmly in place.

I know my Grandma and Grandpa are both buried close by, so I guess this is the natural place for Daddy to be now.

Male family members begin to congregate and Jimmy, Frankie and Billy are directed to stand with them. Together they will carry the casket.

A man in a long dark coat unlatches the rear door of the hearse. With white gloved hands, he pulls the shiny mahogany casket out of the car. The first two pallbearers take hold of the handles.

There is something very formal about death. So much ceremony. The funeral, the graveside, the clothes, the music. People only speak in hushed tones as if they might awaken the dead. They dress in their Sunday best and shine their shoes.

We follow closely behind the casket, as instructed. I can't look at any of the people smiling sadly. I just look down. Another step. Down. Don't trip. Down. It still feels surreal. The harsh violence of my father's death. Excruciating pain for which there are no words. I will never find them. Ever. My soul is weeping.

I can feel their eyes on us. What are they thinking? What are they really saying behind closed doors? Are they looking for clues in our faces? Perhaps waiting for a knowing glance or a secret touch between family members? Who's crying? Who is not reacting? Who is crying too much? Everyone is so curious. They just want to take it all in and then draw their own conclusions. Wrap it all up in a pretty box that they can hide away forever. Because after all, they are not us!

I can only imagine some of the conversations:

Well, you know they had been separated for six months.

Is it true they had seen each other that very day?

I heard it was Oleg who found him.

Chapter Eight

Did you know it was her birthday? Oh, my, no. Isn't that terrible?

We gather around my father's graveside and take one last look into the big hole. Empty. This is where Daddy's remains will be forever more. I loathe this part.

My little sister Vian is sobbing noticeably now. I try my best to comfort her by wrapping my arm around her waist. She is only 8. I'm not sure she understands everything that's going on.

We watch silently as the casket is lowered into the ground. Is this really all there is to the end of a life? I hate this part of death more than anything else. The utter emptiness. The finality.

Daddy's two sisters are each carrying a bouquet of long-stemmed red roses. They pass out a rose to every family member on Daddy's side. My Aunt Violet then walks to me and hands me a single red rose. "Here you go, Honey," she whispers softly. How thoughtful. But I already know what her next move will be. Without a glance or any hesitation, she passes right by Mommy and places another rose in Vian's hand. I can't help but cringe. Poor Mommy.

Slowly, one by one, each family member places a rose on Daddy's coffin. It is meant to be a sentimental gesture but to me it feels more like a show. My mother keeps her head held high, but I feel shame and humiliation. There have been rumors that my father's side of the family is placing blame for his death on my mother. This very public display confirms it. But it can't be true. Can it?

Vian and I are the last to offer our roses. My last contact with Daddy. For forever. I whisper, "I love you, Daddy. I miss you. I will always miss you."

Vian and I hold hands as we return to our mother. The wind is picking up. The air brisker, as the day begins to wane. Surely winter is on its way. I am so cold. Nervous. Weak. The chill of death pierces. I am paralyzed. How will I ever walk again? Death, this death, icy and harsh, has the power to suck the life out of my very being.

After the excruciatingly long drive back to the church we gather in the basement for the luncheon provided by the church ladies. Little crustless triangle white bread sandwiches filled with egg salad, tuna and that funny luncheon meat spread, with bits of pickle. Trays of celery, carrots and sweet mixed pickles - the ones with the bright yellow cauliflower that don't taste anything like cauliflower. The aroma of freshly brewed coffee. It's just an old church basement - the one where I attended Sunday school and learned the stories of the Bible and where I made my acting debut – but the coffee makes it feel warm and welcoming. There are plenty of homemade sweets laid out on heavy crystal plates. Lots of brownies, Nanaimo bars, lemon squares and my very favorite - butter tarts with walnuts. Normally I would dive right in but today I am without an appetite.

I stand close by Mommy's side as the crowd begins to thin. I notice a very tall, dark, clean-cut man, coming from the other side of the room. I know he is someone from Daddy's side. I think he is a cousin who has traveled from the States for the funeral. I can almost read my mother's mind. I know what she must be thinking. *How nice, somebody from Ivan's side of the family is finally going to come over and talk to me.*

She smiles and offers her hand. Before she can utter his name, he abruptly cuts her off. "Vilda, I hope you rot in hell!" Then he turns and walks away.

I am mortified for my poor Mommy. Afraid she might

even collapse in shame. But my mother is one of the strongest women I have ever known. Holding her head up and taking my hand in hers, she gives a firm squeeze. Like an electrical current, I feel her pain. It moves right through me. But here and now, in this moment, what I witness only fuels my love and compassion for my dear mother. More than any other time, I feel such a deep love.

Oh, how I wish I had just one single red rose to give to her myself.

Chapter Nine

Sweet Release

We've been back home for a few weeks now. Home! Our real home on the ranch. I am lying in bed beside my little sister, staring up at the ceiling. The rustic lamp with the pink shade casts shadows on the wall.

So much has happened to lead us back to our farm and here we are in our beautiful house. But it's just a big empty shell. There is such a deep sadness. It should feel good to be back in our own beds. To be sitting around our kitchen table, eating breakfast. It should be fun to curl up on the fancy chesterfield, gazing out the big window counting the cars as they go by. But it doesn't feel good at all. Nothing does. There are too many shattered pieces of our hearts scattered throughout every room. Sometimes my body feels so heavy I wonder that I can even move.

Back in the city we could escape. Pretend. But not here. This is where the 'accident' took place. This is where Daddy's remains were scraped and washed off the walls of our garage. This is where I am constantly reminded there will be no more threats. I don't have to worry about those threats anymore. Because they came true.

I remember him at every turn. His Ford pickup is in the driveway, collecting dust. His well-worn cowboy boots still at the back door. His old jean jacket hanging forlornly on the wall. Today I was brave enough to take it down. I held it close and I could still smell him. And I got so sad as I wondered how long it will take until this never-ending misery fades away.

Chapter Nine

I imagine him sitting at his desk doing paperwork. I keep looking for him out in the pasture with the cattle. I look for him in town or laughing with neighbours or pushing Vian on the swing set he built for us.

Everything reminds me of my daddy.

It's been hard moving back and facing all our friends and teachers. We know what everyone is thinking, yet no one says a word. But really, we're all just hiding. We can see everyone and they can all see us but it feels like there's an invisible wall in the way. It's just not the same. Now it feels like them and us.

Ever since Daddy died, Vian and I keep this small lamp on all night long. We're even more afraid to sleep in the dark now. Because I know that as soon as I close my eyes, I will see the same horrible pictures I see every night. I will recall all our visits with Daddy after the great escape. They were always hard for me. I was nervous and scared. The truth is, I never really wanted to go. I was always afraid of what Daddy might do when we were alone with him. I made sure I knew where he was pretty much every minute. I just had to. I felt so responsible, not only for Vian but for Daddy too.

Even though there was always a hint of sadness in him, Daddy seemed so happy to see us and have us back home. I don't think he noticed my anxiety, but it was there until he drove us back to Calgary. As soon as we came over the hill and saw the lights of the city, I felt like I could breathe again. The tension in my head disappeared and my stomach settled.

Sometimes I feel like I let him down. And now, I can never make that up to him.

I still have so many questions. Why didn't anyone help save Daddy? Why did he have to kill himself? And why the way he did? Wasn't our love strong enough to keep him

here? Could I have been more caring or loving? Could I have somehow stopped him?

The kind of pain I feel is impossible to describe. It's like I'm bleeding on the inside, but no one can see it. I suppose it's like when you break your arm. You can't actually see where the bone is broken but you can feel the pain. Then when the doctor looks at the x-ray, he can see the broken bone. No one can see inside my heart but I know if you were to take an x-ray of it and you would see how broken it really is.

Morning comes again. I must have slept in because Vian is already up. Still in my flannel nightie, I wander down the hall to Mommy's bedroom. I like being in her lilac room. It's her favourite colour. She loves everything lilac. Even her bathroom sink and toilet are lilac. I feel safer being with her. The sunshine is streaming through the large window that faces the foothills. The warmth the sun makes promises a good day. I love Mommy's company, especially now. There is a closeness between us that we never had before. She never talks about the 'accident.' She just seems more relieved than heartbroken. Besides, her heart has someone new.

"Mommy, will you ever get married again?" I boldly ask.

"No, Honey," she reassures me. I am relieved to hear her response. I have already lost one parent. I don't want to lose another. The clothes hamper is in her arms as she exits the bedroom. "Why don't you play the piano for a while. I need to start the laundry."

My mother did finally get me a piano a few years ago, and I did love playing it. Except it was in the basement and you know how much I hate basements! She has now moved it into her beautiful bedroom which is so much better. Except I still haven't been playing much lately. I guess I've been too sad.

I plunk myself down on the padded bench and sit in the

Chapter Nine

silence. The warm sun on my back feels comforting. I breathe in and out, out and in, longing for the serenity that music usually brings. Finally, my hands begin searching the black and white keys. I am looking for something to play. I soon find a place for my hands to rest. The notes I play are soothing. But there is melancholy behind them. As I play softly, words come effortlessly to my lips. It's like the union of my hands on the piano and the words on my tongue has wrapped around the thoughts in my heart. Like someone else is doing the composing. I feel a welcoming lightness, like a beautiful bird let out of her cage. And now, after being in prison for so long, she must learn how to fly. Again.

There is a joy in the sweet release flowing through the pain in my heart. And in this very moment I feel something extraordinary. As I continue to play and sing, I feel another's strong presence in the room. But when I turn around to see who is standing behind me, no one is there. There is no sound, but I hear a voice inside me. It whispers to my spirit.

Kelita, I know I have taken someone very special from you. But today, I give you a gift in return.

The tears welling up in my eyes are soon raining down my cheeks. This song I write is very special. It's about Daddy. The mysterious sense enveloping me promises I am not alone in my sorrow. Something much grander is here with me. I don't understand it. Not at all. But I know how it makes me feel.

Caged Bird ♪

Here I am at age 4 giving my best smile for the camera. My first professional photo shoot.

Photo Credit: Paul Anderson

Lots of love shown here with Daddy. That's our fat lazy Shetland pony Peanuts.

Photo Credit: Paul Anderson

Chapter Ten

Little Miss Starlet

What was it in me that created the 'need' to perform – to sing, dance, entertain? Was it in my genes? Was it the applause and my unquenchable need for love and acceptance? Was it simply because I was designed, created and gifted for showbiz?

My earliest predilection for performing came from watching Shirley Temple movies on television when I was 4. I fell in love with her bouncing ringlets and dimples the first time I saw her, and with great anticipation waited week after week to see another one of her movies. I adored her smile, her voice, the way she danced. She charmed me with her vibrant personality. She was just the cutest thing and I wanted to be a star just like her! There was never any wavering.

I still treasure a small and simple booklet I made in Grade 1. There is an old black and white polaroid photograph of yours truly on the cover, posing, talking into an ancient black phone, dressed in a puffy crinoline with matching brimmed hat, white lacy ankle socks and black patent leather shoes. I remember the dress so vividly. It was soft pink and I loved it! I felt like a little star wearing it. The booklet has subtitles like Family, Favourite Foods and When I Grow Up. My ambitions were simple – movie star, #1 and #2, nurse.

My dreams for a future in the entertainment business were also fuelled by popular American television shows. Ed Sullivan, Carol Burnett, Red Skelton, Sonny & Cher. We also loved Canadian country music shows like Country Hoe Down, Don Messer's Jubilee and The Tommy Hunter Show. And just

to prove that dreams do in fact come true, later in life I made eight guest appearances on Tommy's show, appearing with superstars like Kris Kristofferson and Glen Campbell.

Vian was my partner in crime and we couldn't wait for Saturday nights! We would dress up in our fanciest play-clothes, make-up and heels. Standing off to the side of the big television console, we'd sing and dance along with the square dancers and musical guests. Our parents found us to be most amusing and loved our performances just as much as we did. And of course, being older and more driven in these matters, I never gave my little sister much choice. Many of my days were spent directing, rehearsing and performing new musical extravaganzas with her. She was such a good sport and very talented in her own right. Yet she was always compliant and she always followed my orders. My poor sister!

My 'official' debut performance involved reciting a poem that my mother helped me memorize. I was 5 and it was called "The Shape I'm In." I dressed up as an old woman in a long black skirt, floppy brown hat, white gloves and a beige shawl, with cane in hand. My mother directed me. My transformation was meant for the enjoyment of the local lady's tea in the basement of the Carmangay United Church. Oh, how I longed to be in front of a crowd. The attention was exhilarating and my love for performing was obvious, even then.

Being in front of people came naturally to me and I was constantly playing movie star, singer, dancer, producer and director, every chance I got. Even as a little girl, when my parents were busy running the ranching and farming business (which was most of the time), I found my stages under the yard light and in the hayloft of our barn. I would carefully climb to the uppermost position and from that lofty height, I could gaze down upon my adoring (imaginary) audience. The corral fence

Chapter Ten

was a good perch too. At least there I had a live audience, if you can count the cows chewing their cud. They may not have been the liveliest bunch but they were flesh and blood with a heartbeat.

My head was overflowing with the hits of the day. Petula Clark's "Downtown," "Don't Sleep in the Subway Darlin," and Herman's Hermit's "Mrs. Brown You've Got a Lovely Daughter." Those were standouts. The very first popular song I learned every word to was "Please Don't Talk to the Lifeguard" by Diana Ray. It was recorded in 1963. I was 5 and I can still remember every single word to that song! Talk about an impact.

I started creating my comedic characters by observing and mimicking real people. At the age of 5, my first was inspired by Mrs. Thomas. My mother and I would often visit this elderly, petite Englishwoman. She had, at one time, babysat my three older brothers, when my mother was teaching school on the Hutterite Colony. That was before I was born. Mrs. Thomas lived in a large Victorian-style rooming house in Lethbridge, with all her worldly possessions overflowing into two rooms. She didn't have a phone so when we arrived at her door it was always unexpected. We would have to knock very loudly and when she finally heard us, she would shuffle to the door. Sometimes we'd have to leave because she just didn't hear us. But those times when she did, we'd be greeted happily, while she put her hearing aid on and her teeth in!

"Oh, my goodness, it's so good to see you, my dear. Do come in. It's been a long while and I've missed seeing you."

She was always excited and she always let us know in her delightful British accent.

"Did I tell you the paper boy's been stealing money from my wallet? Right from under me nose. Twenty dollars right from under me nose. I know where he took it from. What a

cheeky thing to do - twenty dollars, yes, twenty dollars. Oh, my dear, Kelita, it's so good to see you. Every time I see you, you're looking more like your dad, more like your dad."

Mrs. Thomas lived alone and although she had some family, none of them ever came to visit. That is why when we did, my mother would let her ramble on about whatever was on her mind. She needed to vent!

"Would you like a nip of brandy, just a wee nip? I think I may have some to celebrate your visit. Would you like a brandy, Vilda? Yes, yes, yes, just a wee nip. Oh, my but it's good to see you. Yes, yes."

On and on she would natter. Her red velveteen couch wasn't just covered in hand-crocheted doilies of every size, there was also a mountain of unfolded nightdresses, old, yellowed newspapers and very outdated Women's Day magazines. Finding a place to sit was challenging. But once my mother and I wriggled into a section, Mrs. Thomas proudly brought out her Queen Mary tin filled with biscuits (that's what the Brits call cookies). I bet those cookies were over three years old! They tasted like the room – stale and horrible! And I mustn't forget the warm flat ginger ale. I politely said yes to both. Because that is what I was taught to do.

Maude's warm English accent was so foreign to my ears, yet I adored every syllable that rolled off her tongue. I was thankful for the times that she did put in her teeth because then she was so much easier to understand. And her good-bye kisses weren't quite so juicy.

Funny, isn't it, how that lovely and neglected yet thoroughly charming Mrs. Thomas captivated me. Her accent, stained bed clothes, minor shakes, blindness, bad hearing, toothless grin and old lady smells were all just part of the fascinating package.

After one visit, I found myself staring into the mirror in my

mother's truck, contorting and moulding my face into the very essence of Mrs. Thomas.

"Oh, it's so good to see you, my dear," I chirped in my veddy best British accent. "It's so good to see you. Do come in, so good to see you. Every time I see you, you're looking more like your mum … yes, so much more like your mum."

My mother was highly amused. Her laugh said it all. Oh, how I loved making her laugh! I felt loved. I felt special. She approved!

That laugh launched a host of comedic characters that I created over the years. That approval was the drug I didn't even know I needed but once tasted, I was hooked for life! There was so much joy in making my mother laugh and the magic and mystery of transforming myself into a fictitious character was even better!

Once I started school, I had plenty of teachers to imitate and that was another good source of amusement. Thank goodness none of them ever caught me pulling faces while in their presence.

As a child I literally spent hours in front of the mirrors wherever we lived. I especially loved the full-length ones. "You'd better stop making all those god-awful faces," my mother warned me. "Because one day you're going to stay that way!"

My first cousins on my father's side, Glenda Ray and Gerry, influenced me profoundly with their singing, tap-dancing, piano, organ and banjo playing. They were extremely talented and their mother, my Aunt Violet, was a wonderful stage mom and coach. They performed around the Calgary area, even at the world-renowned Calgary Stampede. To me they were very famous. I loved visiting their home and listening to the incredible sounds pouring out from the instruments. The near

thunderous clicking and clapping of their tap dancing on the linoleum floor in my aunt's dance studio was magnificent!

And then there were the special guests. The truly famous special guests.

"Kelita, this is Miss Anne." My aunt's smile completely enveloped her face. She *knew* what this meant to me!

What? Who? Oh, my goodness! "I know exactly who you are. You're MISS ANN from "Romper Room" - my favourite TV show. I watch you every morning!"

I was in total shock. Couldn't believe my little eyes. Miss Anne – the one and only - was standing right in front of me! She was a superstar!

"Romper Room" was a wonderful children's program that was franchised all over the world. Each location had its own special (and local) host. Mine was Miss Anne. The show was heavy on music, moral lessons and fun games. It was live and taught its young viewers to be polite and to pray before milk and cookie time. "God is great. God is good. Let us thank him for our food. Amen." I was a middle-aged woman before I realised the grace I had said for years as a child was probably taught to me by "Romper Room's" Miss Anne.

My favourite part of each broadcast was the end, when Miss Anne would gaze through a "magic mirror" (actually an open hoop with a handle). Then she would recite the daily rhyme. After the verse she named the children she saw in "TV Land". We truly thought it was magic! That she could see us and know we were watching and know our names!

"I can see Scotty and Mary and Julie and Jimmy and Linda and Rodney and Judy." On and on she went, day after day. We were encouraged to mail in our names (first only) to be read on the air. Every single day I desperately wanted to hear the words, "And I see Kelita."

Chapter Ten

But never did. There weren't many Kelitas around in those days. But now THIS, this was a dream come true. Miss Anne was standing right in front of me! Turns out her children took tap dancing lessons from Aunt Violet and the timing of my visit to the big city could not have been more destined.

And then it got even better. As I stood there bedazzled, my poor little self in complete shock, she asked THE question.

"Are you able to come to my show tomorrow? I would love for you to be my special guest."

I was overwhelmed (to say the least). Ultimately the show itself was a complete blur. My only job was to smile and look pretty alongside the other children. I do remember the disgustingly warm milk we had to drink. A milk company called "Alpha" was one of the show's sponsors so there was no getting out of that. I was a farm kid used to drinking the very best milk and we never drank it warm. But I pretended to enjoy every last drop and that, my friends, was the dawning of my acting career.

This was perhaps the happiest day of my life (all five years of it)! My television debut! Thank you, Miss Anne. Oh, if Shirley could see me now!

My mother detected the performance gift in me immediately and soon I was racking up stage credit after live show after competition. Because of my parents' heavy involvement in the Charolais cattle business, at age 12 I was invited to fill the after-dinner entertainment slot at one of their shindigs. I had fun impersonating Lily Tomlin's popular character, Ernestine, the telephone operator from the hit TV show "Laugh In."

The laughter had now grown beyond just my mother. There I was in a room full of half-intoxicated, ritzy cattle-owning delegates, dripping in snakeskin boots, sequinned dresses and rhinestone earrings, and they were all laughing at ME!

Not long after my successful convention appearance, I introduced my first "public" creation - Sophelia Flannigan, a fun-loving, sassy trailer park mama, spun from observing my town's mothers, sitting in the bleachers waiting for their children at the local pool. "Sophelia Flannigan here. I got the latest and the greatest of what's doin' and who's doin' what to who". I can tell you proudly that since then, Sophelia has appeared in person before crowds from 5 to 10,000 and even tens of thousands when I performed her on national television.

Both Mrs. Thomas and Sophelia, along with all my early singing and acting roles, were intricately woven masks I diligently wore in order to navigate attention on me AWAY from the private side of my life. Fear, worry and anxiety continued to plague me. I always joked that if there were any psychologists in my audience, they might have an explanation for the many personas and alter-egos who evolved alongside me over the years. Just like so many other comedians who survived traumatic childhoods, I realized early that making people laugh was deeply satisfying and cathartic for me. An escape from my own pain and an outlet for creating fun and forgetting about real life. I know there are many other reasons too but for me, *that* is why a star was born.

Chapter Ten

Daddy loved taking photos of me. I learned how to pose at a young age and loved the camera even back then.

My "old lady" costume for my big acting debut for the United Church ladies. Age 5.

Chapter Eleven

And Now This

Sometimes I feel like I'm living in a bad dream. The burning, stabbing pain may have subsided a little bit, but the guilt and shame have blown up like a bomb. Often I feel angry. And then I feel even more guilty for feeling angry.

It's hard to know what to do with all these crazy thoughts and feelings so mostly I just bury them. Nobody else talks about any of it. They just keep smiling and acting like everything is okay so I just keep smiling and acting like I am too. I pretend that life is going to be normal again. I so desperately want to believe that my family is like any other family.

But our life is not back to normal, and our family will never be like any other family. The unexpected and unbelievable stuff just keeps piling up, like a mountain of pain. I always seem to know when something is wrong even before I know what it is. So here I am, outside my mother's office, once again playing detective.

I can hear her voice behind the closed door. I can tell it's serious by her quiet tone. My ears perk up, trying to catch every syllable.

"I've been convinced for ages there's something going on but every time I saw Dr. Boyd, he didn't think it was anything serious," my mother laments. "But I just knew it!" She pauses to catch her breath. She sounds distraught, on the verge of tears. "Now it's very serious and I have to have surgery just as soon as they can get me in. Dr. Boyd says he's going to fast-track me."

I realize she is speaking with my aunt Lucille. I hang onto

Chapter Eleven

every word in shock and disbelief, waiting for more. My heart thumps wildly as I try to calm my nerves. There is a long pause. I press my ear against the wood as hard as I can. She is crying.

My poor Mommy. I close my eyes as I lean back against the wall. My old friend Nausea hits me like a tidal wave. It slams my heart, my head, my gut - my whole body is ablaze with a need to vomit. But there are more words from behind the door.

"Yes, yes, I'm doing okay. We're going to keep it very quiet." Another pause. "Yes, of course he knows. In fact, he's right here beside me as we speak."

I can hear a smile in her voice. She continues, "I'm glad too. It sure helps. I'll talk to you again soon. I love you. Bye for now." She hangs up the phone and there is silence. A deadly, eerie quiet that renders me afraid to breathe.

Can this be real? After everything else we have been through can it be true that Mommy has got cancer? How can this be? She doesn't look sick. I don't understand. How is this happening?

I can feel my tears fighting to escape but I hold my breath and force them back. I mustn't let them know I've been listening in on her private call. And besides, Mike is with her. Now I can hear them whispering. It's hard to make out what they're saying. I give up trying and just replay what I've heard. Over and over again.

The door opens, jolting me from my thoughts. I immediately slip into actress-mode, composing myself and pretending I've just come from down the hallway.

"Hey, Mom. What's going on?" I smile cheerily, innocent as pie. At 12 years old, I am already a darned good actress.

"Why don't you go get the Chinese take-out menu, Kelita?" Her smile is weak, like she is trying too hard. "I don't feel like

cooking tonight. Let's order in for dinner. Mike, can you and Kelita drive into town to pick it up?"

His cheer is fake too, but at least he's trying. "Sure thing, Honey."

Honey? I hate when he calls her that!

My actress takes over as I join the charade. "Sounds good to me." I try to be enthusiastic. She knows how much I love Chinese. But after such horrible news how can I possibly think of food?

I head to the kitchen, second-guessing myself the whole way. Maybe it's not cancer? I mean, I didn't actually hear the word. Perhaps I'm just blowing everything out of proportion. Maybe I didn't even hear right. Maybe it's no big deal. But why is she keeping this all a secret from us? It's so maddening.

I wish he wasn't here right now. But he is always here these days. At least on weekends. Mike and his wife are separated but he still lives on their ranch because that's where he keeps all his cattle. He also works a full-time job in Calgary (for Alberta Gas Trunkline). And now he comes to our place every Friday and leaves early Monday morning to go back to work. Sometimes he even comes down during the week and spends the night. I hate sharing my mother with him.

What the heck does she see in this man? He's overweight. And his puffy, round face looks just like Archie Bunker from "All in the Family," balding head and everything. He's really rude at the dinner table, making loud chewing noises with his mouth wide open. And if that's not bad enough, he sees nothing wrong with picking his nose! And I don't mean just a little pick. I mean he gets way up in there. It's so gross! None of this seems to bother him in the least. Or my mother. I just don't get it. Is it because Mike is American? Does that make him special? He was born and raised in Texas and he acts the

Chapter Eleven

part to a tee. His huge (oversized) Levi's, his fancy cowboy boots and a giant Stetson must make him think he's some kind of movie-star cowboy. And, just like Archie Bunker, he smokes a fat, smelly cigar.

What's even worse, he's a racist. His real name is not even Mike; it's Edgar Dietrich. Apparently, growing up he was called "Little Mike" because he hung out with one of the black hired hands on his farm and that guy's name was Mike. I guess he thinks that gives him permission to use the term "nigger" for a person of colour. He doesn't even care who hears him! Makes me cringe.

I know I shouldn't be so nasty but the truth is he is truly a disgusting man. Period. And every time he comes to our ranch, he tries so hard to get Billy, Vian and me to like him. Guess what? It's not working.

But there is Chinese food to be fetched and so off we go, Mike and me, just like we're some normal family grabbing take-out. I refuse to go into the restaurant with him. I just slouch down in the car, hoping no one sees me with this dreadful man. I can't handle any more humiliation. Everyone knows my dad just died and my mother already has a boyfriend.

But Mommy is sick and she needs me. So I will do what I need to do.

Chapter Twelve

Mommy Comes Home

Vian and I walk alongside Mommy, guiding her down the hallway into the family room. She is dressed in her new baby blue nightgown with matching housecoat and slippers. She looks pretty, but thin. But she is so happy to finally leave her room. My sister and I tread carefully, so as not to bump the left side of her body. That's where her operation was.

"Oh, it feels so good to be out of that bed!" She is smiling. Or should I say *trying* to smile. This movement is obviously causing her some pain. "Thank you, girls. I couldn't stay there another minute." I squeeze her hand gently. "We're so happy to finally have you home with us, Mommy. We've all missed you so much."

Vian and I did visit her in the hospital, even though we weren't supposed to. We would ride our bikes into town and then find the ledge underneath her hospital room window. Then we would peek in and wave! Thank goodness it was summer.

"Mommy, are you sure you should be out of bed so soon?" I ask, always playing nursemaid and caregiver.

Sally answers emphatically, "Gosh, yes, girls. This is the best thing for your mother. Being home with her family and moving around a bit. She's got to get her strength back!"

Mommy smiles at the blousy woman helping her to the couch. "Thank goodness you've been here, Sally, to help look after the girls and make sure everybody is okay."

Sally is our housekeeper. She's been living with us ever

Chapter Twelve

since Mommy found out she had cancer. She comes from a small town called Nanton which is about 25 miles from us (on the way to Calgary).

"Come and sit right down here, Vilda," Sally gently half-whispers in her cigarette voice. She carefully guides my mother to the sofa, puffing up her pillows to make her comfortable. "How does that feel? Too much or not enough? I can grab another pillow, dear. Shall I do that for you?"

"No, this is great Sally. Thank you so much. I don't know what we'd do without you. The girls have told me they have just loved having you take care of them while I've been away.

"I am just so happy that you're home now, dear. I know everything's going to be just fine. Just fine."

"Well, I'm afraid it's not over yet." Mommy sounds more serious. "Now that this surgery has been done, I need to have radiation and chemotherapy. If they don't get it all, they're going to have to remove the other breast too." She pauses as we all stand shell-shocked, afraid to say a word. "The thing is … Dr. Boyd can't do anything more for me. Not here. He's just not experienced enough. There's no way around it. I need to have my treatments at a bigger hospital." She leans back into the pillows and closes her eyes.

To be honest, I don't really understand all the stuff about the cancer. But it sounds awful. My poor mother. I saw where her operation was and it looks horrible. There's a large bandage covering most of it but I was able to see some stitches. There are so many. She doesn't really explain very much to Vian and me. I have the feeling she really doesn't want us to know what's going on. Probably because she doesn't want us to worry.

I do understand that a bigger hospital means we're going to have to sell our ranch and find a new place to live in Calgary. Just when I was getting used to being back in the country! At

least I won't have to walk through that garage ever again. I hate that more than anything.

I know I will miss all my friends and teachers and I'll have to find a new piano teacher too. But at least this time we'll be able to say good-bye properly. Yes, the more I think about it, this is probably a good idea. Now, when people ask me where my dad is, I can just tell them that he died of a heart attack. No one will ever know. We can make a brand-new start. "Sally, do you think you'd be willing to make the move to Calgary with us? We'd sure love it if you could help us out. I know the girls would love to have you with us too."

"I don't see why not. I've never lived in a big city." She looks over at me and winks, then smiles. "Guess I could become a city slicker."

~~~

I love our new house. It is a large ranch-style bungalow and Vian and I each have our very own bedroom. With shag carpeting that we got to pick out ourselves. Mine is bright pink! I just love it. I feel like Barbie in her dream home!

We're all happy in the big city. Turns out Sally loves being a city-slicker. She takes Billy driving and serves him beers at the same time! Then she teaches Vian how to drive her little blue Datsun on the highway and Vian is only 9! She's a crazy lady and our favourite housekeeper of all time (and we've had lots!).

Maybe this fresh start will help Mommy get better too.

## Chapter Thirteen

# My Big Brother

I have so very many memories of my eldest brother. Jimmy.

Jimmy had a ferocious appetite for raw potatoes and science fiction novels, and he'd be up all night devouring both, flashlight under his blankets. Down in the dungeon.

He was outgoing, charismatic and extremely mysterious. Everyone was drawn to him, including me. But he was also called the black sheep of the family. I'm not really sure why. All I know is that he was a 'handful' as a child and both my mother and Grannie use the term 'holy terror.' Jimmy even had to wear a harness when our mother took him anywhere in public or he would run wild. Then there's the story he and Frankie were playing with matches and burned down the big barn on the farm. I wonder if they got the wooden spoon or the strap that day? I have a feeling it might have been both! Glad I wasn't born yet.

In his teenage years the troubles with Jimmy got worse. I remember more than once hearing Mommy cry because of Jimmy and Frankie. I never really knew why. There were always so many secrets in our family.

I think Jimmy lived in his own fantasy world. I guess that's where some of the mystery came in. He'd go off riding bareback for hours at a time and when he'd return, his face would be streaked with red and white war paint like a native Indian. He always wore a white bull's horn attached to a leather strap, dangling down his bare chest. Jimmy called himself Cochise, after one of the most noted Apache leaders of the 19th Century.

After coming home from his first year of university in Montana, Jimmy kept receiving letters addressed to "Hoss". My mother found it strange at first until the large white Stetson and cowboy boots suddenly made perfect sense. Hoss. From the TV show Bonanza. Yup, that was Jimmy, pretending to be just like the TV star. University? Short lived. Never passed a course. Partied his face off. Shortly after, he signed up for the military and was soon creating his next persona - the man in uniform.

One time, after being away in the Army, Jimmy snuck into the house while everyone was out except Vian and me. We were just turning out the lights (still afraid of the dark) when Jimmy jumped into our room and scared us half to death. We had not heard him coming at all and there he was, looking all dignified in his fancy military uniform. We were freaking out! I swear I just about peed my pajamas. Oh, that guy! He didn't give us any time to calm down at all. He just grabbed us and started hugging and kissing us like he hadn't seen us in years. He was so happy and kept telling us how much he'd missed us. I don't ever remember anyone in our family greeting us quite like that. But that was Jimmy. He always had a way of making you feel special.

Vian and I were often left without parental supervision and Jimmy was our favourite babysitter. I'll never forget the time he put green food colouring in the creamed corn. Served it to us like nothing was unusual. Fried potatoes and burnt bologna with Ketchup and a side of green creamed corn. When Jimmy was in charge, he made everything fun.

He was also our protector. Frankie and Billy? They were just mean. Mean bullies. When we were very young those two would trap us in the dungeon and gross us out with their old crusty socks. They'd shove them right in our faces until we

gagged. They also loved to hold us down on the floor and fart in our faces. They would howl while we almost suffocated! I hated those boys! That's how I honestly felt. They loved nothing more than teasing their two "spoiled" little sisters. In hindsight I think they must have held great disdain for us.

But Jimmy ... Jimmy made us feel special. He made us feel loved.

Funny though, as much as I adored my oldest brother (and I did!), I was always afraid *for* him. Maybe a tiny bit afraid *of* him too? It was just some vague, blurry vision that would occasionally settle in my psyche. I couldn't really see it or understand it. But I could feel it. Just for a moment. And then it would evaporate into the ether, leaving my crazy brother to bedazzle us all yet again.

Yes, Jimmy certainly was one of a kind, that's for sure.

## Chapter Fourteen

# Jimmy's Hideaway

What an exciting day it was when my brother Jimmy got married. That's right. Jimmy got married!

We all loved Mary, his new wife. I got to wear my brand-new yellow dress with the black and white velvet trim. And my hair was done up just like my cousin Rhonda Lee's. We looked so grown up! Vian was still in ringlets, but she got to be the flower girl, in a mauve dress, carrying a single yellow rose. She looked adorable. And I'm glad she got to feel so special. Even Mommy was feeling pretty good that day, which was such a wonderful thing. If she was in pain, she sure didn't let anyone know.

And there's more! Sure, the wedding was amazing, but something even more exciting is on the way. Jimmy and Mary are adopting a little boy named Shawn! I guess when Jimmy was in the Armed Forces, he was exposed to something bad and that's the reason they can't have any kids of their own. Doesn't matter. Vian and I are pretty excited about being aunties.

So, now here we are, just Vian and me, about to arrive in Victoria, BC on an airplane. We've flown here all by ourselves. I must admit I am feeling pretty adult. I mean, I am 14. This is my first time flying without my parents. Vian is with me but she's only 11 so I am in charge. Poor Mommy can't come with us because she needs as much rest as she can get. We understand and the stewardesses have been very nice to us.

We arrive in a flurry of commotion and Vian and I finally get unpacked and settled into our new home. The next several days will be quite an adventure!

## Chapter Fourteen

Jimmy is up ridiculously early every morning because he does the morning show at the local radio station. When he leaves the house Vian and I are still sound asleep. But we love hanging out with Mary all day. Helping to take care of Shawn is hard work! Mary is very quiet and sweet and maybe even a bit shy. She's down to earth and more of a farm girl. But I don't think Jimmy is very much of a farm boy, at least not anymore. No two people could ever be more different than Jimmy and Mary. I have no idea how they ever ended up together but I'm glad they did.

When Jimmy arrives home from work he just wants to eat and then hang out in his basement. I like to call it his hideaway. But Mary encourages us to join him.

I hold onto the side railing as Vian and I tread carefully down the wooden stairs. I can already catch a whiff of the patchouli incense floating up. I love that 'hippie' scent.

Jimmy's music is playing loudly as usual. He loves his role of DJ. Except for the early morning part, his job as the morning man at CJVI is almost perfect for him. Jimmy has always been a huge music fan. In fact, he took me to my very first concert (the Canadian group Dr. Music). It was at the Stampede Corral in Calgary. I just loved that song that was on the radio - a big hit called "One More Mountain to Climb." The whole live show experience blew me away. I loved everything about it, and it made me even more determined to become an entertainer.

My brother adores Roy Orbison (the guy who always wears the dark sunglasses). And the Beatles - Jimmy is crazy about them. I remember watching the Fab Four on their very first Ed Sullivan Show. Our whole family was gathered around our black and white TV. Jimmy was even lucky enough to see them live. Twice! In fact, he loves them so much that when he got married, he wore a Nehru suit, Beatle boots and had

a Beatles' haircut. I think he wanted to look just like John Lennon.

The music is getting louder as Vian and I reach the bottom steps. It's Pink Floyd. I can tell because I recognize the sound of the cash register. It's not my favourite kind of music; I'd rather listen to the Carpenters or Bread or America. As I part the seam to the curtained off area, and then walk through yet another curtain, long strings of dark brown wooden beads swish and jangle. I sense we are stepping into another world.

We enter Jimmy's hideaway where the first thing I see is a large circle and star painted on the floor. There is a black velvet-cloaked alter in the corner and on it, silver goblets, a few small swords and some candles. I don't understand what it's all for but I have heard whispers about "meetings" Jimmy has. It's called a cult and they all sit around naked.

I don't really know exactly what a cult is but I think it must be bad. He does try to explain his out-of-body experiences to me and he's even tried to hypnotize me before. I don't think it really worked though. Jimmy does love to talk about this weird stuff with me and I'm glad he does. I will admit some of it makes me feel a little uncomfortable. But another part of me kind of wants to know more.

Jimmy is reclining in his old, comfy burgundy chair. This chair has big, well-worn arm rests. Jimmy's feet are resting casually on the matching foot stool. On the small wooden table beside him, there is an ashtray full of cigarette butts and a lighter. The tall lava lamp adds an eerie glow to Jimmy's face. The lime green blobs float languidly through the aquamarine water. I love lava lamps. They're so cool.

"Come on in, girls. How ya doing? Find a seat." Jimmy takes a long haul off his cigarette, blowing smoke rings as he exhales. "What do you think of my new posters?"

## Chapter Fourteen

"Yeah, they're nice." I say, looking around. Then I notice my new skin colour under the black light. "Your teeth look really strange, Jimmy. Oh wow, and yours too, Vian."

"Yours do too," Jimmy laughs. "And look at your skin? You can see every tiny piece of lint."

Vian giggles too. "We look so tanned."

"Kinda funny, isn't it?" Jimmy stands up and surveys his kingdom. "Which poster do you like the best?"

"I especially love all the neon colours. But I think I like this blue one the best." I point to a silhouette of a naked couple, down on their knees, embracing one another. I think it's romantic and somewhat daring. Then again, I think everything about Jimmy is daring.

"Look at that big one," Jimmy points to the largest poster in the room. "If you stare at it for a while it'll start moving."

Vian and I gaze at the large design for a few moments. And he's right! It starts moving every which way, in enormous swirls of colour. It actually makes me feel a bit queasy. This is crazy! The entire experience down here is like nothing Vian and I have ever experienced before.

It's obvious Jimmy is really unwinding now. Eyes closed; head tilted back. He's totally digging that old chair. It's almost like I can see fragments of his mind escaping; as if he is allowing the music to wrap around him like a python, slithering its way around every limb. My brother smiles like he's in pure heaven.

Several minutes pass by. Vian and I can't tell if Jimmy is sleeping or just really getting into the music, so we just sit in silence. Finally, Jimmy opens his eyes and reaches for the top drawer of the wooden table beside his chair. He pulls out a carved wooden box. Vian and I look at each other in wonder. What could be inside? Jimmy takes out a funny looking pipe and a small silver ball; something wrapped in tinfoil.

"You ever see this before?" He holds out a small brown lump.

"No!" Vian and I respond in unison.

"This is hashish. Some of the very finest." He raises the ball up to his nose and takes a deep breath. "This is called Red Lebanese. Just smell that."

I lean over and take a whiff. Smells kind of weird to me.

Jimmy pinches the ball with his thumb and index finger. The crumbled hash fills up the pipe's bowl. After lighting it, he takes a big puff deep into his lungs. He holds it in for what seems like a very long time and then finally, he exhales. He takes a few more deep puffs, making this all look like pure pleasure. Closing his eyes once again, he leans back into his chair, resting his head. That python has him totally in its embrace now. Jimmy looks completely at peace. He sure has a way of making all this look incredibly inviting. The music, dim lights, the incense and now the hash wafting through Jimmy's sanctuary. It does create an other-worldly atmosphere. Vian and I have landed on a different planet.

Jimmy stirs and lights up the pipe once again. "Here, you have a puff." He holds it out to me. Me? *What? Really?*

"Are you sure?" I question, feeling anxious.

"Heck, yeah. You wanna relax a little with me don't ya? It's just going to feel so good."

Well, why not? I want to feel good. I want to feel at peace, like my brother. And I sure don't want to be a wimp! I take the pipe and place the hard metal mouthpiece between my lips. Just a little puff. *Wow, that tastes different than cigarettes, that's for sure.* I cough loudly as Jimmy passes the pipe to Vian. She takes a puff too. Back and forth we go with this magic pipe. I am starting to feel a bit uncomfortable. There's tension building inside of me. I think it's been there since we came downstairs;

## Chapter Fourteen

I just didn't want to admit it. My gut is telling me that this wouldn't be okay with our mom. I can't imagine ever telling her. Jimmy would be in all kinds of trouble and we'd never be able to visit him again. I quickly push that thought right out of my mind.

Jimmy is looking super-relaxed now. The three of us sit quietly for a few minutes just soaking up the music. It sounds incredible. I am fully immersed in the organ and the girl singer. Man, she sure is wailing. Everything is magnified in my head.

Jimmy perks up and grabs something from inside the brown paper bag beside his chair. It's an oblong black box that looks like a watch case. He doesn't bother to take the watch out of the box. Instead, he grabs the piece of cardboard attached to the watch. There, behind it, is a long, narrow, sheet of white paper with individual yellow dots, all in a row. There must be at least nine or ten.

What could this be? These dots are not just dots on a piece of paper. Or are they? I'm not really sure and I am too timid to ask. Perhaps I don't really want to know.

Jimmy tears off three of the dots, handing one to each of us.

"Okay, just do it like this," he demonstrates, putting the small dot onto his tongue. "Now ... you girls do it."

Vian and I look at each other for a split second, silently concurring that we will do what Jimmy asks. He is our big brother after all. He would never do anything to hurt us. We place the small yellow dot on our tongues.

"You girls are going to feel really great in a little while. This is something incredibly special. You're going to love it. Just go with it, okay?" he settles back into his comfy. chair.

"What's it going to do?" My lips feel fuzzy as I try to form the words. "I am already feeling pretty relaxed, that's for sure."

Jimmy laughs a little, without opening his eyes. "It's just going to make you feel a little happy."

"That's it?"

"Yup. Now just put your pretty little feet up and enjoy the music." We do as we're told. Vian and I both squeeze into the red bean-bag chair across from Jimmy. I can feel it enveloping us, like a giant hug.

The clock ticks away as I wait for something to happen. I don't really notice anything different. I'm not feeling super happy and I don't feel any more relaxed.

But then ... Whoa!

All of a sudden, it's like a thick blanket of pure maple syrup pouring over my head, right down to the very tips of my toes. My entire body is engulfed in goo! I am feeling so heavy, heavier than I have ever felt before. Every nerve in my body is aquiver. Like I am finally waking up for the first time in my life! I feel so alive. Every inch of me is beginning to tremble. This must be how a Christmas tree feels when its lights have been turned on for the first time.

I'm not sure how much time passes as Vian and I lie silently in our chair but Jimmy soon excuses himself to go to bed. He's standing above us, looking down like he's a giant.

"Goodnight girls. Have a fun night," he grins. "I'll see you later tomorrow."

We don't answer. I feel like my lips are sealed with maple syrup. All I can do is lean against my sister and melt even deeper into the millions of tiny beans in our chair. They're not really beans, are they?

I am lost in the music, feeling something I've never felt before. My guess is Vian is the same. Time stands still, like it doesn't even exist. Nothing moves. I'm not sure if I will ever want to leave from this glorious place.

## Chapter Fourteen

We both continue to lie silently. We say nothing. We just let the music pour over us. After what seems like forever, but might only be a few minutes, or even seconds, I ask, "Should we go upstairs?" I am wondering if I'm actually speaking out loud or just imagining that I am.

"Sure, I guess so," Vian softly mutters.

"Okay, good. I *am* speaking out loud. Whew. That was strange."

Vian looks at me blankly. "What did you say?"

"Oh, nothing." I stand up on wobbly legs and reach for my little sister's hand. We begin our trek upstairs, first navigating through the long, beaded curtain. This time, the swish of the beads penetrates right through our bodies.

"Did you feel that?" I ask with a kind of wonderment.

"Oh, yeah. Should we do it again?" Vian gazes up at me, glassy-eyed.

"Yeah, let's." I am lost in this haze of enchantment.

After walking in and out of the beaded curtain several times, we literally float up the stairs. This is something else. I can't even describe how I'm feeling right now. We enter the bathroom, close the door and flip on the light. The bright blast explodes on us! This is so intense. Our eyes finally adjust and we are immediately mesmerized by the large mirror which takes up half the wall of the small bathroom.

"Oh my gosh, look at your face!" Vian laughs out loud.

Putting my finger to my mouth I whisper, "Shhhhh, we've got to be quiet. We can't wake anyone up."

"I know," she squeaks. "But I can't help it. Look at your face. Oh my gosh. That's hilarious!"

I move my face even closer to the mirror. "Ooooohhhh wow, look at that. Oh, that's so crazy. But look at you?" I try not to laugh but a little peep comes out. "Hee hee hee. You're

just the same. Look at YOUR face? It's just like mine, only way bigger."

"Shhhhh, not so loud. We're going to wake everyone up."

"I know but I can't help it."

Both of us are trying so hard to be quiet. But that's a difficult thing to do. Our faces are distorted beyond recognition. It's pretty freaky and funny and we cannot contain ourselves. We hold our stomachs with one hand and try to muffle our laughter with the other, as we bend over in complete hysterics.

We're hopeless now. Tears are running down our faces as we howl like hyenas.

Then, in a flash, the laughter is gone. The happy tears suddenly turn to tears of distress. We are both overcome with pain because of poor Vian's newly acquired, pre-pubescent face. It is full of acne. Devastating! So many zits, everywhere. We spend what feels like hours in front of this bathroom mirror as I console my sweet little sister.

Finally, we make our way into the kitchen, very guarded because the patterns on the linoleum floor are breathing up and down at us. This is totally crazy! Up and down. Up and down. All of the black areas look like they are going to suck our feet right from under us. Oh, the horror of it all! This is frightening!

Eventually we find our bed and huddle together for the rest of the night. Early morning arrives. Vian and I are completely exhausted. Our minds and bodies are begging to come down from this horrifying ledge. This "trip" we've been on feels like it is going to last forever. We just want it to end. We just want to be back to our normal selves. The way we were, before we took the little yellow dot.

Such a tiny little thing. But wow, so powerful. How could we have known what it would do to us? But Jimmy knew. He

## Chapter Fourteen

said it would make us happy. He said it would be amazing. It was, until it wasn't. Does this mean I can't trust my brother?

I guess we still have a lot to learn. One thing I do know, though. We won't ever forget our visit to Jimmy, or his hideaway.

## Chapter Fifteen
# Drugstore Cowboy

Since being back in the big city and of legal age 14, for babysitting that is, I do a lot of just that. I think I'm pretty good at it. Not one child has died on my watch. My newfound career serves many purposes. I love looking after kids and making my own money. I can indulge in all the great snacks the really nice families leave for me and most importantly, it gets me out of the house and away from *him*.

Yes. *Him*. I am sad to report that my mother married Mike! Even after she told me she would never get married again. Now Mike is not only her husband, he is also our stepfather. And not just stepfather. He adopted Vian and me! We have changed our last name to Haverland.

It feels pretty strange. All of us except Billy have the same last name, which is weird, but it has made life easier. Not so much explaining to do anymore. I can pretend we're almost like a real family. Something cool has finally come out of this. Mom even allowed me to change my middle name to Lyndell. Why Lyndell, you might ask? Well, in my 13-year-old brain it sounded exotic. My real middle name was Lucille, but I never really liked it even though I am named after my aunt. Sorry Aunt Lucille. But I honestly thought Kelita Lyndell sounded like a movie star. I really wanted to keep my dad's name too; that was so very important to me. So, I suddenly took on one mouthful of a moniker - Kelita Lyndell Ohler Haverland.

Moving to the city for mom's health was a definite necessity but she's still not doing very well. She had to have another

## Chapter Fifteen

major operation. This time they removed her other breast and a whole bunch of lymph nodes. I'm not sure what those are but I know it's really disconcerting to see her poor body. I try not to look too hard when she's naked. Between the radiation and the chemotherapy, there's always some kind of treatment going on. She's been in and out of the hospital a lot. My gut tells me she's *really* sick, but she always tries to be so strong. She doesn't want us to know.

She was released from hospital for just one day so she and Mike could get married. None of us kids were invited. Not his three kids either. That really hurt my feelings. One day they are boyfriend and girlfriend and then BOOM, without any warning, suddenly they are man and wife! Just like that.

I'm trying my best to like him, I really am. My mother must really love him, so I guess we just have to do our best and accept him into our lives. Vian and I are even trying to call him Dad. No matter how much time has passed, it still doesn't feel right.

Anyway, back to babysitting. When I go to work it also helps to take my mind off all the stuff going on at home. At least I think it does. I've started babysitting for a new couple who live across the street. This is the second marriage for both of them and she has a little boy. Tommy's a really cute kid.

My bedroom window faces their two-story house on the corner of Willowbrook Drive. We live in a very nice neighbourhood. Much different than the townhouse, where we first lived in the city. In fact, our new house is on the 8th green of Willow Park Golf Course. Pretty snazzy, right? And our neighbours' house is beautiful. I've been inside a few times now.

I see Tommy's stepdad coming and going to work every day in his fancy cherry-red pick-up truck. He's usually sporting pricey snakeskin boots and white cowboy hat. But trust me, he's

no cowboy (like Mike). At least Mike is legit. And that's how it is here in Calgary. Lots of drugstore cowboys. My neighbour has a medium build and is in pretty good shape for his age (yes, I am starting to notice these things). On the weekends, he likes to show off his arms and chest in a tight white t-shirt. His jeans fit him pretty tight too. He is very bald. I know he shaves his head. You can just tell. People on the street are already calling him Kojak after that bald guy on TV.

Tonight I am babysitting for them and he greets me at the front door. "Hey sweetheart, come on in!" He flashes a toothy grin of pearly whites augmented by one gold one. I'm sure it's just for show.

As he opens the door wider, I feel his glare. He barely gives me any space as I awkwardly attempt to slide in past him. His cologne is bold and so is his body language. He opens his stance toward me, keeping one hand on his belted hip. His shiny gold wedding band is sparkling. On the other hand, a heavy gold ring looks like it could knock your block off if he ever tried. A flashy thick gold chain hangs around his neck, completing the look.

I wonder why I've never noticed all this stuff before. I think he is trying just a bit too hard to be cool. I'm sensing this guy has a big ego. It's just a feeling but he sure has given me the creeps a few times with his stares and sexual comments. It happened once when I was out washing my mom's car and another time when I was helping with some yard work. At first, I felt flattered but eventually I was just embarrassed. Awkward and uncomfortable. But just like when you walk past guys at a construction site and they whistle, I never know how to respond. So I did what I always do. Nothing.

"The Mrs. still isn't quite ready yet," he moves in closer. "She'll be down soon. Come on into the living room, Sweetie."

## Chapter Fifteen

I hate when he calls me Sweetie. I am not his sweetie. But what can I do? I follow him silently.

I am led from the vaulted-ceiling foyer into the large, bright, and airy living room. The chandelier is spectacular – exactly what I want in my mansion someday. The Mrs. is obviously a very talented decorator. Everything is just so. But where is Tommy? I'm hoping he'll come running in at any moment. Mr. Cowboy is looking at me funny.

I move toward the sofa and feel my neighbour's hot breath following me. He is really crowding me now, invading my space. There is a warm summer breeze blowing through the windows but I'm pretty sure my temperature is skyrocketing because of my nerves. *Gee, he is awfully close. What the heck is he thinking?*

Without even a tiny warning, he suddenly slinks his hand down the back of my shorts. *Oh my god, what is he doing?* He reaches further down into my panties and slides a few fingers as far as they can go.

Thank God I hear his wife coming down the stairs! He yanks his hand out fast. I can feel that ring scratching me. He leaps back a few steps as we both turn toward the doorway. My heart is in overdrive.

Her Chanel Number 5 greets us before she does. "Hi Kelita. How are you doing?" Her ruby red lips are smiling brightly, like absolutely nothing is amiss.

*Did that even just happen?*

My mind goes blank. "Oh, oh, oh … I'm great," I lie, still stunned and in a daze. I know my face is turning as red as her lips, like I'm guilty for what just happened.

"How is your summer going, dear?" She checks her hair in the gilded mirror, hanging over the fireplace.

"Oh, it's great, thanks for asking," I respond robotically, staring at my feet.

She turns to look at me, a serious expression clouding her eyes. "And how is your mother doing?"

*Oh, thank God. I almost thought she had me!*

"Um, you know, she has her good and bad days." The floor still has my undivided attention. I absolutely cannot look at her. Or him!

"Well, please tell her I hope she's feeling better very soon."

I nod my head agreeably as she begins to give me instructions for Tommy's care. Mr. Cowboy slithers out of the room without a word.

*Focus Kelita, focus. Listen to her instructions.*

I am present in body but my thoughts are swirling. I have no idea how to respond to what just happened. *What the heck did just happen?*

Tommy scampers into the room and grabs my hand. "C'mon Kelita ... let's go play trains!" Without so much as a farewell to his folks, he drags me to the playroom, chattering the whole way. I hear the front door close and immediately feel safer. I am now ready to do what I came here to do - babysit. Tommy and I play trains and many games of Snakes and Ladders, but my brain keeps wandering back to the living room and that horrible man. I am still in a state of shock. *How does someone just do something like that? Out of the blue? Did I do something to lead him on?*

I keep trying to drag my head back to the job and when Tommy begs for chips and pop, I readily agree. After snacks it will be bedtime. A quick story and lights out. Finally, I can be alone with my thoughts.

I'm still in a daze as I make my way down the winding staircase to the kitchen. I am starving and sick, both at the same time. I wolf down some more chips and a can of salty shrimp. Feeling just a little bit better, I return to the living room where

## Chapter Fifteen

this crazy evening got even crazier. I draw the heavy blue velvet curtains and dim the lights. My mind is still whirling. *What exactly was all that? Does Cowboy's wife have any idea what a rat he is?* She is such a nice lady. And he is such a creep!

I would love to talk with someone about this. But I can't even think of telling anyone! I could never just do that. I'm way too scared. Nope, I'm not going there. I just can't. I can't tell Mom, not now with her being ill, and I especially cannot tell Mike. He'd go crazy on the guy! No, I just can't tell anyone. I mean, Cowboy is our neighbour. He lives across the street from us. He's Kojak! Who would believe me?

I guess I'll just have to keep his dirty little secret to myself. That's the best thing. That's the only thing I can do.

I search through their record collection and choose an album with the most attractive cover; a beautiful black woman dressed in a sexy gown. I love female singers. I've never heard of this one but she sure looks glamourous. I carefully pull the vinyl disc from its white sleeve and place it on the turntable, meticulously dropping the needle so as not to make a scratch. My hands are still a little shaky.

Sinking into the sofa, I allow the music to lull me into a relaxed state. Shirley Bassey's voice sweeps over me like a warm breeze. She sings with such power. Such drama and emotion. "And I Love You So" is a beautiful song. It touches me deeply. Whenever I hear music like this it makes me cry.

And so ... I let go. I sob into the velvet pillow with all my might. I sob until I run out of sobs and tiny whimpers are all I have left. I drain myself of guilt and shame and confusion and terror. I let it all go until there is nothing left but shallow breaths and a damp pillow.

I lift my head, wipe my eyes and stare at the fireplace. I am alone in this nightmare. I will always be alone in this nightmare.

There is no one to tell. It will be my dirty, dark secret. For all time. One of the most bizarre experiences of my life. And one that I will never understand.

Shirley begins to sing "The First Time Ever I Saw Your Face" and I feel a second wave bubbling. I know there will be more tears. I welcome them and the catharsis they bring. There is just something about crying that tonight, feels completely and utterly right.

**Naked Soul** 🎵

## Chapter Sixteen

# Vilda Pearl

My eyes follow her frail, naked body as she gingerly steps out of the glassed-in shower. Now, instead of the nurturing symbols of her womanhood where I once suckled, I see disturbing, uneven, purple incisions. The cruel burn lesions from the radical radiation are too numerous to count. Her face is drawn and pale. I hand her a towel then gently dry off her back with another as she stands weakly, shivering.

She shuffles across the carpeted bedroom floor, her upper back hunched as she cradles her swollen left arm in her right hand. The swelling is severe and causes her immense pain. She has to wear a sling all the time now. And she is always exhausted. My heart aches for my poor mother. And yet, throughout two radical mastectomies, endless rounds of chemotherapy and radiation, experimental treatments in Houston, Texas and a visit to the Mayo Clinic, my mother wages her cancer battle like a prize fighter.

She is so terribly thin. Almost like a skeleton with skin. She looks like death. But she can't be dying. She is my mother. Still so young. So incredibly strong.

There has never been any display of weakness. Ever. Not until this cancer. For the first time, I sense her slowly ebbing away. Right in front of me. How can I deny it any longer?

I turn my head, brushing away tears, and catch a glimpse of myself in her vanity mirror. Stand up straight, Kelita. Shoulders back. Be strong. Don't let her know what you know. This is the most painful thing about my mother's cancer. No one is talking

about it and telling the obvious truth. How crazy is that? How can we all keep pretending? But still, we do.

My mother is Vilda Pearl Whitney. And now, Haverland. Even her name is extraordinary. Not one you hear every day, that's for sure. In fact, I don't think I've ever met or even heard of another Vilda. Hilda and Matilda yes, but no Vilda. And Pearl? That's after my great aunt on my grannie's side. She was the prettiest of all my grannie's sisters, but that's not saying much. From the photos I've seen most of them were darned ugly. Mom must have instinctively known from her own experience growing up with a unique name, that choosing Kelita for me would bring with it a sense of individuality. That certainly has been true. I've been told my name comes from the bible and can be found in the Old Testament. It means 'little one' or dwarf-like. I think I prefer little one.

When I face the cold, hard truth, I realize how much deep love and gratitude I feel for my mother. She's always had the ability to pull the actress and performer out of me. From the time I could sit up and talk, we were a team. She was so proud when people would ask me how old I was and I'd profess loudly, "I'm soon 2!"

My mother was the one who dressed me up like an old woman and helped me memorize that poem for my first live performance. She's the one who made sure I was given piano and singing lessons. The one who signed me up for the United Church children's choir and all the Kiwanis speaking competitions. She's the one who helped me memorize my lines for my school plays and musicals. And when Vian and I were much younger, she was never upset when we helped ourselves to her fancy clothes, shoes, wigs and make-up, while playing movie star. When I started being her hairdresser at only 12, she applauded me.

## Chapter Sixteen

My mother always saw the performance spark in me. She nurtured that flame with love, encouragement and a strong work ethic. She was never a typical stage mother in any way. She always taught me to believe in my dreams and to believe in myself; to work hard and be the best I possibly could be.

I also witnessed the performer in her. Maybe that's where I get it. I will never forget the time she and Daddy dressed up for a Halloween party. She wore ugly old green pants tucked into brown leather boots, a red checkered flannel shirt and a black wool toque. She blacked out a few teeth, painted on a fake mustache and chomped on one of Daddy's pipes. How my father managed to fit into *her* pink Klondike Kate dress, I'll never know. He did not make a very good-looking woman, even with the ruby lips, thick mascara and blonde wig. He was such a good sport wearing those high heels. I'm not sure how he ever walked in them.

My mother is not only funny but bright, intelligent and a good businesswoman too. She also has a very big heart. When we lived on the ranch, we'd often find someone in trouble, sitting at our kitchen table receiving financial help.

Recently she has been wanting to buy a car for me and some diamond stud earrings. I have the feeling these are gifts she wants to give me now because she knows she won't be able to give them to me later. Maybe they are for my graduation? Or even my wedding? I don't want to think about that; it's way too sad.

My mother has always had a great passion for our family and its 4th generation Canadian roots. She adorned our walls with yellowed, black and white photos of our great grandparents and aunts and uncles. Some are on horseback and some in a studio. These folks are all without smiles and all have crazy hairstyles and very proper outfits. She tells me stories

of how my great grandfather, David Whitney, was one of the first pioneer cowboys to help settle Southern Alberta. And that my great Uncle Stanley participated in the first-ever Calgary Stampede in 1912. And that he was also a world champion trick roper. My other great Uncle William was enlisted with the RCMP's 2nd contingent to Fort Macleod in 1877. She wants me to know of my family history. Mom used to belong to the local Historical Society in Claresholm and helped to compile a book about the history of some of the ranching and farming families in our community. She has always loved the country life and cattle ranching. It's in her blood.

In the wake of Daddy's suicide, my mother had to struggle with all the blame his family placed on her. While dealing with the owning and operating of our cattle business and ranch. But now her life is quite different. She has been busy getting all her affairs in order. There have been many appointments with lawyers and accountants. This scares the heck out of me.

Through it all and even now, in so much pain, she's always more concerned about others. She never complains or is negative. She usually stands with her head held high and smiles that beautiful smile that can light up any room.

But today, as I watch her trying to get dressed, her clothes hanging limply on her withered frame, I am seeing my mother through different eyes. And it breaks my heart.

I'm also starting to wonder if there is a whole other side of her that I don't even know. There have always been so many secrets. I think she's been hiding something for a long time. She has started talking to Pastor Charles and my Aunt Lucille has been seeing him too. I have no idea what they talk about, but he invited us all to his church.

Of course, Mike would never come but Vian and I accompany our mother. I like it when it's just the three of us.

## Chapter Sixteen

We haven't been to church in a long time. Not since Daddy died.

From our very first visit we find the people friendly and welcoming. I discover that my friend Sandy also attends. We go every Sunday and when Mom's not well enough to come along, Sandy's family picks up Vian and me. Sandy has also invited me to join the youth group and I'm meeting some really great new kids.

My mother must have told someone, perhaps Pastor Charles, that I really love to sing. I am instantly accepted into the senior choir. There's so much music at this church and I get to sing a lot. Melody, one of the girls in the youth group, is a talented piano player and we've already been practicing one of my favourite Carole King songs, "You've Got a Friend." We're going to be playing it for the whole church really soon.

And it gets even better. The director of the choir is married to a very famous singer. Her name is Dorothy and she's part of the famous 1950s trio called "The McGuire Sisters." She has gold records for number one hits like "Sugartime" and "Sincerely." I remember seeing them on the Ed Sullivan Show when I was really little. I get to sit beside her in choir because we're both in the alto section. She has the most beautiful long, fingernails and her perfume reminds me of Aunt Lucille. I think it's called "Youth Dew" by Estee Lauder. I know it comes in a pretty glass bottle with a little gold ribbon around the middle. And you should see her wedding ring! It's beautiful - the biggest diamond I've ever seen!

Mrs. Williamson (that's Dorothy) and her husband think I have a lot of talent and are always encouraging me to keep writing and singing. They even sent a cassette tape of me singing the song I wrote after Daddy died to Murray Kane in New York City. He's their personal manager and vocal arranger.

I can't wait to see what he says!

The Williamsons have two boys and one of them is also a musician. Rex is just a little bit younger than me (and very cute!) and plays the drums. We get along really well. His parents are a very generous couple. They always invite the youth group to pool parties at their gorgeous country estate just outside of Calgary. Their house is a mansion! They have long hallways of pure white carpet, stretching endlessly. It's the plushest rug my feet have ever walked on. In their living room there are floor-to-ceiling picture windows that overlook the manicured grounds and beyond, to the lush foothills. My favourite feature is a white grand piano and tall golden spheres. They are beautiful pieces of art and probably worth a lot of money. They have maids and grounds-people and tennis courts. It's just perfectly awesome.

It's so much easier to forget about the devastating reality of my home life when I'm at this unreal paradise in the country. Or with the youth group having fun. Or at the church making music. But then I must return home and face the truth of my mother's life. Our family's life.

What if she doesn't have much more time? What if she dies before I am even an adult? What will Vian and I ever do without our mother?

I hate cancer.

## Chapter Sixteen

Mommy with Vian and me in our family room on the Claresholm ranch. More matching outfits.

My parents in their crazy role reversal costumes. My sister and I loved seeing this happen.

## Chapter Seventeen

# The Conversion

*"If this is you, if this is how you really feel, if this is where you're at tonight, then you need to come down here and ask Jesus to come into your heart. Don't waste any more time. If He is speaking to your heart then don't wait until tomorrow. Tonight's the night. If you can feel His presence and know that He's speaking to you, then you need to get up out of your seat and come down here tonight, right now, and give your life to Jesus. He's waiting for you. He is waiting to forgive you and make you new. Tomorrow could be too late. Now is the time. Don't wait. Please don't wait. Your life could end tonight. Don't wait. Come on down. There are people here just waiting to pray with you. Don't waste this opportunity."*

The young youth pastor is pleading with us. He's pleading with me. I can feel his voice penetrating my heart. I can feel it. Right here in my chest.

The band members, with heads turned upwards, play with frenzied abandonment. With eyes closed they lift their faces to heaven. Familiar guitar riffs and sweet old melodies fill this hallowed church sanctuary. These songs are soothing my soul and I can feel my heart stirring in a new and beautiful way. There is something in the air. The electricity is tangible.

Every word the pastor speaks feels like it is meant only for me. I need a friend; I need a father and I need to be loved. I need to know someone is here for me when I feel alone and when my world is caving in, threatening to smother me completely. How much longer am I going to have a mother? My father is dead and Mommy is dying. This is my life.

## Chapter Seventeen

I push these morbid thoughts out of my head. My heart wants to linger but my mind fights, wavering between the truth and denial. Not one single person has told me she is dying. She's trying so hard to keep the truth from us. But right now, in this moment, I am so scared she's going to leave me. Forever. I can sense it in a deep spiritual place. I just know she is not going to make it.

My own pain is consuming me right now. Self-pity pours out of me like one massive teardrop after another. My body is tingling, bubbling over in my core, anxious yet with quiet excitement. I feel a gentle nudge from a power existing outside of me. Could this be the Holy Spirit that I have heard so much about? Is this the Spirit of Christ himself flowing and present in this place? Maybe this is it!

The pastor beckons me. Me – personally. I feel it. I *know* he is speaking to me. Soft voices continue to sing as others whimper. These voices unite me, drawing me into the flow of something intangible. I cannot see it or touch it. But I know it is there. It can only be spiritual.

Influenced by the waves of emotion, my teardrops become sobs. My whole body is now weeping. Jesus is allowing me to encounter His divine presence. It is physical, it is metaphysical, it is divine and it is very, very real.

I rise from my pew slowly, afraid and yet not afraid, and I shuffle down the aisle, careful not to step on the feet of others whose heads are bowed. What was a gentle nudging is now a strong yearning and I know I am being led by something or someone. Pace quickening, with my hand sliding down the wooden railing, I descend the flight of stairs from the balcony. I enter the main door of the sanctuary, blanketed in a divine sense of awe as I find my way down the burgundy carpeted aisle. Slowly, as there are others in front of me, I walk towards

the alter. I am joining so many. I kneel on the worn carpeted steps and bury my head in my hands. I whisper to God through my tears and sobs:

*Jesus, I need you in my life. I surrender everything I am. I make this commitment to you. I need you to be my strength. I need your comfort. I need a friend. I am so scared. Please, please help me to be strong. Oh God, I need you.*

Someone joins me on my step. She gently places her warm hand on my back and leans in towards me. She hands me a tissue. I dry my eyes and turn my gaze to her, still kneeling.

"Thank you."

"Not to worry." She silently waits for me to contain my crying. "What's your name?" she asks softly.

"Kelita." I am still sobbing.

"How old are you, dear?"

"I'm 14," I stutter.

"Would you like me to pray with you, Kelita?"

"Yes. Yes, I would. Thank you."

"Kelita, what has brought you down to the alter tonight?"

I pause. What *has* brought me to the altar tonight? Not sure I can really put it into words. I take a deep breath and try. "I just felt like I was being guided. I'm going through a lot of stuff right now at home." The tears are welling up again. "And I just really felt that what the pastor was saying was directed at me."

She pats my back tenderly. "I'm so sorry you're going through some tough things right now. Is there anything you'd like to share with me?" She seems caring and genuinely interested.

"It's my mom. She's got cancer and she's not doing so well. And my dad passed away a few years ago. I guess I'm just really needing God to help me with everything. I'm really scared."

## Chapter Seventeen

"Oh, I'm so sorry, what a horrible burden you're bearing. Your mom and your father too? You've been going through a lot, haven't you? That's so much to be taking on. I can see why you were guided to this altar tonight. Sometimes we try to carry these heavy burdens on our own but then we realize we just can't do it. We simply do not have enough strength. We need God's strength." She pauses and takes my hand. "Can I ask if you've ever received Jesus into your heart?"

I realize with sudden clarity exactly what she means. "No. I haven't. Not until just now. I just surrendered my life to him, right here, right now." The tears are really flowing but my soul feels strangely full.

She smiles so warmly my heart melts. "That is wonderful to hear, Kelita. When we surrender to Jesus and ask him to come into our lives, we know we are no longer on our own. I'm going to pray for you right now and I know that moving forward, you will feel the power of Jesus in your life and you won't be carrying this huge burden on your own any longer. Shall we pray together?"

I close my eyes tightly and press my palms together. This heartfelt decision is what I have needed. It feels so right. Tonight my life is forever changed. I know it deep within me, like a sacred truth that has always existed but has only just now been awakened.

I am walking on a cloud when I get home. I creep into my mother's bedroom. Mike is snoring loudly but I ignore him completely as I kneel by Mommy's bedside. Quietly, in the softest whisper, I share my deep spiritual experience. She squeezes my hand and I know this means she is happy. There is an unspoken connection we share in this very special moment. And I find peace in knowing that this deep love and understanding will last forever. No matter what happens.

## Chapter Eighteen
# The Caddy

Mom's mobility with her bad arm is getting worse which makes driving tricky (if not impossible). She's still in a lot of pain and even maneuvering in and out of the car is difficult. It's summertime and the roads are dry, so I have become her chauffeur. I'm now the one driving her to the hospital for all her chemotherapy appointments. The Caddy and I are getting to be best buddies. I'm much more used to the size of that boat and Mom is becoming more secure with me behind the wheel. Sometimes Vian comes along but other times it's just mom and me. I love these special bonding moments for the two of us. I do feel bad that I'm not spending more time with my friends this summer. But how many of them are driving a luxury Cadillac every other day?

Most days I wait by Mom's hospital bedside until she falls asleep and then I quietly slip out of the room. I can't wait to get outside into the fresh air. Luckily, I have managed to find a secluded spot on a beautiful piece of green grass. Lying under the big Alberta sky and soaking up the warmth of the July sun brings me a little bit of comfort.

I am way too familiar with that horrible hospital and poor Mom despises being there. Who could blame her? She's been in and out so much this summer. She's been rushed off in an ambulance more than once. Those sirens and flashing lights are nerve-wracking but I know I have to stay strong.

My new faith helps so much. I pray every night for God to keep me strong. I pray that I don't show any sign of weakness,

## Chapter Eighteen

especially in front of Mom. And Vian too. For some reason, I fear that if I stop being strong for even one minute, something dire will happen. I'm not sure what but I must stay strong to keep this dire thing NOT happening. That's the way I have to be.

Today I'm home alone. Mike is at work and Vian is visiting a friend. I'm listening to Carole King. I just love her "Tapestry" album. I plant myself by the stereo and lie down on the soft green shag carpet. I close my eyes and just listen. I feel a deep sadness as I listen to the words of "So Far Away."

I can't help but think of Daddy. If he were only here, he would help me. I would feel safe with him by my side. I know I wouldn't have to worry so much, about the future. About what it might be like when Mommy's gone and Vian and I are left alone with Mike.

The phone rings and I run to answer it. It's my mother calling from the hospital. "Honey - it's Mommy. They're letting me out and I need you to come and pick me up. Mike's out of town so you'll have to come and get me."

"But Mom - I can't drive by myself." I am in shock!

"Yes, you can - you'll be fine."

"But Mom!" I stammer, scared beyond belief. *What is she thinking?*

"Look, Kelita, you've been driving me all summer. I just want to get out of here as soon as I can. I don't want to have to spend another minute in this place. You'll be fine."

"But I only have my learner's permit, Mom. I'm only 15! What if I get caught?" Remember me? That good girl? I don't break laws.

"You won't get caught. Stop your worrying and please just come and get me." She is getting impatient. I can hear it in her voice.

"Okay, if you say so, but I really shouldn't be driving all by myself." I am trying to be adamant. It's not working.

"You're a good driver and you'll be fine."

I marvel at her confidence. Her confidence in me! "Okay. You're the boss." I smile, despite my trepidation. "I'll be there as soon as I can."

I drop to the couch, head in hands. I cannot believe this! Oh my God, what did I just agree to? What is she thinking? What am I going to do now? I know how much she hates that hospital, but I'm going to get pulled over by the cops for sure. How can I possibly make myself look like a mature adult sitting behind the wheel of that Cadillac?

My brain goes into overdrive. Then a light explodes. I know what I need. I need a disguise! Sunglasses - yes sunglasses, that's it. They always make you look older. I need a pair of sunglasses. But I don't have a pair of sunglasses. Okay, I need to find a pair of Mom's. And a phone book. I'll sit on the Calgary phone book and then I'll look taller. I'll put on lots of make-up. Women who drive Cadillacs wear lots of make-up, don't they? And maybe a wig. Yes, one of Mom's wigs.

I get my disguise together, apply finishing touches to my overdrawn hot-pink lips and make sure there are no long brown strands of hair sticking out of my short blonde wig. I actually think it kind of suits me. Mom's new wet-look coat is a bit large on me so I belt it as tight as it can go. The fur trim might be a bit much for August, but I need to look rich so it's going to have to do. Finally, I put on the oversized dark sunglasses. Perfect! One final glance in the mirror and I'm all set. I grab Mom's shiny brown purse and throw in my learner's permit (as if that's going to help). Oh, and I can't forget the phonebook.

With sweaty palms and a sweaty head (wigs are hot!) I carefully back the Caddy out of the garage. Come what may, I am hospital-bound.

*Please, oh please God, don't let me get stopped by the cops!*

## Chapter Nineteen

# No Good-Bye

Following my great solo adventure in the Caddy (and no, I did not get pulled over!), Mom came home. For the first week she did really well. She was even able to sit outside in the backyard with us. Most of her time was spent in bed so Vian and I crawled in beside her and watched TV. Can't really say we actually watched much of what was on. It was just a nice excuse to snuggle up and be close. Just the three of us.

Sadly, that glorious week has ended. Yesterday she was in so much pain we had no choice but to call for the ambulance. Again. She can't handle the pain like she used to and her lungs are shot. They keep filling up with fluid and constantly need to be drained. My poor mother.

Today, when Mike gets off work, we go to visit her. She is sitting up, talking, acting strong like she is bouncing back, just like she always does. I figure she just needs a few days and then she'll be home with us again. We visit and chat as she eats her dinner. She doesn't say much as she tries to force down the bland hospital food. It's obvious she is getting tired. The nurse will soon be in to ready her for bed.

"I hope you have a good sleep tonight, Mom." I hate to leave her but I know it's time to let her rest.

Vian and I take turns bending down to give her a big hug. There isn't quite so much to hug anymore. I'm careful not to squeeze too hard.

"Thanks, Honey, I hope so too. I'll see you girls tomorrow. I love you."

"We love you too, Mommy," Vian whispers. We blow her kisses as we leave her and Mike to say their good-nights. We always do that. We understand they need their grownup privacy.

It is a beautiful August night and the sun is just beginning to set. Living so far north, we get long summer nights. The sky is painted with beautiful shades of lavender, pink and blue. It is breathtaking.

"I wish Mommy could see the sunset," Vian gushes. "I can see some lavender, her favourite colour."

"I know, it's beautiful. You're right. She would just love it."

I am feeling wistful this evening and it's difficult for me to match Vian's enthusiasm for the sky. I sense my mother slipping away. She is a wisp, like the soft clouds we watch floating into the sunset. Maybe she is floating away too?

Morning comes and I am awakened by the loud clanging of the phone. I hear Mike talking to someone at the hospital. They tell him we need to come right now. In a silent flash we are out the door and on our way. I feel like I am in somebody else's movie. Foggy, like I don't want to be here in the world right now. I want to escape, run away, to hide from whatever is coming. I don't want to feel. I just want to be numb.

As we enter the hospital I am accosted by the ugly grey walls and the overwhelming smell of sickness. Oh, how I hate it. My heart is beating faster and faster as we get closer to her room. What will we find? I don't even want to guess. My stomach is flipped sideways, my head is burning up and my nerves feel like they're on fire.

We are greeted at the nurse's station by my mother's doctor. We know him well by now. He is frowning and deadly serious. "I'm sorry but she's gone into a coma." He continues speaking to Mike, whose face is expressionless. "We've made

## Chapter Nineteen

her as comfortable as we can. Her lungs simply can't handle the fluid anymore. I'm afraid we've done all we can do."

Cold, hard facts. There they are, out in the open. No sugar-coating and no false hope. We do not respond. What could we possibly say?

No one has to tell me - I know. We are here to finally watch the cancer take Mommy from us. *But I never even got to say good-bye?* This can't be the end. It's not fair. I never got to look into her eyes one more time. How is that possible? Don't people have to say good-bye? No one ever told us she was going to die today. How could she die without words?

I feel panic rising in my throat. My stepfather isn't saying a word to my sister or me. Not a single word. No one is saying anything. There is just deathly silence.

The three of us walk solemnly down to the end of the hall, almost like we've already begun the funeral procession. The door to her room is ajar. Mike opens it gently and we enter, noticing they've dimmed the lights above the bed.

My beloved mother. She looks almost angelic. Gently lit and peaceful in her slumber. It is only a matter of time now. We gather around her bedside, mesmerized by her every breath. Every time she exhales, time stops. We stand frozen, waiting for the faint sounds of just one more blessed breath being drawn into her lungs.

"I love you so much, Mommy – so much," I whisper.

Death is near. I can feel it approaching. It's getting closer. I know it's coming. I want time to stand still. I want to fight it off. But death always wins. Time does not stand still and there is no fight to be won. Death arrives quietly as, ever so faintly, my beautiful mother exhales her finishing breath. The machine monitoring her heart lets out the cry of finality as the endless beeping fills the room. She is gone. Mommy is really gone.

I fall to my knees, remembering a few weeks earlier when I had offered the most difficult prayer of my life: *God, please take Mommy*, I had begged for mercy. *We can't stand to see her suffer anymore. I don't want her to go but it's devastating for Vian and me to see her this way. Please God, take her soon. Take her out of her misery.*

I had found the courage to pray for the exact thing I did not want. And yet I knew it was what my mother would want. I knew she was dying. And I knew the pain was too much. I knew I had to let her go.

And yet now, with the moment I had prayed for at hand, an unimaginable agony has taken over me. The debilitating sorrow of seeing my beloved mother take her final breath has literally brought me to my knees.

She is gone. It is done. My prayer has been answered.

As Vian falls into my arms on the floor, we hold on to each other for dear life.

*Are we orphans now?*

**Deep Need** ♫

## Chapter Twenty
# Mean Mike

The immense heaviness in our house continues to weigh me down. It's brutal living here without Mom. Sometimes, in the middle of the night, I lie awake planning my secret escape. Vian and I have been left with the wicked stepfather. I'm not exaggerating when I tell you he is one of the meanest and angriest people on this planet. This man is like a sizzling volcano just waiting to erupt. And when he does? Look out. The lava he spews is hot, cruel and violent. These episodes are ugly and frightening. And you never know when they might happen. He might be on the phone with people who work for him. Bam! No warning. He can blow in an instant. That's when Vian and I go rushing to our rooms.

Sadly, there is no escaping his rage. His name-calling, bullying and roaring obscenities penetrate every wall. It's unconscionable how horribly he treats his employees. I feel defeated just listening. Vian and I keep waiting for the day that he becomes so enraged his huge head and fat body literally explode. So far, no such luck.

If he's not cursing the Russians because they're going to take over the world or cussing out the government for anything and everything they do and don't do, he is degrading his own son and daughter. His own flesh and blood! It doesn't really matter who he's angry at because everything seems to infuriate him. Heaven forbid we ever interrupt him while he's watching the evening news at the dinner table. While he pigs out on his double helping of chicken fried steak (his favourite), Vian and

I are forced to eat in silence like monks. When he does decide to talk to us, he's either up on his soap box ranting or moaning about how hard-done-by he is. It's pretty much always about him.

Vian and I keep our antennae high. We never know if he's going to pay us a compliment (which is rare) or scare the crap out of us (more common) with his verbal artillery. And talking back? Are you kidding me? You don't dare! You can't even comment or ask a question. You never have a chance. Ever! Even just a tiny sound coming out of your mouth and the lava spews again. This evil man truly derives pleasure from watching Vian and me squirm.

Our stepfather controls people with anger and fear. He's an accomplished manipulator. Just look what he did with our mom! He borrowed tens of thousands of dollars from her for his cattle business, which he never paid back, and now he's contesting her will. He's going to end up getting twice as much as he should. And when you think about it, it's really my parents' estate. They're the ones who worked so hard for so many years to build the business. And this creep and my mom were married for less than three years! Three years! He's such a crook.

Now that Sally has been let go, we have no one to turn to. No one to listen to us. No one to complain to. Mike is such a cheap jerk. We loved Sally so much and he knew it, but he refused to keep paying her. I honestly believe my mom never really saw his true colours. She thought she was doing the right thing by marrying someone who would take care of us. I know she would want Sally to still be here.

I'm always nervous around Mike, especially if I need anything from him. Like permission to go out with friends on a Saturday night. If I want to make plans to go out on the

## Chapter Twenty

weekend, I need to start sucking up to him on Monday and every day after that. It's all a game. And guess who's teaching me? HE IS! I'm learning how to lie and manipulate, just like him. I'm always working the game just to get on the right side of him. It is all about performance.

Vian and I were raised to do chores around the house. From a very young age, farm work was expected too. But Mike believes in an untenable work ethic. If we aren't busy doing something productive when that back gate opens at 5 o'clock we are in deep trouble! My sister and I are now in charge of all the cooking, cleaning, laundry, ironing, yard work, grass-mowing and snow-shovelling. I know it's good to learn how to do these things but it sure sucks having to do *all* of them when you're only 15. Especially when our friends are doing fun things! There is no fun for my little sister and me. We are stuck like two Cinderellas, doing all the chores and ironing his darned shirts. I hate those bloody shirts!

If we ever forget to empty the dishwasher, he will haul us out of our warm beds in the middle of the night. One time, one of us had thrown a piece of chewing gum in the waste basket and it was stuck to the bottom. He freaked out! He dragged us out of bed at 3 o'clock in the morning to remove it!

You just never know when some miniscule thing is going to make him blow a gasket! The mental anguish is insane. It's exhausting. We can never let our guard down. We can never relax in our own home. So much for this being a safe place.

And friends? I rarely ever bring friends home. Our mother spent thousands of dollars so we could have a beautifully finished basement, but it's hardly ever used. I know he doesn't want a group of teenagers hanging around his house or property. Besides, I'd be terrified of what embarrassing prattle might come out of his mouth.

The telephone is another issue. If anyone dares to call our house after 8 pm, look out! He figures, like him, everyone should be up at 5 am and in bed when the sun goes down. If he is in bed and the phone rings, he'll get on the extension and start cursing and making threats to my poor friends. On one occasion, a new boy came to the door and Mike told him he has a shotgun and was not afraid to use it. Another time the poor youth leader from my church showed up in cut-off jeans. Did Mike ever let him have it! He thought it offensive for any boy to come to call on one of his daughters dressed like that. I just wanted to die.

Mike really likes his Scotch on the rocks. And I guess I'm learning to like it too. Because when he drinks, he's more lenient and likely to allow me to go out. But sometimes, late at night when he's had one too many, he comes into my room. He sits on the edge of my bed and gets all teary, telling me how much he misses my mother. He tells me how much I remind him of her. I actually feel a little sorry for him during those rare moments. However, those feelings stop abruptly when he insists on giving me a sloppy old man kiss right on the lips! There have been a few times when his behaviour has become highly inappropriate. He will tease me about my breasts or about my panties getting wet. Sick. I cringe just thinking about him looking at me that way.

The man has no filter. A few weeks ago he said to me, "The only reason I ever adopted you and your sister was because your mother wanted me to. She didn't know who else would look after you when she was gone." Who says that to a young girl? A young girl with no parents?

Although he's never physically harmed us, we live in perpetual fear that one day he might. I know we have to stay strong. Especially me. I need to be strong for Vian and for myself. I have no other choice.

## Chapter Twenty-One

# Tousled Sheets

It's late fall and I can feel the leaves crunching beneath my feet as I sprint home from school. The weekend is finally here and that is worth running for. I want to be quick so I can get my chores done. Then I have to get homework out of the way, dinner made, do the dishes and pick out my clothes for the night's entertainment. And of course, get ready! That means taking a long hot shower and doing my hair. The hair alone, well, that could take hours! And then makeup. I don't wear a ton, but I do like to wear some.

I love hanging out with my girlfriends. I also love chasing boys. And more often these days, getting drunk behind the 7-11. Friday nights are for fun! Especially when you're 15! And live in a prison!

There is a part of me that, because of church, feels torn. And a bit guilty. Well, actually a lot guilty. I know I shouldn't be going out and partying, but all my other friends do, and I just don't want to miss out on anything. I'm not hurting anyone and besides, it's all just innocent fun. Isn't it?

When I finally get home the house is dead quiet. As I walk past the master bedroom, I am taken aback by what I see - the queen-sized bed is unmade, and the sheets are tousled. The bedspread is pulled back. Why? If Mike had, for some strange reason, come home in the middle of the day for a nap (which he never does), he would have made the bed again. It's just not like him to leave a mess. Not at all! This is very odd indeed.

I stand and stare for a moment. And then it all starts to

make sense. I have been trying to figure out a puzzle for a few weeks now. It began when I came home early one Friday night. I heard noises downstairs in the rec room. When I went to see who was there, I was most surprised to find Mike sitting next to a lovely woman, on the love seat no less! He never goes down to the rec room by himself!

He looked pretty darned surprised because I was home so early. But he jumped right in. "Well, look who's home early? Did you get all your kissing in already?" He's forever teasing me about boys.

"No, I wasn't doing any of that!" I could tell he was a bit nervous. But not really, because nothing ever bothers his conscience.

"Honey, I want you to meet Evelyn". He gazed at her proudly. "She's in the horse world and we've just been discussing her business. We're just about finished here."

*Yeah right - the horse business! More like the BS business if you ask me.*

"It's nice to meet you, Evelyn." I smiled demurely. Of course, I was my sweet polite self. She seemed nice enough.

"Nice to meet you too, Kelita." I wondered how she knew my name. I guess he told her he was now father to two teenage girls. Strange that he introduced her as someone who was in the horse business. And they were discussing horses? *Hmmm ... horsing around maybe!*

The whole encounter did not sit well with me, at all. Number one, he was in the cattle business and not the horse business and two, my mother was barely cold in the ground!

And now another piece of the puzzle. These tousled sheets! I am no dummy. I may only be 15 but my female intuition has experience in these matters. I have been a sleuth my entire life. Out of necessity. And now here is that feeling again, the

## Chapter Twenty One

one that I have grown so aware of. It's creeping all over me. It begins in the pit of my stomach. Shame on behalf of my departed mother. And then the shame quickly multiplies and twists into a trio of fear, pain and betrayal.

Why? Why so soon? Why did he not cover his tracks? Who is this woman he is seeing? Who is she, really? Why is he lying? Does he think I'm stupid?

~~~

It doesn't take long before Mike and this new woman are in a full-blown relationship. Soon it is out in the open and their love affair is moving quickly. They marry in a private ceremony fifteen months after my mother's death. The bright side is now Vian and I have a stepmother; someone else to help with the cooking and cleaning.

We have more siblings too. Yes, this crazy family grows again! First there are the five of us kids. But my brothers are long gone and living on their own. Jimmy is married and now living in Alberta, Frankie has escaped to Australia and Billy has been travelling somewhere in Southeast Asia. As soon as Mom passed away Billy and Frankie were gone. Far away gone.

Mike's two daughters and son are living on their own. Our new stepmom has three girls and one son. The two youngest, a boy and girl, have come to live with us.

With all the different families coming together, there are now twelve kids in this convoluted menagerie! There are stepbrothers and sisters, half-brothers, deceased parents and divorced parents. And then there's alcohol abuse, babies up for adoption, multiple abortions, drug abuse and even prostitution. You never really know what is going on behind the doors of this so-called family. So many secrets and lies. Everything

looks very pleasant from the outside. Nice cars in the driveway. White picket fence. Just one big happy blended family.

No. More like a family that's been put in a mix-master and turned up to the highest speed.

There isn't a whole lot of parenting going on either. The old man rules by fear and intimidation and the lovely new stepmother is passive and probably just as fearful of Mike as we all are. Evelyn has her own brood to deal with, so my sister and I are pretty much raising ourselves. We do keep in touch with my Grannie but she lives in Lethbridge. Aunt Lucille just tries to keep out of my stepfather's way. She is wise to his tricks and I'm sure she would rather not stir the pot. She doesn't want us to feel any more stress than we already do. And quite honestly, I don't think anyone has a clue as to what is really going on. It's pure insanity. With all that is happening behind the scenes, I just try to focus on Vian and myself.

I continue to hide my true feelings about Mike's introduction of Evelyn to our lives and home. Our house is still full of MY parent's belongings. There is not much evidence of Evelyn's family here. It sure is strange when you think about it.

And stuff happens. Really weird stuff that I have no clue what to do with. Like the other night when the happy newlyweds were going out for dinner. As I stood in the same hallway where months before I had discovered the tousled sheets, Evelyn walked out of the master bedroom dressed in one of my mother's outfits. It totally caught me off guard. I was stunned. How dare she? How could she? How could HE? I truly wanted to understand but my heart was silently screaming.

My guess is Evelyn was caught between a rock and a hard place. I know Mike bought that particular outfit for my mom and, remembering his cheapness aided by his insensitivity, he

probably insisted his new wife wear it so as not to "waste" it. She probably didn't even know it had been my mom's.

Once again, a bucket full of shame and sadness came pouring over me. I did not respond. I just stared at my new stepmother dressed like my mother and fell eerily silent. There were no words.

Just more feelings to bury.

Chapter Twenty-Two

Western James Dean

It is a day like any other. I arrive home from school surprised to find Mike in the kitchen. He is home early, with a rather bewildered look on his face. My stepmother must still be at work.

"I need to speak to you and your sister. Go and get Vian. She's in her room." He is pacing around the kitchen, refusing to look at me.

"Is something wrong?" The butterflies have already invaded my stomach. *What the heck did we do now?*

"Just go and get your sister." He is staring out the kitchen window and he doesn't sound mad. This is all unusual and very confusing.

I fetch Vian and we sit demurely at the table. Neither of us wants trouble. And we don't even know what trouble we might have caused. My heart is racing as Mike sits at the head of the table. His voice is icy calm as he finally meets our anxious gazes.

"I got a call about your brother, Jim." His voice is surprisingly soft as he takes a deep breath and continues. "He died of a drug overdose this morning."

He looks at us as if he just told us he sold another cow. Vian and I are speechless. "I don't really know anything else," he continues flatly. "I'll let you know when I hear more."

Vian and I just stare at each other, terror flooding our faces.

"Okay, girls?" Mike is sounding impatient. Exasperated.

My little sister and I are literally stunned into silence. I don't think we are even breathing.

Chapter Twenty-Two

Mike doesn't utter another syllable. He just pushes himself away from the table, stands up and goes to the fridge. *How can he eat at a time like this?*

Vian and I sit motionless, frozen in fear as this latest emotional blow smashes into our souls. We must be in shock. Covered in yet another cloak of pain. A cloak we are far too familiar with. But here we are again, Vian and me, gut-punched with another tragic family death.

Truth is this news is not altogether surprising. We knew how much Jimmy loved his drugs and I think we also long suspected death did not scare him. Still, I'm not prepared for it. How can you *ever* prepare for news like this?

As I regain my equilibrium, I find myself surprised that Mike doesn't have something nasty or insulting to say. He never liked my brother. He knows how much grief Jimmy caused my mother. She had actually taken him out of her will, then put him back in shortly before she died. Which may well be the biggest reason my stepfather didn't like Jimmy. It meant Mike didn't get nearly as much money from my mother's estate. Trust me, he got plenty, but I guess he wanted more. It was all just a big ugly mess.

Mike is standing at the counter, stuffing meatballs into his mouth as Vian and I continue to sit silently. I have no idea what to do next. What is the protocol for death by drug overdose?

I decide that this devastating news is just another secret needing to be kept. I will tell no one. Vian will tell no one. I don't want anyone to know the humiliating truth. I hate when all eyes are on me, especially for this scandalous reason. The shame surrounding my father's suicide is like a worm burrowed deeply beneath the surface of my skin. You can't always see it but it's still living inside of me. And now, another worm takes root.

I silently plead to God. *Why? Why another assault on my family? Why another humiliating death? Why so much pain? So much heartache.*

I am only just barely coming out of the torturous fog caused by my mother's death. The cruel sting has just begun to diminish, ever so slightly. And now this? It's just not fair.

My thoughts go to Jimmy who was so much fun but definitely lived on the edge. I can still hear his voice: *I never let myself worry. Hell, I might die tomorrow. It doesn't bother me. I live only for today. We only have today.*

It was almost like he had a death wish. And now here it is. He is dead. He has subscribed to his very own predestined exit from planet earth. He was a Trekkie. Isn't that how they talk?

As the days stagger on there are many hushed phone calls between Mike and the police. We learn about the fateful day when, after announcing the local skidoo race for the radio station where he worked, Jimmy went straight home to his family. The assumed narrative is that he took cocaine for his evening's entertainment then went to bed. When my 5-year-old nephew, Shawn, couldn't wake him up in the morning, Mary checked and found him gone. Mary wasn't really sure how long he'd been dead. She called 911. The coroner's report said *asphyxiation due to a cocaine overdose.*

If there are small mercies, then I am thankful that my mom isn't here to witness Jimmy's ultimate heartbreak. It would have broken her.

The police turned Jimmy's place upside down looking for any clues leading to dealers or druggie connections. They didn't come up with much. Except for one small, empty envelope at the bottom of a waste basket, addressed to Jimmy with no return address. The post mark - Thailand.

My youngest brother Billy was travelling in Thailand at

Chapter Twenty-Two

the time. Obviously, they were in cahoots on some nefarious drugged-out level. But no charges were ever pressed. Mary knew it wasn't anyone's fault. We all knew it was Jimmy's choice, period. I very much doubt he intended this to be a lethal dose. Coming from Thailand, the cocaine was presumably purer than anything Jimmy had ever tried. How could he have known this would be his last high? The true "killer" high.

Now Mary has a 5-year-old boy to raise alone, along with a 6-month-old baby girl they have just adopted. How absolutely despairing.

Jimmy.

The wild child. Black sheep, actor, award-winning speechmaker. Dr. Jekyll and Mr. Hyde. The radio personality morning man, making you laugh on your drive to work. The ultimate escape artist, searching for other spiritual planes to which he could transport himself. Hypnosis and out of body experiences. The marijuana, hash, cocaine, hallucinogens and who knows what else. The sexual Satanic rituals and perversions, séances and orgies. My brother was always desperate to find a way to escape.

In hindsight, I guess I too found ways of escaping, maybe without even knowing it. Perhaps God protected me from my own memories. But with Jimmy's passing, certain vague dreams which had long plagued me, turned into tangible visions. Suddenly all my senses were awakened and my blurry remembrances of Jimmy and me went from black and white to living colour. I could actually feel the scratch of the poplar leaves on my skin. And I could now understand my disdain for their sweet scent.

The truth is, Jimmy sexually molested me several times before I was even in school. There was never any penetration, for which I am thankful. He was nearly six feet tall and very

strong so if he wanted to, he could have hurt me badly. Even though there was pain and fear, I was a young girl and I trusted him. He was my big brother, after all. Is it crazy that he was actually my favourite?

I was a child. A child with very little knowledge of the difference between right and wrong. Jimmy was my brother. I was special to him. How could I have known then that his "special" treatment of me was so very wrong?

I always believed that Jimmy loved me so much. Maybe he did?

But he was obviously a very sick man.

Unusual Child ♫

Chapter Twenty-Two

My brother Jimmy as a teenager.

Frankie, Billy, baby Vian, me and Jimmy. I think I'm around age 4.

Chapter Twenty-Three
Mad Crush

He is tall, blonde and 100% pure hunk! Sexy, handsome and dreamy just like a movie star. I first met him when I was underdeveloped and oh so innocent, just a kid, really. But whenever I saw him, my insides melted like an ice cream cone in July. But that was kid stuff. Now, after all these years, being in his company has me melting in a much more intense manner. My attraction to him is so strong I experience a pulse of electricity whenever he is in our home. I have absolutely no control. I feel helpless. And I'm always terrified that everyone around me can tell!

Looks like I am "boy-crazy." Or maybe just crazy? I just really love boys! I gravitate toward the athletic type. And the artistic and creative type. But I also like the quiet, sweet and sensitive type too. I love funny types and the treat-you-like-a-queen types and I've even fallen for a bad-boy type on occasion. See what I mean about crazy?

There is only one minor little hitch with this new boy. He isn't one. Nope, he is most definitely not a boy! He's a man! He is Frankie's friend and that means he's ten years older than I am. His parents were also friends of my parents so there's more than one connection here.

He and my brother hit it off the first time they met, for two big reasons - fast cars and girls. And they're always messing around with both. Every time Frankie comes home for a visit, I pray that Dreamy will drop in. When he does, everything in my life stops. He always acknowledges me. And when he gazes

Chapter Twenty-Three

at me with those baby blues, I am putty. I hang onto every word he speaks. And he does speak to me. As I've grown older, you could even call our communication a little flirtatious.

Dreamy has seen me transform from a kid to a young woman. He has always jokingly told me that when I turn 18, he's going to take me out for my birthday. And now, with the Christmas holidays upon us, my 18th birthday is only four short weeks away. Dare I be hopeful? He really doesn't mean it, does he? Only kidding, of course. Why would a 28-year-old man want to date an 18-year-old? But I can't help fantasizing.

And then … it happens.

"Have you got any plans for your big birthday?" Dreamy is looking straight into my eyes as we sit across from each other at the kitchen table. Frankie is still in the shower and no one else is around. I feel like I am the only female on this planet.

My face is on fire even though I try with all my might to act nonchalant. "Ah, no I don't actually." I try to return his gaze in a mature, matter-of-fact fashion.

His stare penetrates even deeper. "Well then, Kelita, why don't you let me take you out to dinner?"

The planet stops spinning as the kitchen begins to whirl. I am in shock! Did I hear him correctly? Take ME out? On a date? For real?

I can't believe he is serious. But he doesn't burst into laughter or get up and walk away. He just sits there, quietly, waiting for my response.

My response? I am flattered and intimidated and incredulous and yes, even a bit embarrassed.

I sputter out the truth. "Yes, that would be really nice. Thanks."

Nice? Seriously, Kelita. Try UNBELIEVABLE. Or FANTASTIC. Or MY WILDEST DREAM COME TRUE!

"Great. I'll look forward to it." He stands up as Frankie enters the room, hair dripping wet. And then, just before they take off, he winks at me.

My knees are jelly and now my head is really spinning! What should I wear? How should I do my hair? How should I act. What should I say and more importantly what should I not say? There is just so much to think about. What are we going to talk about? Is it really just going to be me and him? I'm assuming so. What if the conversation gets boring. Am I crazy for saying yes?

I so wish my mom was here so I could talk this through. It's at times like this I really, really miss her. I could use her help. Going out with guys my age hasn't really been a problem. But this? This is different. There is so much to figure out on my own. And I just don't have that kind of relationship with my stepmother. So, as usual, I just have to figure things out on my own.

January 22 rolls around and just as planned, Dreamy arrives at the front door for my big birthday date. Six o'clock right on the dot. A burst of cold Alberta winter air shoots through the house as he enters. I (on the other hand) am combusting in a hot nervous sweat!

"Hi. Come on in. I'm ready to go. I just need to grab something."

"Happy birthday, Kelita!" He grins like he's just won the lottery.

"Oh, right. Gee ... thanks." I am fumbling with my words (and thoughts), feeling more than just a bit nervous. I hope he doesn't hear it in my voice. "My dad's in the family room. Just go on in. I'll just be a minute."

I disappear to grab my purse which gives me time for one more quick look in the bathroom mirror. Do I look okay? I

Chapter Twenty-Three

know I'm 18 but right now I feel like I'm 12. And that new zit on my chin isn't helping. I'm feeling heavier after all that Christmas baking. Do I look fat? I must be out of my mind because I'm way out of my comfort zone. *Oh God, please help me not make a fool of myself.*

As I walk into the family room, trying with all my might to exude a confidence I do not feel, it hits me that Dreamy looks different. He is dressed up. Sort of. He's actually wearing a collared shirt. I've never seen him like this. Maybe it's his hair. I don't know what, but something is definitely off. He isn't quite as attractive as I remembered. That doesn't make sense, right? Here he is, trying to look nice for our date. For me! And I am disappointed.

Is he dressed up too much? Do I prefer his more everyday rugged look? T-shirt and jeans? Was it the lure of the chase I was attracted to? What the heck? I don't know. Kelita, settle down. Breathe girl. Just breathe.

Mike walks us to the door. *Please don't embarrass me. Please just act like a normal human being. Please, please don't say anything rude.*

"Okay, Dad, we'll see you later."

"Okay, Honey." Mike glares straight into the eyes of my date and commands, "Make sure you have her home by eleven now, you hear?"

"Yes, Sir. Will do."

That's it? That's *all* my cantankerous stepfather has to say about me going on a date with a man ten years older than I am? Whew! But my dad does know Dreamy so perhaps there is already a level of trust there.

The date starts out well. The restaurant he has chosen is lovely. I feel very grown up, confidently ordering my own Pina Colada. I am now officially of legal drinking age (although that

hasn't stopped my girlfriends and me before). We seem to have enough to talk about. Ranching, parties, Frankie and music. Another drink arrives. And then another. It's rye for him and these Pina Coladas are going down pretty smoothly. I'm not even sure there's any alcohol in them. Doesn't taste like it. I'm collecting a lot of cute little umbrellas.

I am really looking forward to the food because, despite my initial nerves, I am starving. I settle for the fresh bread and keep sipping. I am beginning to feel much more at ease on my big date now and I think Dreamy finds me a little entertaining. I do wonder what's going through his mind.

We finish dessert. I just love my Crème Brule. It is so fun when they set it on fire right at your table. The bill is paid. Then Dreamy helps me with my coat, gentleman that he is. We step out into the cold night (and I mean cold, like -30 degrees Celsius cold!). My date guides me across the icy parking lot and opens the door to his pickup truck. Normally, I wouldn't be wearing a dress in this freezing weather, but I really wanted to wear one tonight. My high-heeled boots are a little tricky on the ice but Dreamy takes my arm and leads me to his chariot. I like when he touches me. It feels so protective and loving. He helps me climb into the cab and then we sit for a while, waiting for the truck to warm up.

"It's too early to go home, wouldn't you agree?" He takes my hand gently in his.

"Yes, it is kinda. I guess." The feel of his warm fingers is heavenly.

"What do you say? You wanna go back to my place for a bit? The night's still young, isn't it?"

He looks so hopeful. Like a little boy, waiting for Christmas. "Sure," I reply softly. "That sounds good."

Right about now, anything sounds good to me. I am feeling

Chapter Twenty-Three

as free as a bird. I'm 18 and life is pretty exciting! I am out on a date with a man I've had a crush on since I was a kid. I don't think it can get any better than this!

The drive to his place doesn't feel long. My perception is a tad clouded from all those fancy drinks. *How many did I have?*

Dreamy lives in a basement apartment and when we arrive, he once again takes me by the arm and helps to guide me down the steep steps.

The rush of warm air is most welcome as we enter his place. "Let me take your coat," he offers. He really is quite a gentleman, that's for sure. "I'm just going to mix us a few drinks. Go on in and make yourself comfortable."

"Sure, sounds great." I am always so agreeable. Perhaps too much so? I'm starting to feel a little nervous.

As Dreamy prepares the drinks, I settle myself in his living room. This couch has seen better days. So have the rest of his furnishings and there aren't many of them. The apartment is bare and stark. Not at all what I expected from a handsome bachelor in his late 20s!

Dreamy hands me an ordinary drinking glass filled with something that looks like Coke. I take a sip. Eww! I'm not sure what it is but it sure is strong. And there's no ice. Yuck. How do people drink this stuff? I think it might be rye and coke. I set it on the old crate that doubles as a coffee table as my date nestles up beside me on the worn old couch. Part of me is swooning with crazy youthful desires. But the other part? Well, that part of me instinctively knows that whatever happens next could take me some place I may not yet be ready to go.

And then it happens. Without any hesitation at all, Dreamy leans over and kisses me. Full on the lips. *Wow!*

Although I'm intoxicated, I instantly feel a sense of unease.

The kiss is nice but I wasn't really expecting it. Or was I? Oh dear. I'm feeling very confused.

Then without another beat, his hand is on my breast! *Oh my gosh – that was quick!*

Is this how people in their 20s do it? Just one kiss and get right to it? I am so confused and I know I must be flushed with embarrassment. Or is it excitement? They could look the same, right? How am I going to respond? What should I do? Should I say something? Should I pull away? Should I moan with ecstasy and plead for more? *Somebody help!*

I have NO time to think. Dreamy sweeps me off the couch and starts carrying me. Somewhere. The bedroom?

The room is pitch black. He lays me on the bed and lands on top of me, straddling me with his strong body. His hands quickly move up my skirt and before I can even breathe, he reaches for the waistband of my pantyhose and yanks them down. WAIT! This is NOT how it's done in the movies. His hands are fierce and rough as he fumbles with my lingerie.

Fear and panic have set in but I find my voice.

"I can't do this," I beg weakly. "Please get off me."

He does not stop.

I try again with a little more force. "Get off me - please"!

"Oh, come on Kelita - you're 18 now. I know you want this." His voice is husky and his breath heavy on my face. He smells of rye and coke and garlic and he is not listening to me!

This time I bellow. "I said get off me. Get off me - NOW"!

Has he suddenly gone deaf? He keeps pawing at my pantyhose until they are down to my knees. How can this be the same man I shared dinner with a few hours ago? No, this is some kind of wild animal going after his prey. And that prey is me!

I grit my teeth and arch my back, tensing every muscle in

Chapter Twenty-Three

my body. I'm trying to remain calm and, weirdly, trying to be as polite as possible. I push gently on his chest. "If you don't get off me, I'm going to scream as loud as I can!"

I know there are people living upstairs. I just pray they're at home. I push harder against him. "I mean it. I will scream as loud as I can if you don't get off me. Right now!"

Reluctantly he takes his hands off my pantyhose and backs off. He says nothing. Not a word.

He climbs off of me and the bed. I know this animal is not pleased. His plans to initiate me into womanhood have been thwarted. It's obvious he needs to cool down. He stomps out of the bedroom, leaving me to lie there in the dark.

I am sobering up fast. I pull off my pantyhose and toss them into a corner. I smooth down my skirt as my pounding heart finally begins to slow. I am relieved but also mortified and embarrassed. All I want to do is get out of here and be back home in my cozy pink princess bedroom listening to Karen Carpenter on the radio.

I straighten my hair as I walk into the living room. Not-so-Dreamy is sulking on the sofa, drink in hand. He won't even look at me. This party is over!

Together we face the cold January night yet again. At least he understands that he *has* to drive me home. We say absolutely nothing the entire trip. Everything feels awkward and fuzzy. His eyes are forward as I stare out the frosty window, silently mulling the entire crazy evening. This date did not exactly turn out to be the romantic 18th birthday extravaganza I had envisioned in my dreams. I am sad and humiliated. My young girl's dreamy crush has truly crushed me.

Finally safe and sound in my pretty pink bed, I cry myself to sleep. Did I bring this on myself? Did I ask for it? Did I lead this man down some garden path, only to deny him that which

I had promised? Even inadvertently. Was this all my fault?

I finally doze into oblivion, praying that the light of a new day will wash away the dark thoughts consuming me.

Bring Love Home 🎵

Chapter Twenty-Four

Stardom Awaits

I truly believe I am a born entertainer. My desire to perform sprouted early and was the medicine I needed to survive. It gave me purpose and an escape from a tension-filled house of anger, strict rules, well-kept secrets and responsibilities way beyond my years. It allowed me to push all the sadness and deep longings in my heart to a hidden place. Music and performing were vital to my sanity.

Writing songs, prose and poetry, playing piano, acting in plays and musicals – I did whatever I could whenever I could! The high school choir, singing in festivals and competitions plus a tour to the UK. The church choirs. And how could I forget my summer gig playing piano and singing for food and drinks at Primo's Mexican restaurant. They were all creative opportunities that kept me moving forward.

I always knew what I wanted to do and no matter what was thrown at me, I just kept my goal in front of me. What didn't kill me just made me stronger and more determined.

After my mother passed away, I was asked to join a handpicked Christian music band at my church. It was put together by Lowell and Dorothy (McGuire) Williamson. Four guys and two female lead singers. We called ourselves the "Love & Truth Company."

Lowell and Dorothy were extremely generous and paid for our band to record an entire album. It was a first for me because I got to do two original songs. Being in the studio was a thrill and although we didn't really know what we were doing, we had a blast.

The summer I was 16, the band set out for our first and only big tour in the US. Our itinerary took us down the west coast into Washington, Portland, California, Nevada, New Mexico back up through Wyoming and home to Calgary. We were chaperoned by our youth leaders (a husband-and-wife team). The churches we sang in welcomed us warmly as we hawked our "hot off the press" album. We were billeted with different families every night and stayed in some hotels too. So many unbelievable experiences including my first time visiting an all-black church. I loved it! So many God-loving people and boy did they know how to worship!

Las Vegas was another highlight. Although I had been there as a kid (with my parents for a Charolais cattle sale), this was much different. I was far more aware of the dazzling sights and sounds.

While there I was lucky enough to meet both other McGuire Sisters and ride in a stretch limo owned by Phyllis, the youngest of the group. Although I didn't get to visit her mansion, her nephew, Rex (part of our group), did. He came back brimming with exciting tales of the moat with black swans, bullet-proof windows and electric shutters that closed instantly with just one touch of a button. It was well known that Phyllis was in a long-time relationship with Mafia leader Sam Giancana and had one of the most expensive jewellery collections in the world. I guess she had good reason to live with top notch security.

The Williamsons were huge supporters of my talents, but I had other musical mentors as well. My high school teachers awarded me leading roles in two musicals and serious dramatic parts too. But with school winding down, I had to seriously think about my next steps. For all my singing and clowning around, how was I going to become a professional entertainer?

Chapter Twenty-Four

Would it be music or acting? I wanted to do both but knew I had to somehow make the hard choice. I decided I'd go with theatre training. With the immense popularity of musicals, I knew I'd be able to sing as well.

When I was accepted into the four-year theatre performance program at York University in Toronto, I was ecstatic. Obviously, I was looking forward to learning more about my craft, but even more so, I was relieved to know I'd soon be a free girl. Finally, out from the clutches of Mike! I'd be on the other side of the country, living my own life without his strict rules, abusive behaviour and non-stop stress.

When the time came to flee the nest, I jammed my clothes and 8-track into a large trunk and said good-bye to Calgary, my boyfriend and of course, my dear sister, Vian. Leaving her behind was by far the hardest thing I had to do. She would now have to fend for herself with that wicked man. It was concerning because she was never as strong as I was. I felt such a huge responsibility for her and her well-being. We had an extremely close bond after experiencing so much together. Our mutual heartaches and losses had only drawn us closer. I loved her with everything in me and I knew I would miss her desperately. There was a part of me that felt guilty for abandoning her, but I knew I had to get out of there for my own sanity and survival.

Besides, stardom was waiting!

PART TWO
Music, Marriage & Misbehavior

Chapter Twenty-Five
Cheap Blue Blanket

The blinding Sunday sun bursts through our apartment window. That's our wake-up call. No sleeping in today. Or any day for that matter. There are no curtains or blinds, not in this bedroom. We snuggle our warm bodies close together. I wrap my nakedness around his tall, lean frame, mostly because I don't want to fall off the mattress. It's a good thing I'm petite because he is more than 6 ft tall. But at least when we get a little *rambunctious*, we don't have far to fall. This lonely single mattress is the only piece of furniture in our bleak little bedroom. There is not even a Farrah Fawcett poster or cheap velvet painting to brighten up the wall. Not a lamp. Not a chair. Nothing! But hey, that's student poverty for you.

The cheap, blue synthetic blanket is anything but cozy and soft. A Walmart special, probably. And the sheets? Well, as my mother used to say, *You could spit right through them.* You know what? These things don't matter to me. The warmth of flesh on flesh and hearts intertwined is the most amazing feeling I have ever experienced. This all feels so new. Totally foreign. I guess this is what it feels like to be safe. Being held. Feeling loved. Not having a care in the world. I don't think I ever realized how

much I need this. I have been desperate for so long to feel like I belong. Like I am cared for. It's all intoxicating. I don't ever want these feelings to end.

Sometimes in the early morning hours, just like this, he lets me talk and talk. I talk a lot about all the things that happened to me growing up. I talk about how much I miss my parents. How much it still hurts. I can get really emotional. And he just holds me and lets me cry. Sometimes I cry a lot. It's like I am in possession of a great river of heartache and the river has been held back by a giant dam. But little by little, ever so gradually, the dam is weakening and all the barricaded sadness and pain is being allowed to flow. Sometimes it's a slow and steady stream, other times it is fast moving rapids. Or beautiful gushing waterfalls. It is all powerful. He seems to understand my grief and all my suffering and it brings us closer together. The more he lets me share with him, the more I love him. The more I need him.

Even though I had a boyfriend when I left Calgary, I don't think either of us expected a long-distance relationship to work. Not really. Stephen and I had a lot in common. In our final year of high school we played opposite each other in "My Fair Lady." That was very romantic. He was a very kind person with such a gentle soul. We wrote letters for awhile and he even came to visit me once.

But this. This is different. I have never felt like this before. Not the way I feel with Hudson. I can honestly say Hudson is my first true love.

We met two years ago when I first arrived at York University. It was "Frosh" week and everything was new and a little intimidating. I was a bit nervous and yes, even a little shy (I can be in certain situations). Arriving in Toronto from Calgary was almost like landing on the moon - a huge and blinding cultural

awakening. Even though I had lived in Calgary for many years, I still felt like a farm girl. Hey, I didn't even know what a bagel was. Or yogurt. Seriously.

Hudson and a few other guys were in charge of some activities for us first-year newbies and I was excited to get involved. I knew it would be a good way to get to know some new people. And I very much needed to do that.

There was the pub crawl (which I can't actually remember much of) – a total blast (I think). There was a baseball game. Lots of other stuff too and there was always Hudson, right in the thick of things. I actually wasn't the least bit attracted to him. Other girls were, but not me. He seemed a bit arrogant and a lot cocky - two traits I really didn't care for. But then, one cold December night just before exams, some friends invited me to go dancing. I loved disco so it didn't take much persuading. Besides, it was a Thursday night and in campus life that's pretty much the beginning of the weekend.

"Kelita. Meet Hudson. Hudson, Kelita." Morrisa introduced us. "Sorry, maybe you've already met? Kelita's on 4th floor."

"Uh, no I don't think we have," Hudson replied nonchalantly.

I was a little surprised he didn't remember me. *Guess I made a really good impression.* "Well, actually we did meet." I smiled as nonchalantly as I could. It wasn't easy because he really was awfully handsome.

"Oh, we did?" He looked a little embarrassed. Not a lot. Just a little.

"It was during Frosh Week. Don't worry. I know there were a lot of new people. I was on the pub crawl."

I couldn't tell if he was just playing it cool or what. I was pretty sure he would have remembered me from that night.

"You were? Oh gee, I'm really sorry." He graced me with a gorgeous smile.

Chapter Twenty-Five

"Oh, that's okay. Not a big deal." *Of course it's a big deal!*
"Well, it's really nice to meet you – again."
We both chuckle.

Morrisa, her friend Gus, Hudson and I drank cheap beer and partied on the dance floor all night long. But for the most part it was like the other two weren't even there. There was definitely some chemistry happening between Hudson and me. It was a fun, impromptu, alcohol-fueled night and this new attraction was tantalizing.

Christmas break came and went and once again Hudson and I were drawn together to stage and promote a campus talent show. Just a little something to help fight off the winter doldrums. It was then that we really discovered each other's skills. He was doing graphic design and promotions, and I was in charge of the talent. And of course, I was in the show.

There weren't a lot of people signing up, so my friend Holly and I devised a solution. We both loved to perform so we created a duet competition to be interspersed throughout the show. The two of us portrayed all four very different acts. From country crooners singing "Delta Dawn" to Roberta Flack wannabes singing "The First Time Ever I Saw Your Face." We had a ball and the talent show had eight additional performers! It was a win/win for everybody.

Hudson and I fell into a very natural friendship. And then, once he broke up with Debbie (one of his many female friends), we fell into a romance.

My new love did seem to have A LOT of female friends. One time I actually caught him and Debbie making out at a party when he was supposed to be going out with me! I quickly forgave him. I figured it was just a minor setback.

We did have our challenges. You see, when I first arrived at York, I was determined to remain a "good girl" – true to

my Christian values and convictions, the way I was raised. But university life got hold of me fast. And, within a year of our initial meeting, Hudson got a hold of me too. I had always believed I would remain a virgin until marriage, but Hudson had been sexually active since a young teen. To say he was frustrated with our sex life (or lack thereof) was an understatement. But I just couldn't hold out. Hudson's reward finally arrived under the cheap blue blanket.

My life was suddenly a whole different ballgame. After living under the strict military rule of Mike, I really began to let loose in Toronto. I was having the time of my life. I was far away from all that had defined me. No church, no Christian friends, no church music and absolutely no one to answer to. It was heavenly! I was experiencing the allure of sex, drugs, alcohol and disco! I figured I didn't need God or Jesus anymore. I had Hudson. My tall, dark and handsome saviour. In the flesh. The longer I was with him, the more he began to fill all the empty places in my broken heart. Mentor, teacher, father, mother, brother, lover and friend. He played all those roles and I welcomed each one of them!

I was also a good support to Hudson. When I first met him, he had only one pair of jeans and no winter coat. He had been putting cardboard in the bottom of his one pair of shoes! I was generous with everything I had so made sure he had some warm clothes and new footwear for the next winter. I loved helping him in every way I could.

Hudson was forced to grow up early. He was born in Canada but when his father's never-ending philandering became too much, his English mother moved him and his two sisters to the UK. His mother was ill with TB and needed her parents' support, both practical and financial, to help her raise her three children.

Chapter Twenty-Five

By his early teens, Hudson was not only attending school but working various delivery jobs, taking charge of his mother and sisters and screwing around with the very-willing married women on his delivery route! Then, at the age of 18, with only a one-way ticket and the confidence of a prize-fighter, he left England for his home and native land. He hadn't seen his father since he was 4 and he was hoping they could begin a new relationship and make up for all the lost years. Hudson anticipated a new life in Canada, a life which would be supported by his very accomplished father. The man held not one but two medical degrees!

Alas, after only a short period of time living with his father, stepmother and toddler half-sister, Hudson was rejected by his father once again. He felt deserted and hurt. But rather than return to England, he decided to take advantage of his Canadian citizenship and obtain a student loan to attend York University.

The first and only summer I ever went back home to Calgary, Hudson and I wrote copious love letters. His letters kept me from going crazy back home in Mike's prison camp. But I was also feeling another kind of crazy. Crazy in love. I was falling madly, and Hudson was too. Apart from the letters and the occasional phone call, I was miserable. My job working for Alberta Gas Trunkline kept me busy, but my heart was empty. I started to satiate myself with food. It didn't seem to matter that the weight was piling on, I continued to stuff my face. I wrote in my journal about my longings for Hudson and soon learned how to satisfy some of my own physical longings. At least that was new and exciting. I guess I was just a late bloomer.

One of the few things I had been looking forward to in Calgary was seeing my sister Vian. But I hardly recognized her. While I was away, she had been flexing her teenage muscles

and had gotten in with the "wrong" crowd. There was some trouble with the law - driving without a license and shoplifting. And no one had bothered to tell me, so it was all news! I guess I was kind of like the parent she wanted to keep bad info from.

She was sleeping with some guy and she let him slap her around! I was mortified to learn these things. In some ways I felt responsible because I had left her. I knew there wasn't anyone who cared about her as much as I did. I was always the little mother. We had been through so much together and I always did what I could to protect her. But I also knew I couldn't save her. She was on her own path and would have to navigate it for herself. The truth was, I couldn't wait to get back to Toronto and Hudson. I loved Vian but I guess I loved Hudson just a little bit more. I knew my future was no longer in Alberta and I was desperately longing to be back under that cheap blue blanket with my guy.

So now ... here we are. Just Hudson and me. Together. Two lost souls clinging to one tiny life preserver under a scratchy old blanket covering a dumpy little mattress on a cold parquet floor. Romance at its finest.

"Do you want to get married?" Hudson pops the question from out of nowhere.

"Really?" I am totally taken a back and sit bolt upright, knocking the blanket to the floor.

"Yah, what do you think? Should we?" He is gazing at me intently as he retrieves the blanket and wraps it around my shoulders.

I have absolutely no idea how to respond. "Do you really think we should?"

He laughs and tousles my hair playfully. "Sure, why not."

I giggle too and, without missing a beat, reply confidently. "Well, okay."

Chapter Twenty-Five

"Really?" He is grinning from ear to ear.

"Yes, let's do it." I dive into his arms, wrapping the blanket around both of us. "Let's get married!"

I am elated. More than a little shocked but bubbling over with excitement, I lay my shivering body down on top of his. He pulls the blanket over us and we kiss and embrace this very special moment.

"I love you so much," I whisper as tears well up in my eyes.

"Me too." He kisses my forehead.

"This feels so surreal. I can't believe this is happening." I reach for a tissue.

"Let's go and tell Ken and Brenda. Shall we?"

"Okay, yes! Let's!"

I grab Hudson's tattered, navy terrycloth robe and throw it on. I'm swimming in it but I don't care. It belongs to my fiancé. My FIANCÉ! He pulls on his underwear and we rush down the hall to tell his roommate and girlfriend our great news. They're super excited for us and, as much as we'd love a champagne toast, we decide that beer will have to do.

"I think once you tell someone, it's official. Right?" I'm grinning as I walk to the kitchen fridge. My heart is overflowing!

"Sounds about right to me." Hudson grins back at me as he pops the cap off the beer bottle.

"Well, I guess that's it then. We are now - ENGAGED!" The four of us clink our bottles in an enthusiastic "cheers!"

Wanted. Accepted. Desired. My heart is bursting with pure joy and love. At least I'm pretty sure it's love. I realize I haven't ever heard Hudson say the words "I love you." But he must, right? He wants to marry me!

Excitement is pulsing through my veins. But this time it's feel-good excitement. Hudson and I have so much in common.

Truth is we're both kind of messed up. We both have closets full of skeletons. On some levels we are very much alone.

But now we have each other and soon it will be official. I have a feeling we'll be continuing to cling to each other under that cheap blue blanket for a very long time.

Chapter Twenty-Six

Drug Daze

Hudson and I are big on celebrating. Truthfully, it's just another excuse for a party and hey, who doesn't like a birthday party for some good clean fun! The birthday boy doesn't get to party quite as much anymore, not since dropping out of university. Managing a 24-hour Fullers restaurant is pretty much all-consuming. I know he misses university life but most definitely not the classes. Economics just really wasn't his thing.

It doesn't take much convincing for our friends Ken and Brenda to join in on this weeknight celebration. It's second term for the three of us and we're needing a good pick-me-up. Final exams are soon. Then I will be done! I can't believe it. It's rather daunting when I stop to think about it but very exciting at the same time. I can't wait to see what my future brings.

Smoking weed is always part of our celebrations. It's just everyday life. Whether hanging out with friends, watching a hockey game or having a party, the weed is there! Some people have their liquor cabinet, we have our "dope duck." A bag of weed and our stash of hash are all kept in the small decorative wicker basket shaped like a duck. It was a wedding present and is quite possibly the most utilized gift we received. Of course, I wouldn't tell that to the people who gave us the crock pot. I like their pot, honest. It's just the wrong kind of pot!

Hudson grabs four beers from the fridge as we pass the first joint around. My husband is an excellent roller, unlike me. I am useless so don't even try. Then, from out of nowhere

(just like a magician) - POOF! He produces a small piece of mirror, a sharp new razor blade and a crisp 100-dollar bill.

"Hey guys, I just happened to pick up a little birthday present to myself. Would any of you like to share it with me?" His eyes are twinkling, fully mischievous.

"Cocaine? Do you have coke?" I am surprisingly excited.

"Yes, I most certainly do," he smiles, retrieving the small paper packet from his shirt pocket.

"Where did you manage to score that?" Ken is elated.

"Oh, I have my connections." Hudson loves to be important.

He methodically lays out all the paraphernalia on the wooden coffee table. Everything in our apartment is old, including the pink couch. It's a convertible sofa bed fondly known as Pink Floyd, rescued off the street one night before garbage day. Many a couple has made its acquaintance. It even made it into our wedding photos!

I can feel the excitement building as Hudson carefully pours the white powder onto the mirror. Then he grips the tiny razor blade and, with surgeon-like precision, divides the small pile of cocaine into narrow rows. He rolls up the 100-dollar bill and places it just inside one nostril while closing off the other. We each lean over the table and take our turn. *Whoa. Instant buzz.* This tastes like a science experiment. Guess that's why they call it a chemical.

Suddenly I am feeling pretty high. I've always been overly sensitive to any kind of drug or stimulant. Even one tablespoon of cough medicine can send me over the top. It's a horrible feeling. But this? Well, I must say I am feeling pretty darned amazing. And with the cold beer chaser I feel even better.

It's such a blast to party with good friends. Hudson deserves some fun too. That restaurant practically owns him. He works crazy-long hours which means I spend too much time alone. In

Chapter Twenty-Six

fact, every time he calls and says he's coming home it's always at least two hours later when he finally arrives. Sometimes more! And his staff? Some of the waitresses are just a bit too friendly with him. I'm sure he doesn't mind at all. But I do!

"Anybody hungry? Feeling like a nice juicy steak?" Hudson stands up, a massive grin on his face.

"I think we're ready." Ken and Brenda stand too, excited for the next part of our evening.

"I'm not really all that hungry," I purr contentedly. "But sure, whatever. We can go now if you'd like. You're the birthday boy." I am always pretty agreeable and right now I need someone else to make the decisions.

As cold as it is outside, I don't think we're feeling any pain as we climb into the car. The steakhouse isn't far, no doubt a very good thing considering our current condition. I am buzzing like a chainsaw. I'm also starting to feel paranoid. Pot can do that to me, especially if we're going out somewhere. Dining out high is something I've done many times, but the added buzz of the coke is taking its toll. I am pretty out of it.

The cute blonde hostess greets us merrily and soon the four of us are cozy in a corner booth. I look around the empty restaurant. "It's sure not very busy, is it?"

"It's midweek, that's why," the bubbly hostess responds, handing us menus.

Oh dear, did I just say that out loud? I thought I was talking to myself.

We're all laughing and celebrating Hudson's birthday. This is so much fun. Feels so great just to be out. It's pressure-time at school. This kind of night just lets you leave it all behind. We give our waitress our drink and food orders and keep on laughing.

Wow. She's back already? That was fast.

We girls are enjoying fancy drinks tonight and the guys – more beer. We'll have some wine with dinner, just like proper adults. She's brought us some warm bread and butter too. Yum. The guys dive in like they haven't eaten all day. More laughing and talking. Our table is literally abuzz with energy and celebration. There's a tantalizing aroma of grilled steak permeating the restaurant. I am finally feeling hungry now, especially smelling that pungent garlic.

"Everybody stay still! Nobody move! Nobody's going to get hurt. Just stay still!"

We all freeze. *Oh my God! There are two men in balaclavas! And they have guns! What the hell? For real?*

An immediate hush comes over the restaurant. We're too far away to hear what the robbers are mumbling to the woman overseeing the cash register. The two of them are standing very close to her. It looks like she is emptying the contents of the till. The four of us sit motionless, like zombies. Nobody breathes. I swear I can feel everyone's pulse. I feel like I'm going to have a heart attack.

Is this some sort of sick joke? Is this for real or have we entered the Twilight Zone?

Maybe all the drugs and booze are sending me over the edge? If I could, I would pinch myself. But I can't. I cannot move one inch. Those guys with guns said, "Nobody move!"

Quickly and quietly the thieves empty the till and dash out the front door. I am speechless. Numb. And wrecked! My adrenalin is surging and I just want to get the hell out of here. The last thing I want to do now is eat! We are all rattled to the core. But thank God we're safe!

Within a few short minutes the police arrive on the scene. Two cops. They waste no time. "Listen up, everyone. We want you to stay where you are. We'll be coming around

Chapter Twenty-Six

to each table to take a report on the events you were all witness to."

Okay Kelita, sober up. You have got to sober up! You need to talk straight and tell them what you remember. Don't slur your words. Try not to draw attention to yourself.

The police come over to our group and we're directed to split up and move to vacant tables. I am nervous and extremely paranoid. Yep ... this is Kelita on drugs. *What if I'm not able to clearly communicate what I saw? What if I'm a bumbling idiot? Will they know I am ripped on cocaine? Will they search us and find we have pot on us? Will they come back and search our apartment?*

This is a huge mess and I am making myself sick with fear.

I survive the questioning and now I just want to get out of here. The food comes but I can't eat. The mood in the restaurant is very tense. The laughter and fun have been sucked right out of us. Some birthday party this has turned out to be! We finally drive back to the apartment and bid Ken and Brenda good night. Hudson begins to get ready for his all-night shift.

"I wish you didn't have to go to work." I curl up in a ball on the pink sofa. I am feeling very fragile and still a little scared.

"I know. Wish I could stay here with you. But I can't." "I'm still not myself, Hudson. I don't know if I can sleep. And I'm still really high."

He gives me a quick hug. "Oh, you'll be fine after a while. Everything will wear off. Don't worry. You'll be able to sleep." We kiss good-bye and my husband is out the door.

I lie down on Pink Floyd. I'm not feeling very well so I grab the knitted blanket that was a wedding gift from Grannie. I am hoping it will bring me some comfort as I throw it over my shivering body. I'll just stay here for a bit and watch something on TV. Maybe that will take my mind off things and I can fall asleep. I just want this high to be over.

It hits me like a bolt out of the blue. *Oh no, I think I'm going to be sick!*

I race into the bathroom and lift the lid with barely enough time to puke hard into the toilet. My beleaguered body wretches and then I break into a cold sweat. The shakes sweep over me. *Oh geez - now I'm losing all control. Of everything!* I jump onto the toilet. Then back down onto the floor. More puking. *Oh my God, this is so gross! Both ends?* My head is swirling. *There can't possibly be anything left in me!*

Up, then down. Down, then up. Damn, I didn't even eat any dinner. How can this be happening? The dry heaves take over, leaving me depleted and completely spent. Finally, the torture abates. I am still shaking but curl up around the toilet on the cold tile floor. I can't move.

I hate this feeling. I'm still so out of it. I just want it to be over! This is worse than anything I've ever experienced in my life. This makes food poisoning seem like a vacation. Seriously. I don't want to feel like this anymore. I don't want to be high. I'm starting to feel really frightened. I said I would never do the hard drugs, especially after Jimmy's overdose. I promised myself that. Now here I am. So messed up. *Is this what an overdose feels like? What is happening to my body? Should I call someone? Should I be taken to the hospital? Am I going to die here? Alone?*

I am so cold. This floor is freezing. After what feels like hours, I finally feel strong enough to pull myself up. I stagger to the bedroom and drop my aching body onto the bed. I am burning up, tossing and turning. I can't get comfortable no matter what I try. I finally curl up in a fetal position but have to keep rocking back and forth or I feel even worse. I rock myself like a baby until the calming rhythm finally gives me just a little bit of relief.

Oh, sleep. I just want to go to sleep. Please, please, make all of this stop and never come back. I just want it all to be over.

Chapter Twenty-Seven

Trouble in Paradise

We slowly inch our way out of the packed movie theatre parking lot. People are scattered everywhere. There is a small group crossing the street in front of us. Hudson is annoyed. "You think they could move any slower?" he growls, leaning on the horn. As soon as we pass them – BAM! – one of the pedestrians slams the trunk of our car. Without missing a beat, Hudson squeals into reverse and, burning rubber, brings the car to a screeching halt. He jumps out, struts straight over to the culprit he spotted in the rear-view mirror and sucker punches him square in the face. My husband is right-handed but it's his left hand that sports his large, chunky wedding band. And that's the hand that connects with the poor guy's face. He drops like a bowling pin.

Hudson leans over his victim, leering up at the others. They don't back off nor do they approach. Everything is happening really fast. I jump out of the car (not really sure why) but Hudson yells, "Get back in the car. Now!" In a flash he is in the driver's seat, and we speed off.

I feel sick. Adrenaline shoots through my body in waves of terror. I'm scared these guys are going to follow us and force us off the road. It wouldn't be the first time. What if they tail us and find out where we live? My mind spins into worst-case-scenario overdrive. I've witnessed my husband's outbursts too many times to count. At this moment I'd rather be anywhere than sitting in the passenger seat.

"The cops are going to be at our place by the time we get home." Hudson sounds convinced.

"How do you know that?" Now I am really worried.

"I just know. Those guys are going to take our license plate number and call the cops. They're going to be there soon."

I start to tremble. "Then what?"

"They'll take a report and maybe the guy will press charges, I don't know." His mood is not pleasant. He is short with me, spewing out his words like bullets.

I keep glancing in the rear-view mirror to see if anyone is following us. Or for flashing lights. I'm listening for a wailing siren. I keep checking the entire way home. I'm on fire with tingling nerves. Still in shock. This whole episode totally disgusts me. Hudson is silent and I certainly have nothing to say. I'm protecting myself. I don't want him to explode at me. Best just to shut up.

Why can't he just be like a normal person? I hate his anger. There's always some kind of crisis. He can never just leave well enough alone. Always has to be making some kind of a scene. I hate it.

Hudson is right. No sooner do we arrive home than a police cruiser pulls up in front of our house. That old familiar feeling of shame quickly greets me.

Two tall officers walk up to our door. Hudson answers and invites them in. I stay quietly in the kitchen, but I can hear everything. They ask Hudson a lot of questions and fill out the report. Hudson knows he's guilty and doesn't attempt to hide the fact. They tell him they'll be in touch.

Early the next day we receive word that my husband did in fact break the guy's nose! He is surprisingly remorseful and feels lucky nobody is pressing charges. Lucky is an understatement.

The rage that lives within Hudson isn't just confined to our marriage and home anymore, as evidenced by this most recent flareup. I thank God I've never been at the receiving end of

Chapter Twenty-Seven

that fist. More and more often I am seeing Hudson's anger explode without warning and leave destruction in its wake. I guess I've always seen it. The problem is I just don't know what to do with it. When we were first together, there were signs that things weren't always perfect, but I was so crazy about him, I refused to acknowledge the red flags. I just didn't want to see it. I thought I had truly found someone who could love and protect me. Just accept me for me. We were so in love, and I thought he was so right for me.

But Hudson has always been jealous. Of me and other men or women. Even of my goals and aspirations. He's jealous of my own sister. When we were visiting Vian, he couldn't believe we would change in front of each other. Sisters, simply seeing each other naked. It's just normal, right? When I would visit her, we'd sometimes sleep in the same bed. I mean, really - we're sisters. But Hudson would go crazy and lecture me for hours. Then I'd start to wonder if there really was something wrong with me. Lately I seem to be doubting myself more.

I've experienced the full gamut of Hudson's crazed fury in the form of mental, emotional and verbal abuse. His own insecurities constantly place me in the direct line of fire. I spend many late nights enduring seminars, brow-beatings, put-downs, accusations and threats. After which comes my river of tears and feelings of unworthiness and shame. And the swollen eyes. I have hidden a profusion of open and bleeding wounds inside my soul. No one will ever see those. People think we're a match made in heaven. They have no idea what my life is like behind closed doors.

When Hudson drinks too much it's even worse. At times his anger is self-directed and that can be frightening. Once, after having too many Scotches at a party, his behavior went completely off the rails once we arrived home. He plunked

himself down on the living room floor and leaned against the wall. "You don't love me," he moaned woefully. "I know you're going to leave me. You're going to fucking leave me. Why wouldn't you? Who could love this fuck-up?"

I join him on the floor. "Hudson, don't be silly. Of course I love you. And I'm not going anywhere." I tentatively touch his knee.

"I've always known you were going to leave me." He refuses to look at me or take my hand.

"Hudson, I'm not leaving you." I wrap my arm around his shoulder and try my best to comfort him. "I'm right here."

"How can anyone love *this*?" He slumps over, hangs his head and mumbles, "You don't deserve this. I should just kill myself and get it over with. I'm only going to live until I'm 27. I've always known it. I'm just a piece of shit. And I hate this fucking piece of fucking shit."

I lean into him and half whisper, "Hudson, don't say those things. Please don't. You're just talking nonsense. I love you. And I'm not going anywhere. I'm right here."

"I'm just going to kill myself," he repeats, slumping even further to the floor.

Now I am really begging. "Please don't say such crazy things. You're just having a bad night. I love you and you know that. You know how much I love you, Hudson." I take his face in my hands. "Look at me. Look right at me. I love you so much. Now let's just go to bed, okay? I know you'll feel way better in the morning."

He does not budge. His torment seems indelibly etched. But eventually, after much cajoling and affection, I manage to get him into bed.

I feel helpless. It's debilitating to witness this much self-hatred. I am trying very hard to do everything I can to show

him just how much I love him. To show him he is worthy. To show him he can count on me.

It just never seems to be enough.

Chapter Twenty-Eight
Music Biz

Hudson constantly encouraged me to drop out of York U and start my career in the theatre world. I was probably ready, but I really wanted to complete my four years and in hindsight, I'm happy I did. One of my leading roles earned a large print photo in Canada's biggest newspaper, the Toronto Star. That was pretty exciting. I also wrote and starred in "Traces," my one-woman musical cabaret. It featured several of my childhood characters, and it's where my fun-loving, original burnt-out honkytonk queen, Dixie Lee, was born. I took a lot of chances and wasn't afraid to put myself out there.

Meanwhile, on the songwriting front, I had started to record demos with just me and the piano, on a massive (borrowed) reel-to-reel tape recorder. I also travelled by bus, subway and streetcar to a tiny 8-track studio called Comfort Sound, downtown on Queen Street.

And what an exciting day it was when, fresh out of university, I landed my first professional job as an actress. Four months in the small lakeside resort town of Port Dover with TWO leading roles. I felt completely at home on that stage and couldn't wait to do more.

Being away from Hudson had its issues. I did miss him (perhaps not as much as I should have) but what I did not miss was his constant hovering and watchful eye. I loved the sense of freedom, being on my own and hanging out with the other actors. I even had a crush on one of the band members. I knew it was wrong and I felt guilty, but it was hard to turn down

Chapter Twenty-Eight

the attention. Nothing serious ever happened between us but neither of us could deny the attraction. It was a wonderful four months.

After my stint with Summer Stock theatre, I had a big decision to make. Should I take a position in the comedic cast of the Second City Improvisational group or a 4-month contract to perform in a six person show at Toronto's "Imperial Room" at the Royal York Hotel. I was torn. I excelled at the Second City workshops and was flattered to be asked to join their cast. After all, that's where so many successful funny folks got their start. John Candy, Gilda Radner, Catherine O'Hara and Martin Short, to name a few. I adored comedy improv, but my heart was longing to sing. The Imperial Room was the most prestigious show room in the country. Big stars like Tony Bennett, Ella Fitzgerald, Tina Turner, Joan Rivers and even Duke Ellington had graced the stage.

In the end, I chose the musical route. The original show (called "We Got Love") wasn't exactly a hit but it paid well, and I got four months of steady work in a beautiful venue. Plus, I got to perform for Princess Margaret of the Royal Family.

My next gig, in "Godspell", led to another crush with another cast member. Again, nothing serious developed but I was really starting to question myself. Why was I attracted to other men when I was married? I knew being in a close-knit cast didn't help; it was difficult on anybody's partner who didn't understand the camaraderie we shared. Naturally this caused more jealousies for Hudson. And with that jealousy came many more hours of verbal assault. No wonder I was looking for positive attention from the opposite sex!

But life went on and, after a few years in the business I began to experience the very real frustration of the actor's

life. Always, always scrounging for the next gig. Rejection, dejection, the odd break, rinse and repeat.

This is when I started to seriously think about music again. Maybe singing and songwriting was the route for me to go? I called up the musical director of "Godspell" and asked him to produce my first single. We recorded two original songs at Master's Workshop.

Thus began a new and most welcome role for Hudson - my manager. He leapt at the chance to promote me as a recording artist. Didn't matter that we had no clue what we were doing. We worked hard and just kept learning! Imagine our excitement as we mailed my newly-pressed single to radio stations across the country! Even more so when we got a little bit of airplay. However, we did not set the music world on fire.

I needed to find a direction. I had always been inspired by female singer/songwriters like Carole King and Carly Simon. But the 70s were over and that genre wasn't exactly popular anymore. I had won a talent show at a pub singing "Help Me Make It Through the Night" and it seemed people liked me doing country. Not really my dream but hey, when you're desperate for stardom, you do what you need to do. Quite honestly, country music seemed the closest thing to singer/songwriter at the time and when I discovered Johnny Cash's daughter, Rosanne, I knew I was on to something! And Juice Newton. Those two women were crossing over from country to pop and racing up both sets of charts. I was super inspired!

The next step was to record an album and shop it. After being turned down by every major label in Toronto and Nashville, I was finally signed by Boot Records, a small independent company owned by Stompin' Tom Connors.

The album was financed by inheritance from my dear late parents. Yes, we personally floated the whole shebang because

Chapter Twenty-Eight

that's how it worked with the smaller labels. My producer, Grammy songwriter Glenn Sutton (once married to Lynn Anderson of "Rose Garden" fame) and a famous group of musicians (who had played for Patsy Cline, Elvis Presley, Dolly Parton and Bob Dylan) were flown up from Nashville to record several Canadian artists over a week's time. My self-titled album was done on a shoestring budget - live off the floor, no second chances, ten hours to be exact!

I was a nervous wreck upon completion and immediately lost five lbs. Would this thing fly? I didn't like some of my vocal performances. What the hell did we just do with all that money? And I hated the album artwork; looked like it was designed by someone who was colour blind. (Speaking of blind, my favourite song on the album is an original called "My Only." It featured just me accompanied by the legendary blind piano player, Hargus 'Pig' Robbins. That song was the closest I got to Carole King and I *knew* I so needed to do more songs just like that. One day.)

Once we released the record, Hudson and I embarked on a cross Canada tour. We drove thousands of miles in our white t-roof Camaro coupe with our two dogs in tow. We slept in our car on the roadside many a night and tapped our supply of bennies to ward off sleep when we needed to get to our next destination. Thank God for MacDonald's bathroom blow dryers, coffee and Visine.

We introduced ourselves to all the radio stations and retail outlets that would agree to see us. I'll never forget the first time I heard myself on the radio. As we drove away from the station, the announcer said, "And here's a new artist who actually stopped by the station today to promote her brand-new single. This is Kelita Haverland with "Where Is Love." *Thank you, Taber, Alberta!*

Hudson even got me onto a few local television shows. All I can say is thank God our hard work and investment paid off! The album garnered three Top 10 country hits and crossover airplay all over Canada. It landed me a guest spot on the popular Tommy Hunter Show and on a CBC TV Variety Special hosted by Ian Tyson. I had fun hanging out backstage with one of the guests, a young comic upstart named Jim Carrey.

That album won me country music's "Rising Star of the Year" award. To attend the ceremony, we drove from Toronto to Regina (2,700 kms) with the dogs *and* a childhood friend of Hudson's from England (who sure got a quick tour of Canada). When I accepted my award, I was so exhausted I exclaimed, "I get so nervous when I'm exciting!"

Hudson and I both felt proud of our accomplishments. We were off to a very good start. I had embraced my new role and we were transforming me into a country music artist. I studied what the other female singers were doing and started adding my own flair. I was rhinestone-studding my denim jackets and jeans, sporting short shorts and skirts and 80's hairdos. I added a few feather boas too.

Hudson had put on his marketing hat and was finding his way around the business as my manager. Momentum was starting to build. There was a buzz happening. Then came more award nominations including Canada's equivalent of the Grammy, the Juno. I was up against the famous snowbird herself, Anne Murray. We knew we didn't have a hope in hell but still, it was an honour to be in her company. The Globe and Mail's TV Guide printed my promo headshot with the header, "A Star to Eclipse Murray." People were starting to talk.

There was absolutely no support from the record company. There was no stylist or marketing team. There was no budget! But the good news is we had full creative control. Hudson and

Chapter Twenty-Eight

I were determined, innovative and we worked hard. We made sacrifices too. We spent our money on flashy cowboy boots and slick promotional materials instead of household furniture and motel rooms.

We did our homework and studied the business and Billboard charts. We got to know "who was who" and we got good at pressing the flesh at industry events and parties. We listened to and learned about every country music artist on the airwaves. If there was even a fragment of worthy (or unworthy) news involving my career, we ran with it. We used every single opportunity to send press releases to radio and record companies. We started making regular trips down to Nashville. We kept knocking on doors at all the record companies and publishing houses.

We were on a mission. We were going to make me a star.

Chapter Twenty-Nine

Too Hot To Handle

Pink hair.

I now have a shock of pink hair just screaming, "I'm not your typical country girl!"

No kidding. Heck, Reba is still wearing jeans held up by shiny rodeo belt buckles and Dolly Parton hasn't even dreamed up Dollywood yet. And Shania? Well, Shania is still Eilleen!

But I have hot pink hair and I love it!

Even though I am now all about Nashville, people are always telling me I should go to Vegas. They think that's where I belong because I put the "show" in showbiz. What the heck are they going to say when they see my pink hair? I want to be an artist who is taken seriously for my original music and singing. But at the same time, I do love exploring and taking chances. Isn't that how great artists are born? By being courageous and daring?

Hudson and I are still working toward that illusive dream of a major US recording contract. Unfortunately, there are very few 'signed' Canadian country artists. And there are twice as many males as there are females being signed or getting airplay. These are the days when radio programmers say, "No two bumps in a row!" Which translates to *You can never play two female artists back-to-back.* It's very much a man's world. On both sides of the border. (I'll let you figure out what "bumps" stands for!)

RCA Canada is pretty much the only label that actually signs Canadian country artists. Carroll Baker, Dick Damron

Chapter Twenty-Nine

and Family Brown. That's it. Anne Murray is with Capitol, but she is an international superstar and in a league all her own.

Still, we keep doing what we can with our limited resources. We continue making trips to Nashville. It's only a 12-hour drive from Toronto when we do it straight through. That's not so bad. We stop only for the essentials.

Or strip searches.

Thank goodness that only happened once and all I can say is this: when they asked me to pull down my jeans and panties and bend over, I gave them a damn good show! Good thing I'm flexible!

The main purpose of this particular trip to Nashville is to record a new song. "Too Hot to Handle" was co-written with my band member Cyril Rawson. We think it's a pretty catchy tune and I am elated when Cyril tells me his publisher, Mary Bailey, is willing to record the new song in Nashville, at her expense! I am in between albums and have just won the Rising Star award so I need to get something out to radio. This is win/win!

Mary Bailey, a Canadian recording artist in her own right, has a young 19-year-old female wanna-be rock star staying with her in Nashville. Somebody named Eilleen Twain from Timmins, Ontario. When Mary greets us at the studio, she immediately asks, "Kelita, would you mind if Eilleen was to sing background vocals on "Too Hot to Handle"? She's dying to sing something while she's down here. I think you'll find her voice very powerful and it will blend well with yours."

"Why not?" After all, Mary is footing the bill for this recording. How can I say no?

Eilleen and I go into the booth together and cut the background vocals. We have lots of fun and that's that. Little do I know that a few years down the road she will become Shania!

Hudson and I continue scheming as we make the drive back to Toronto. The pink thing is fast becoming my signature. Now all things "Kelita" are pink! Pink spandex, pink earrings, pink high heels, sweaters, ribbons and gloves. Hudson is running with the pink theme full speed ahead. He's designing Kelita buttons, t-shirts, posters and promotional materials. We coordinate everything with the release of the new single which will come out on our friend Gilles Godard's Bookshop Record label.

Soon enough the record is at radio and everybody is falling in love with the energetic, upbeat song. It starts climbing the charts and takes me to new heights. At one popular radio station, "Too Hot to Handle" becomes the theme song whenever Edmonton Oiler hockey star Wayne Gretzky scores a goal.

With all the attention, my popularity attracts an independent financial backer. Finally, I have the funds to complete my second country album! Add to that Ron Solleveld, my supportive music publishing executive friend at BMG, who helps us ink a nation-wide Canadian distribution deal with a partner publishing deal with RCA Records Canada. I'm on my way now!

The Pink Lady marketing plan is working! The album "Too Hot to Handle" garners numerous award nominations including two more JUNOs. My favourite is the one for Entertainer of the Year, the highest accolade given out by the Canadian Country Music Association. Hudson and I can feel the momentum building and are so happy our dedication and hard work are starting to pay off.

Besides all things pink, the other big change is I have now dropped my last name. I simply go by Kelita. Like Cher and Madonna. My stepfather Mike has been enjoying his

Chapter Twenty-Nine

own personal Haverland spotlight on the 'that's my daughter' bandwagon. I'm actually happy to remove his credit. He's still a self-centred ogre and I still fear him.

Sadly, my song writing isn't too revealing or personal. "Too Hot to Handle" is playful, fun and a little sexy. I am still finding ways to hide behind my music and now I can hide behind my new pink lady persona as well. I can't expose any of my true emotions so I mostly write about other people or I make things up. Quite honestly, I live in fear of being found out.

My marriage to Hudson is increasingly unstable and with my newfound success he's grown even more overbearing, controlling and insecure. For years he has accused me of being unfaithful and I can honestly say I have been a "good" wife. But now, as I desperately long yet again for true love and affection, I am beginning to look elsewhere. Even if it is sometimes through a haze of Grand Marnier and marijuana.

Perhaps "Too Hot to Handle" is closer to reflecting real life than I can admit? The little farm girl has grown up and I've finally become a woman. There are many desires not being fulfilled within my unhealthy marriage. My heart and soul feel beaten and my spirit shattered. The more abuse I take the more I withdraw into my own little world. It's virtually impossible to be intimate with the person who constantly hurts me. And so, as my love for Hudson dissipates, it becomes so much easier to give myself sexually to someone else. What I am longing for in return is simple – gentleness, kindness and acceptance.

It would appear my attraction is to older men. Some much older. That little girl in me may have become a woman but she is still searching desperately for unconditional love.

The kind she remembers from her daddy.

Here I am with Shania Twain - recording "Too Hot to Handle" BGs at Chelsea Studio in Nashville.

One of my promo shots for The Pink Lady era.

Chapter Thirty

The Naked Truth

We are visiting friends in Florida. After the past few months of non-stop enterprise, Hudson and I are both desperate for some R and R. Truth be told, I'm also hoping some time in the hot southern sunshine might heat up our marriage as well. When it comes to my husband, I've been feeling decidedly cool.

The pool is refreshing as I take my first dip, popping up for air with a huge smile on my face. Suddenly Hudson is behind me and in one fell swoop, like Houdini, he pulls the string of my bikini top, whips it over my head and tosses it out into the water.

"What are you doing?" I gasp, horrified, as I cover my breasts with my hands.

He is not listening. He dives behind me and yanks down my bikini bottoms. It all happens so quickly I don't even have time to respond. He swims under my legs, spreading them with his strong hands. His head comes up hard at my crotch and then up I come, as he hoists me up above the water on his shoulders. I am frantically trying to balance myself as I hold onto his head. He grabs onto my legs, HARD, making sure he has total control.

"You want to show yourself off to people?" he bellows menacingly, as our friends stare in disbelief. "Well.... HERE!! HERE YOU GO!!"

I laugh awkwardly, trying to save face in front of the others. But no one else is laughing. Hudson is screaming. "Now everyone can see you. Everyone can see your naked body!"

I am completely dumbfounded, turning twenty shades of red. Trembling and embarrassed. How could he do this in front of our friends?

The silence is awkward and humiliating until finally, he lets me down into the water. I feel so much anger towards him. Even hatred. I literally want to die.

And yet, what do I do? NOTHING! Absolutely nothing. I pass this off as normal, everyday pool fun. I pretend that Hudson is just a regular husband getting boisterous with his wife. Yes, that's me. Always acting so that other people are spared the unthinkable truth. I suck it all into my soul, knowing well I will be tortured by it later.

It seems that the longer Hudson and I are together, the more violent he becomes. And the more obsessed with this 'starlet' he is creating. He eats, sleeps and breathes the music business. He is always working on my career, which also happens to be his career. The business has literally consumed both of us. In fact, we're really more married to country music than we are to each other.

Sometimes I hate it. All of it! I know it's cliché, but I feel like a piece of meat. The merchandise. The product. Hudson is always selling ME. It's agonizing when he gets up on his soap box promoting me to our peers, business associates and even our own friends. And he does it right in front of me like I'm some object.

I also have come to realize that my husband completely turns people off with his know-it-all attitude. I carry around a heavy load of mortification as a result of his arrogance. He's become the kind of guy people go out of their way to avoid. Consequently, he burns more bridges than he creates. He seems to derive pleasure from demeaning people, including me. Yes, his wife and his bread and butter! There are times when I

Chapter Thirty

honestly feel like he treats our two dogs with more decency and respect.

Hudson finds pleasure in seeing me cry. There is a sick part of him that loves pushing all my buttons. Many times, right before I go on stage, he will say something hurtful and demeaning. His goal is to make me feel inadequate. To feel like a failure. Like I will never live up to his expectations. He loves calling me stupid. And then I have to go out on stage and perform, pretending everything is wonderful. One minute he's holding me up on a pedestal, primarily as *his* prized possession, the next he's taking a strip off me. Thank God I'm a good actress when I hit that stage.

These mixed signals are really playing a number on my head. In one breath he's screaming at me for not wearing a bra and in the next he's directing a publicity photo shoot where he wants me to do just that. It's crazy making.

Every time I muster up the courage to stand up for myself, I get shot back down. My stepdad was also a tyrant, and I was never given the chance to speak my opinions. No arguing or even healthy debate. There was only one way. HIS! Now here I am with Hudson and it's all too familiar.

This is not the way it's supposed to be.

The other thing is … Hudson loves women. All women really, but especially beautiful and busty. It never seems to matter that I'm around. Weird, because even though I am the woman in the spotlight, I become the shrinking violet when he sets his sights on someone new. In the early part of our relationship, I competed with pornography (and for all I know this competition may be ongoing). But his obsession has now moved on to women in the flesh.

My family, what remains of it, isn't much help. They're all 2,200 miles away. There isn't any real relationship with my

stepparents and my sister Vian isn't emotionally available as she navigates her own survival within her abusive marriage. My two older brothers, Frankie and Billy? When Mom died, they both ran as far away as they could get. One to Australia and the other to Singapore.

Hudson and I are like a lonely island. There is so much co-dependency and he uses this to his advantage, perhaps unknowingly, but just the same. I feel isolated. And his snowballing jealousy prevents any meaningful friendship. My friends have to be his friends too.

My heart breaks from all the horrible things he says and the despicable way he treats me and yet I count on him for so much. And THAT scares me. It's warped. Everything we have is totally intertwined, to the point of strangulation.

I'm starting to really dislike who I have become when I'm with him. My inability to affirm my own personhood causes me to climb further back into my shell. I really can't be myself anymore. I haven't been myself for a long time. In fact, I'm beginning to feel like I don't even know who myself is.

I'm trapped. Oh God, how did I ever get here? And how the hell do I get out?

Breakin' Down ♫

Chapter Thirty-One

Secret Love

It's such a relief to be out on the road. Without Hudson.

Much of the time, travelling with my own band feels like I'm traveling with children; like I'm more glorified babysitter than boss and entertainer. Some musicians sleep all day and then show up for the gig at night. That's it. I have to ensure they're rounded up for mid-week rehearsals and our nightly sets. It can be a bit of pressure.

But Jake is different. He is my musical director which means he handles charts and arrangements and communicates with the others about availability and tour dates. Plus, he handles all the rehearsals before and after I fly into town. I do a lot of performing in Western Canada, so these guys are based out of Calgary.

For this tour I'm travelling with four musicians and a sound/light man. We rent two vans. One is for the musicians and me. The other is for the sound gear, instruments and lights. We have fondly named the latter Creamsicle. She's a worn-out piece of junk and barely survives the many miles we need to cover. But she does come with her own air conditioning. Yes, even in the winter. You can see the ground beneath the floorboards!

Jake is an extremely talented guitar player. I'm fortunate to have him play for me. He truly is one of the best. Oh, how he loves to play his instrument. I think he lives for it. It's a part of him. An extension really. He always has a guitar in his lap. He treats his guitars like friends. I swear he'd much rather hang out

with his six-string than socialize with strangers at a gig. Not like me. I love meeting new people.

Introverted Jake has a dry sense of humour which I find oddly alluring. It can come out of nowhere. And when it does, he is most engaging. There's a unique language musicians speak and all the ones I know love to have a good laugh.

Jake isn't really what I'd call my type (my mind shouldn't even go there, right?). He's older, bearded, wears glasses, battles his weight and wears polyester 'slacks.' Not one ounce of cool. No physical attraction there at all. At least I don't think so.

However, tonight he has left a note under my hotel room door. *Let me know when you get back.*

That's it. What could it mean?

Truth is I'm beginning to feel a little bit different about this quiet, laid-back guy. There's a sweetness, a caring and a softness.

Jake enjoys both booze and pot (as does the entire band, both off stage and on!). At the end of the night, we often continue drinking and smoking. Then the munchies kick in and we need to order pizza or find a late-night gas station to satisfy our cravings. Jake and I also love to play backgammon, so we often stay cozy indoors on frigid winter days, enjoying our favourite game.

Tonight, I rap on his door as requested, and we settle into a lovely game, augmented by a warm buzz from Grand Marnier. That seemingly innocent glow leads to a simple kiss. This is neither planned nor is it something I have dreamed. In spite of my surprise, I am caught completely off-guard by the tenderness in his touch. It warms a place in me that has grown bitterly cold. There is a deep longing in me, for this sweet and gentle kind of affection.

But Jake's kiss is more than just gentle. It arouses me. Every

single cell in my body begins to awaken. Like a welcomed thunderous rain over a parched and barren land, I feel a wellspring of hidden passion rising up. We are both taken aback by the spark we have ignited. Even with our childlike awkwardness, we can both feel it. We know we are moving into very dangerous territory.

But passion will have its way and in the days that follow, our relationship bursts into a whole new pallet of beautiful colours. What started as a simple friendship soon grows into a shameless and powerful affair. The love that's been secretly growing between us must be acknowledged. Our spirits are united and our bodies usher us to a place I have never before experienced.

Up until now, everything I have done has been geared toward productivity or performance. How well I can sing. How well I can act or entertain or make people laugh. How well I behaved as a little girl in school. How well I could keep all our family secrets from the outside world. How strong I remained as one after another of my family members dropped like flies. How well I am succeeding at playing the game of music, meeting the right people and schmoozing with those who might take me up the next rung on the ladder. How pretty or sexy I should or shouldn't look and act in live shows or photo shoots. How high my songs go on the charts. How many award nominations I receive or don't receive or don't win. How well I perform for talent buyers and club owners and patrons, so that I will be hired back. How good I try to make other people feel when they are having a rough time. How I feel the need to make sure everyone else is happy. How made up I have to be every single day, so my husband feels good about being married to me – or good about himself. How clean my house is, how well I cook. How much I need to smile when I am dying inside.

This is me through and through. I truly do not know anything different. Isn't this the way everyone is? I don't know how to just be. To be myself. To be me. Who the hell is me?

With Jake, for the first time in my life, I feel accepted even when I'm doing nothing. Sitting, breathing, being. No makeup. No fancy clothes. No performance. No covering up or hiding my imperfections.

I find myself struggling with these unfamiliar feelings. I'm not used to someone not only accepting me this way but *encouraging* me. Telling me he loves me – this way. Loves me for just ... ME.

Being loved in this unconditional manner is so foreign, I am tormented. I have a difficult time believing it might be true. And as we all know, feelings that flow from a jammed-up well often gush with unabashed abandon. With such power. And then fear sets in and up go my concrete walls. My very own heart abruptly stops the flow of all the loving feelings. The feelings of freedom and acceptance. There is a part of me that begs to run. How sad to think that I must run from something so life-giving and beautiful. Simply because it is foreign to me. Terrifying. But I have been so perfectly conditioned, my self-worth is based purely on my ability to perform well and be perfect.

I know that this affair is dangerous. I am betraying my wedding vows and I feel a deep sense of guilt. And yet, I find myself swept away by glorious feelings that overwhelm me. Love, this kind of love, is such a powerful force. It's not unlike a drug and it's unimaginable to think of giving up this painful pleasure.

Jake and I continue our secret love affair for the next few years. I am entranced and held captive. Yes, we must live a double life and yes, it is heartbreaking and exhilarating at the

same time. Little do I suspect it will prove to be one of the most soul-stirring relationships of my life. Alas, it does come to an end. But it does fill my heart with new hope. Maybe, somewhere out there, there is a better love for me.

In the Shade of the Willow Tree ♪

Chapter Thirty-Two
The Major Affair

When I receive a call from the producer of a Canadian Armed Forces show tour, I jump at the opportunity. These shows are the equivalent of the old "Bob Hope" shows in the USA. I love the prospect of being involved in a large musical production, performing for our soldiers. But equally attractive is the prospect of being away from home. It's the perfect set-up. Two weeks away, including rehearsals and tour dates. I'm thrilled for the opportunity to visit several Canadian military bases in Northern Canada.

After a quick stop in Newfoundland, we land at the top of the world. Alert, in Nunavut, Canada, is the northernmost permanently inhabited place on the planet. Only 500 miles from the North Pole (to be precise). There is a "military signal intelligence radio receiving" facility and we are here to perform for these isolated personnel. And of course, to socialize, aka ... party! I quickly learn that the partying and mingling are even more important than the show itself. Boosting moral and delivering a bit of home is the job.

Within hours, the soldiers and our production crew have us set up and we deliver our variety show featuring singers, dancers, musicians and a comedienne. After the show is over, all the girls donate a pair of panties (new ones, I might add) to the mess hall, which is a rather odd, long-standing tradition. They're proudly displayed on the wall for all to see. A bit of fun for everyone.

After our 48 hours in the most remote place I could

Chapter Thirty-Two

imagine, the group moves on to Yellowknife, North West Territories, and then down the Pacific coast to the Queen Charlotte Islands. This stop is the absolute highlight of the tour for me. These islands possess biological and cultural treasures that are duplicated nowhere else on earth. They harbour the largest sea lion population in BC and are home to whales, dolphins, porpoises, seals, and sea otters. What an unforgettable experience; something profoundly spiritual for me. I feel enriched and renewed.

~~~

Our Northern expedition is such a hit with the Canadian Defense Headquarters we are invited to take the same show on a month-long overseas tour. Our destinations: Germany, Cyprus, Egypt and Israel. I'll arrive home just in time for Christmas. This is going to be the trip of a lifetime!

Most everyone on the tour is single and by the end, nearly everyone is sleeping with someone. Me included. I willingly partake in copious amounts of free alcohol which lead me to the bed (and intentions) of a much older man. He is, in fact, the one in charge of the entire tour. Major Howard, with the National Defense Headquarters.

The 'wild girl' part of me soon embraces the whole 'live in the moment' philosophy. At first, I feel tentative and shy. But since most of the French dancers have little or no inhibitions, I follow their lead. By the end of the tour, I don't appear to have many left either. The 'good girl' who has never dared push any boundaries (except for Jake and that was such a quiet, intense relationship) is suddenly off the rails! Plain and simple, I am rebelling.

After a lifetime of responsibility, now is my time to sew

some oats (wildly) and experience a lifestyle I have never known. There's a brazen freedom on this tour and my sexuality oozes on and off the stage. I really let my hair down with reckless abandon. I'm totally removed from any connection to God, and I don't care. If there's ever a wave of self-doubt or confusion, it's quickly drowned with more shots of tequila, rum or Grand Marnier!

I'm intrigued by the Holy sights we visit in Israel, including Bethlehem, Nazareth, Garden of Gethsemane, the Sea of Galilee and River of Jordan. However, my new wanton conduct is a shameful distraction. I'm so busy being "free Kelita" I miss out on the richness of the country's religious history and culture, including the birthplace of my Christianity. "Old Kelita" does find her way back (for a moment) when we sing "O Holy Night" in the church in Bethlehem where they say Jesus was born. I am truly moved. Even though I am struggling with my faith, my heart feels profoundly touched.

Being away from my husband during these tours gives me time to gain courage and plan my getaway. As evidenced by my freewheeling activities, it is pretty obvious our marriage is over. As I party outrageously, I lose self-respect. But I keep crying out for attention. Positive attention. I am continually searching for love, affection and acceptance. Obviously, I'm a messed up woman.

As the tour comes to an end, I embrace a new sense of freedom. I have built up the courage to tell Hudson I want a separation. A real one. Not like the time I left and flew out to Calgary to stay with my sister. Or when I rented a room from a friend in Toronto. No, I need a separation that is permanent. Where I leave and don't come back. I feel this might finally be it. I believe I can be the strong woman I dream of becoming.

I arrive back home just in time for Christmas. The day

## Chapter Thirty-Two

is interrupted by an unexpected phone call from the Major, setting my nerves to jingling like proper silver bells. Didn't he understand it was just a fling? Doesn't he understand I have a husband?

And I do. Still. In spite of my best intentions, I find myself caving to Hudson's paralyzing will yet again. I fall back into my dismal home life like I never left.

I hate that I'm not brave enough to do to what I know I need to do. Why can't I just tell him this marriage is over? Why can't I find the courage? What is wrong with me and why am I so damned scared?

I now feel like a rat in a cage, very much missing the exhilarating tour and the liberty it afforded me. I am back on this corroded wheel, just going around and around endlessly. Is this what my life has come to? Is it my destiny to be imprisoned forever, with Hudson the warden from whom I cannot escape? What is wrong with me? Why is it impossible for me to follow through and do what I know needs to be done?

Depressed, I withdraw.

I am such a failure.

## Chapter Thirty-Three

# Good-Bye April

The doctor's office is white and sterile. I feel like I am going to be sick. The back of my neck is clammy and the pounding of my heavy heart reaches all the way up to my brain.

My breasts are tender. And heavy. So much so, they feel like they don't belong to me. And then there's my period. The one I prayed would come. Only it didn't.

When my doctor walks into the room she doesn't need to say anything. I already know. My body does not lie. My worst nightmare has come true. I am pregnant. I should be ready to have a child. I'm 31, a good age to start a family. But that's not the problem. It is a nightmare because I know the baby does not belong to Hudson. He has a very low sperm count (he's been tested). I've been off the pill for years now and we never use any protection. I am in deep, deep trouble.

My mind is racing. Should I lead him to believe this baby is his? Should I leave him and go be with the true father? Should I run away, not be with either man or raise this child on my own? I am overwhelmed, but more than anything I am terrified of being found out by Hudson. I have visions of him wanting to kill me, knowing that I am carrying some other man's seed.

"Get back to me and let me know what you want to do, okay Kelita? There will need to be a decision made soon." The doctor can tell I'm upset. She knows the story. I can only imagine what she's thinking about me. I feel like such a fool.

"Yes, I will. Thanks for seeing me on such short notice." I had held off making this appointment until I thought I might

## Chapter Thirty-Three

literally go insane. And now the truth is mind boggling. Barely able to steady myself, head still swirling from the news, I get up and stagger out of the office.

I keep my naked breasts covered so Hudson doesn't see the changes. I sleep on my stomach a lot. It's hard to keep him away so I have to make daily excuses as to why I am not "in the mood." My husband likes to have sex every day but, at this point in our relationship, I am far from interested. I only participate out of duty. But now, I am petrified to let him see or touch any part of my flowering figure.

This should be a joyful time and a welcome experience. My maternal instincts flow through every pore of my being. As a little girl, my baby dolls were cared for deeply. I spent hours dressing, undressing, bathing, cuddling, strolling, feeding, entertaining, rocking, tucking in and loving my children. I fondly recall our cold Canadian winters, when I ensured that each doll was warmly dressed for sleep and tenderly tucked in for the night. I had always dreamed of having several children. In fact, I planned that I would be a mom by the time I was 27. For some odd reason that was the magic number. But instead, I find myself pregnant at 31 and scared beyond belief.

But a decision has to be made. Time is not my friend. Every night when I go to bed I can't wait to go to sleep. I plead with God endlessly, "Please, take this baby from me. Please God, grant me a miscarriage."

But in the morning my breasts are still heavy, and I must do my damnedest to hide my nausea. Sometimes I have to swallow the vomit that sits in the back of my throat. What to do haunts my every waking hour.

There is just so much turmoil. My heart and head feel like volcanos, bursting with fire and ready to erupt! Maybe I'm having a nervous breakdown? Is this how it feels when you're

losing your mind? Do I need to check myself in somewhere? I just don't know how I'm going to continue to deal with the extreme stress. The whole mess is traumatizing me.

I must move forward. I rebook with my doctor. I've made my decision. At this time in my life, I don't have any other choice but to terminate the pregnancy. I have no desire to have a child that will be subjected to my husband's abusive behaviour – even if I lie and say it is his. And the father of the child? That's not the right path either.

There is no way I could take care of a baby on my own. Right now, I can barely take care of myself. My mind is made up. I don't receive any counsel, and my doctor never attempts to give me any other options. She does not speak to me about adoption or suggest I talk with someone else. Or maybe she does, and I just don't have the ears to hear her. Perhaps I'm so resolute I don't *want* to hear. All I can think is *Get this baby out of me!*

The timeline is becoming serious. Hudson goes everywhere with me. And that includes today. I am booked for an ultrasound to see exactly how far along I am. I have concocted a story that I am suffering with 'female issues' and need to have a D&C. This also helps me to keep his advances in check. I am lying so often I'm almost starting to believe the lies myself. Any notion of carrying a real baby that is forming fingers and toes and has a heartbeat, is just not real to me.

The appointment is downtown and Hudson insists on driving me. I am more than capable of driving, but he won't have it any other way. Panic sets in as I attempt to circumvent a potential disaster.

"Why don't you just stay in the van and wait. That way we don't have to worry about parking. I don't think it should take that long. I'm fine doing this on my own." I am trying desperately to keep my voice steady.

## Chapter Thirty-Three

Hudson agrees and drops me at the front door of the high-rise office building. I breathe a huge sigh of relief. I am already buzzing with nerves and the thought of him deciding to come up to the office nearly paralyzes me.

I am standing at the receptionist's desk checking in, answering her questions through the circular hole in the glass partition. Suddenly, out of the corner of my eye, I see a man walk through the office door. At that exact moment the receptionist blurts, "And how far along are you"?

I think I'm going to pass out. The man is Hudson!

Frantically, I lean into the window and whisper, "Shhhh, shhhh, don't say anything. My husband doesn't know. That's my husband right there. Shhhhh. Please just be quiet." I am freaking out because I can feel the veins popping out of my neck!

Hudson takes a seat. He looks around at the others waiting. Oh God, I pray he didn't hear her question or see the horror on my face. *Keep it together Kelita. Stay calm, girl. Contain yourself.* My nerves are in earthquake mode.

"You need to go up to the twelfth floor for your ultrasound," the receptionist instructs me, sweetly. She understands.

I walk over to Hudson. He looks fine. He acts normal. I do not look fine. I do not feel normal. If it weren't for my professional acting skills, I'd be sunk. "I just need to go up to the next floor for an ultrasound. You can stay right here and wait. Okay?" My voice is calm and controlled.

"Yes, sure." He starts to go through the magazines on the coffee table, no doubt relieved that he doesn't have to hold my hand.

All I can think is, *Thank you God!*

From here on, I bury the reality of my pregnancy and treat all the steps that follow as a simple clinical procedure to rid me

of my problem. I remove all emotion from the process. I bury every single feeling. I just need to survive and get myself on the other side of this abysmal mess.

My procedure is set for April 13th. A date I will never forget. Hudson and I start the morning with coffee and the newspaper, just like any other day. I am supposed to arrive at the hospital after lunch. We have some errands to run, including a Post Office stop. There are promotional packages and albums being sent out as usual.

As Hudson enters our van, he places a handful of envelopes on the dash. Just as he does, he lets out a scream that can only be associated with pain. *What is wrong? Is he having a heart attack?* "What, what is it, what's wrong?" I am shouting.

Hudson cups his hand over his right eye. "My eye! It's my eye! Bloody hell!" He is writhing as he hits the steering wheel repeatedly with his other hand.

"What do you mean? Your eye? What happened? Tell me!" I lean into him, trying to understand.

"I don't know. I think I must have poked my eye with the edge of an envelope!"

"Oh no! Oh God! Can you see?"

"I don't know. I don't know. Damn!"

My brain is in overdrive. What do we do now? Hudson is immobilized.

"You don't want to mess with your eye," I proclaim confidently. "Let's get you to the Emergency." Perfect. Now it's me driving *him* to the hospital. This is all crazy. I'm supposed to be the one going to the hospital - not him!

The doctor informs Hudson that he has a scratched cornea and that he's very lucky it's not worse. My husband will now have to keep his eye patched and lie flat on his back in the dark for at least 24 hrs.

## Chapter Thirty-Three

*Can this really be happening? Divine intervention?* I breathe a sigh of relief and thank the heavens.

After tucking Hudson into our dark bedroom, I take a cab to the Women's Hospital. I am admitted and the pre-op begins. All I can think is *It's almost over.* All the weeks of worry, stress, lies, hiding and fear of the unknown. The heavy breasts, the morning nausea. The agony of travelling this road all alone. I am starting to feel a glimmer of relief.

Perhaps I'm not really alone. There is someone - *something* much greater, watching over me. God? My guardian angel? But why?

I realize I don't need to know all the answers today. I do know, with great certainty, that this entire experience did not unfold as it did by chance. I am being protected.

After the procedure, all the emotion that I have buried bubbles to the surface. I am disgusted with myself. How did I let something like this happen, especially while I am still married? My crushing shame is covering me like a scratchy horse blanket. All I want to do is hide. I want to hide from my husband and our friends and the world. But mostly I just want to hide from my own weakness, my own choice and my own guilt. I promise myself I will just block this entire experience from my psyche. If I am to survive, I must forget and move on.

The day after my abortion I fly out to Winnipeg to play the opening of a new country music club. I dive right back into my work, performing for three nights. The show must go on.

I am very thankful that I have these days to myself. The club has put me up at a band house, only there's no band in it. They all live in Winnipeg so it's just me. This gives me much needed alone-time to pull myself together and muster up some strength to face going back to Hudson. I'm exhausted from all the lying. All the pretending. I am completely spent. This

whole crazy mess has made me realize I must end my marriage once and for all. I know it's what I have to do. Now I just need to follow through. Hudson and I have decided to put our little house up for sale. I think we both understand it is time to part company.

But once I return to Toronto, I remain muddled and weak, and he is persistent and strong. Once our house is sold, he moves into the new rental with me. We exist in a new and yet achingly familiar volatile arrangement for another whole year! The street we live on is called Warland.

No kidding.

I decide that when the lease is up, I will find an apartment just for me. But when I do, Hudson moves into that place too! We are both so co-dependent and seriously messed up. I do know that at some point, the insanity will have to stop. I feel like I'm riding on a speeding train. I want off desperately but jumping might kill me. Where will I land? What if I don't survive? Is it actually possible to make it out alive?

A deep longing within me is calling for a fresh start, a chance to break free from the chains of my current existence. To emerge into a brighter, more loving life. My heart is open, my soul is crying out for this new reality. Now if only I could get my brain and body to cooperate.

**Good-Bye April** 🎵

## Chapter Thirty-Four

# Hot Summer!

The buzz of singers chatting and musicians noodling on their instruments fills the large washed-out rehearsal space. I nervously glance around the room. Anyone look familiar? That would be comforting. But I only recognize the producer, John Allen. I've once again been hired to do an oversees Canadian Armed Forces tour. This time it's an all-Toronto cast and crew. No more "lessons" from the French contingent! We'll get to visit all the same places - Germany, Israel, Cyprus and Egypt - the Middle East in the summer. It's going to be a hot one. Little do I know, in more ways than one.

As I continue to trace the room, my gaze abruptly freezes. On … him. HIM.

Everything and everyone in the room stands still. My heart does a soaring flip. I can't help but stare blankly at him as I enter another stratosphere. *Earth to Kelita!* I don't ever recall someone taking my breath away. Not like this!

HE is an extremely attractive man. A gorgeous body (from what I can see) peeking out from behind his bass. And his smile! That, more than anything else, is what catches my attention. And he's not even smiling at me.

Although I'm a born performer, I can be a bit of an introvert, especially in a new situation with people I don't know. It's for this reason I hang back and let the other performers mingle and rehearse. I pull up a chair and try to be patient while I wait for my time slot with the band. I keep watching the guy with the beautiful smile. I hope I'm not too obvious. I feel like my

body is betraying me even though I'm trying desperately to control myself.

Finally, my music charts are handed out. I step up to the microphone and begin my introductions to the band. I'm especially jittery when introduced to him. He is the bass player, and his name is Gord. I'm also introduced to the other two female lead singers, Rosita and Suzanne. The three of us will each have our own solo spot in the show. Then we'll all come together for the big group production numbers. Those will include the dancers too who we'll meet after a few music rehearsals.

These shows are really fun and the production values are first class. The government pulls out all the stops with a healthy budget. Having been on the Christmas tour only six months ago, I'm super stoked to do another one. Plus, it's a chance to escape from Hudson. Nothing has changed and nothing has improved. Maybe, just maybe, THIS will be the time I'm able to build up the courage to make my exit. I'm beginning to sound like a broken record. I hate that about myself.

After rehearsing for ten days, we perform the full show at a theatre in Toronto. It's a private function for friends and family, plus the big-wig military personnel who come from Ottawa. They are the ones who have to officially approve the show so really, it's for them.

The show proves to be a hit. The large cast is just oozing with talent. Singers, dancers, musicians, a magic act and one very famous country and western honky-tonk queen named Dixie Lee (me). Yes, I get to do my Dixie Lee comedy act in the show.

Within days of the final approval, the cast and crew bid farewell to our families and take to the sky. Our first stop is Germany, a country I love. I'm very excited (especially about

getting to know Gord) but also concerned. Major Howard, the same Major I had the fling with six months ago, is once again in charge of this tour. He's been *extremely* friendly since boarding the aircraft. In fact, he made sure we are seated beside one another for the flight. By all indications he is very keen on continuing where we left off.

I am not keen at all. That was a one-off. Old news. I am far more interested in new news, and HE is sitting just one seat away.

There is definitely a positive connection developing between Gord and me. It's pretty easy to be attracted to this guy. Not only is he handsome but he's talented and funny too! Such a great combo. He's singing some background vocals for me in the show which is pretty cool. I could be converting a jazz snob to country.

When we go out for our first dinner in Germany, I'm hoping Gord and I will be seated at the same table. No such luck. He ends up sitting at a different table beside the head dancer, Erica. You can't miss her. She's the one with the legs that never stop. It's obvious from the jump that Erica has her eyes on Gord. Actually, a lot more than just her eyes! After a few drinks those two are giddy and feeding food to one another. I'm quite certain they are making everyone else sick. Okay, maybe not everyone.

In the days that follow, Gord and Erica continue to flaunt their flirtatious relationship. He and I are also getting to know each other but not like they are. We don't have any late-night rendezvous (word travels fast in this tight little entourage) but we do have some great laughs and I can tell Gord likes my company. But he's a friendly guy and likes everybody!

In my corner, the good Major continues to work on rekindling some old flames. Still no spark here. Not one

smouldering ash. I try to ignore him but it's not easy for me. I don't want to be rude and being a chronic people-pleaser does not help. The whole thing just feels smarmy to me even though no one else in this group knows our history. But I do. What took place was fueled by alcohol and it was a mistake, plain and simple. The Major is old enough to be my father! Maybe I was still looking to replace mine?

Gord is different. He is a peer and a beautiful performer. I love watching him from backstage, playing his heart out. One night, on an isolated army base in Egypt, we perform in the Sinai desert with the Red Sea as our backdrop. Talk about an exotic setting! It is the hottest outdoor show I have ever done in my life. Temperatures are still in the high 90s, even at show's end. The smoldering air blowing off the dry desert sands is stifling just to breathe, much less perform in. Add the heat from the stage lights and everyone is sweating profusely. I am dying for any kind of relief so, after my solo segment I secretly slip out into the audience to try and catch some sort of breeze. My eyes are transfixed on Gord.

Dressed all in white, sun kissed from a day on the beach, he and his bass move and groove to the music. His charisma and passion are intoxicating. This man has hypnotized me.

After an enchanted concert under the stars, we're ready to board the UN bus. As we clamour on, most of us are happily drunk. The military sure know how to throw a fun party! The alcohol just never stops flowing. The men and women never want us to leave and so our goodbyes always take a bit longer. Just boarding the bus can take 30 minutes!

We usually continue the festivities with more drinking and dancing in the aisles, but not tonight. We'll be traveling through the Gaza Strip, so we need to be mindful. And besides, everyone is exhausted from the long day in the scorching heat.

## Chapter Thirty-Four

As the bus cuts through the black night, the chatter subsides. There is only soft laughter and for once, no dancing! I'm sure our driver is relieved that we're all behaving. It is a peaceful trip along the dark, deserted road. I feel good just to be still. Putting on your best happy face and schmoozing and boozing can be exhausting, night after night. Some of the others have unbelievable stamina for partying. It's all part of the gig. And we are all happy our presence lifts the spirits of those who are serving our country.

I gaze out my window. It sure is dark out here. Nothing but the jet-black Egyptian sky dotted with the glow of stars, millions of miles away. We are in the middle of nowhere. The bus hums along the deserted road as people start to nod off, and then ...

BANG! BANG!

What the hell was that?

Another BANG.

*What's going on?*

"Everybody down. Everybody down!" The Major is shouting, "Get down. NOW! NOW!"

The sound of glass shattering pierces the air. I frantically hit the floor as, all around me, bodies are dropping to safety. Adrenaline is gushing. We are being shot at! We must be! Our driver cuts the lights - inside and out. He hits the gas full throttle and the bus surges into the black hole.

Nobody knows what's going on. It's happening too fast. It's pitch black and impossible to see anything. I can barely make out the bodies crouched beside me. Some in the aisles. Others, like me, curled up into balls.

The bus drives on, with no one making a sound. The Major finally calls out, "Everybody listen up! Stay down for just a little longer. We want to make sure we're in the clear."

We hunker down for what feels like forever. I pray to God no one's hurt. The silence is eerily overwhelming. The only sound is the whirring of the bus. We're all terrified. I still can't believe this is actually happening. What the hell?

The Major finally speaks again. "Okay everybody, you can get up now. Return to your seats. Is anyone hurt?" The Major is tough, but I can tell even he is shaken. The bus is now buzzing with chatter.

Someone calls out over the noise. "Back here. It's Rick. He's been hurt. The window smashed where he was sitting. Anyone have something to wrap his hand?"

"There should be a first aid kit on the bus somewhere," the Major shouts back.

Thankfully Rick is the only casualty. He was leaning up against the window using his hand as a head rest when the shots were fired. His head and hand have taken a hit from the shattered glass. He has cuts on both. Stitches will be in order once we get back to civilization. Other than some shaken up entertainers, we are all okay. THANK GOD!

We are now fully awake. How can anyone possibly think about sleeping? And if anyone was drunk before, they are pretty damned sober now. We arrive back to our hotel. The leaders examine the bus. What was thought to be soldiers firing bullets is deciphered as simply Bedouin punks stoning the bus. A common occurrence along the Gaza Strip, we soon learn. We are so grateful it was nothing more. Now we will all have a story to tell our grandkids.

When not performing and spending time on the military bases, we're treated royally by the UN. And this is an especially good day because Gord chooses to sit with me on the bus as we head out for Cairo. I'm trying to play it cool. And he is obviously somewhat cautious. Can't say I blame him. After all,

## Chapter Thirty-Four

I'm the one who's married. Married and totally ecstatic. I feel like a schoolgirl. It all seems so silly. I'm pretty sure he's loving the attention and not just from one but two women! He is spending much less time with Erica (which makes me very happy). I'm pretty sure he's still visiting her room late at night but honestly, the attraction is so darned strong for me, I don't care. This is something I've never experienced before.

It's a harrowing bus ride, flying over bumps, hills and the dusty mountainous back roads of Egypt. These last few days I am feeling thankful just to be alive. I will admit it's also fun experiencing the drama and excitement with Gord beside me. We laugh, grit our teeth, hold on tight and then laugh some more.

Everyone's pretty thrilled when we arrive in Cairo. There's an energy bustling in this city of over 9.5 million people. Everyone is abuzz as we check into the lavish King Farouk's Palace. The towering Turkish architecture presides over the lush grounds which reach out to the Mediterranean. Someone pinch me! How is it that we get to actually stay in such a place?

After a quick shower and a bit of sprucing, I drop by Gord's room. He's hanging out with three women, including Erica! This guy sure has no problem attracting the opposite sex. We are all like groupies as we wait for him to get ready before heading out for the group dinner cruise on the Nile.

The next day, we visit the Pyramids and The Great Sphinx of Giza. Gord is a history buff and everything about Egypt excites him. We do many things together, including riding camels beside the Pyramids and the Sphinx. These exotic experiences are certainly adding a dash of romance to this trip.

Sharm El Sheikh is a beautiful resort town on the southern tip of the Sinai Peninsula. I was here on my last tour and I'm excited to show it all to Gord. We spend the afternoon

snorkeling in the crystal-clear waters, in awe of the magical underwater kingdom. It's like nothing we've ever seen before. The whole day is like a Disney movie and I'm feeling very much like a princess.

In the early evening before dinner, I call over to his room.

"Hey, it's me. What are you doing?" I ask nonchalantly.

"Not much. Just waiting to go to dinner."

"You want to come over to my room?" I boldly inquire.

"Sure. When should I come over?"

Excited that he's agreed, and hoping he doesn't hear it in my voice, "Well, anytime is good."

"Okay, sounds great. I'll see you in a bit then."

*He said, yes. Oh my God! This is my chance.*

I check myself in the bathroom mirror. Hair slicked back in a braid, Sade-style (I can't wear it any other way in this humidity) and make-up not too heavy. My body has some nice sun from the day on the water. I apply the creamy coconut scented après-sun lotion. Might as well smell yummy. I can feel my heart quickening.

There is a knock at my door and my heart goes into full overdrive. I check the peep hole and yes, it's him. I am nervous, but much more excited as I answer the door.

I am dressed, of course, but only just. An obvious undergarment is missing. Oops! Okay, sue me, but the man is gorgeous, and I am unreserved in pursuing him. It may be humiliating but I have no shame. I am throwing myself at him. And I don't care!

It works. He takes the bait. In what seems like one simple heartbeat, my life changes forever.

And now we are - lovers. Call me a hopeless romantic but I truly believe Gord is the man of my dreams. The one I have been waiting for all my life. I feel like I've finally found him. It

## Chapter Thirty-Four

matters not that I am still married. I feel it is my life's purpose to do everything within my power to be with this man.

Unfortunately, the man of my dreams continues to mess around with Erica. But I can see that, day by day, she is fast becoming just 'one of the dancers.' Possibly because there is a special bond forming between us as we perform more shows together. Gord sees the audience response to my music and comedy. He is discovering that there are many sides to me. I think he's even becoming a fan.

I feel like I've been cast in the leading role of a romance novel. To be falling in love on this whirlwind tour of the Middle East is nothing less than extraordinary. Our senses are continually heightened. Gord and I experience so many firsts together. What could be more exciting than exploring the ancient ruins of Israel's Masada Fortress or dipping our feet in the Jordan River. Covering ourselves in black mud from head to toe at the Dead Sea? Smoking our first hookah pipe and sharing Turkish coffee with the local men on the streets of Cairo. Getting lost in the labyrinth of its sprawling bazaar with the lure of exotic spices and perfumes filling the air.

Sharing the privileged military and UN experience together is a true gift. We are constantly being wined and dined by important officials. We are escorted into a demilitarized war zone in Cyprus, only patrolled by the UN - a place where civilians are never allowed. We ride in military tanks and shoot Colt C7/C8's at a driving range. It is all incredible!

There's an ease and comfort to our relationship but it is also exhilarating, powerful and frightening. I don't think I've ever felt so natural with anyone in such a short period of time. Gord and I are beginning to finish one another's thoughts. The chemistry, our love of music and performing and our similar sense of humour, all seems too good to be true.

Could this be what real happiness feels like?

But every fairytale must come to an end. As Gord and I board the military aircraft, the reality of what is awaiting me at home kicks in. Staring out the small window with Gord seated next to me, knowing that this will all soon end, I feel a hurricane of anxiety wash over me. The familiarity of this pure, agonizing fear makes it no less palatable. Within minutes I am drowning in it.

"You okay? What's wrong?" Gord can sense my change in mood instantly.

I lean closer to him and whisper softly, "I don't want this to end. I can't stand the thought of going back home. It just makes me sick."

Gord takes my hand and looks directly into my eyes. "You know what you need to do. You can't continue to live like this. It's driving you crazy. You deserve so much better."

Gord knows my whole story. We've had plenty of travel time over the course of the last month for him to hear it all. And he has been nothing but supportive.

"I know. You're right. But you don't know *him*. It's hard to understand."

"I know that it is something you really need to do for yourself, Kelita. It's long overdue." He touches my cheek gently.

"I know. I know. I'm such a disaster." The tears are starting to fall.

"No, no you're not," he whispers, wiping away a tear. "Don't say that."

I look back at him in wonder. How can this beautiful man be so understanding, so caring and so kind?

"Thank you, Gord. Thank you for everything. I know what I need to do but I just don't know how to do it! I'm so tired of it all."

## Chapter Thirty-Four

He wraps his arm around my bare shoulder. "I know you'll find what you need inside to finally just do it. The time has come. You know it. I know it. Now it's time for the world to know it."

I squeeze Gord's hand tightly and cuddle up even closer. "You're right." I close my eyes for a moment just before staring up at him. *What did I ever do to deserve this man?* "Thank you."

I realize now that all these years of crazy, self-inflicted stress stemmed from my unquenchable need to find the love and acceptance I so fiercely craved. But as I feel my hand in Gord's, as I listen to and actually feel his belief in me, there is a small glimmer of hope. Perhaps it will push its way through my heart ... if I let it.

We both know there is something very special between us. We also acknowledge it's going to be impossible to deny the strong and powerful feelings we have for one another. To not see each other will be torturous, but I know I cannot bear the thought of another full-blown affair.

Or ... can I?

My country music character "Miss Dixie Lee" hams it up backstage with the Canadian Armed Forces Show Tour dancers, 1989.

Here I am belting out a Christmas song.
I always loved a feather boa on stage.

Photo Credit : Vanessa Hernandez

## Chapter Thirty-Five

# Out of Control

The big old yellow moon hangs right in front of me. Suspended like a magnificent jewel, lighting up the cold, clear prairie night sky, she is keeping me company. Only 1,600 miles left, and the tour will be officially done. I am ready for some peace and tranquility. Although I adore the excitement of being on stage, meeting new people and hanging out with my crazy band, the quiet feels good in my bones.

But I am not really alone. Hudson is trying to catch some sleep in the back seat of the van so he can take a turn with driving duties. It's just the two of us.

Nine hours ago, we dropped the band at the Calgary airport. Lucky them. They get to fly home. Hudson and I get to drive the van packed with all the musical gear, all the way back to Toronto. We will see a total of 2,124 miles and 33 hours of straight driving time. Just me and my husband.

It is now 4am and my body is oozing with exhaustion. A nice hot bath and a warm cozy bed would be so welcome about now, but I must drive on.

I am alone with my thoughts and my anxiety. And I only have myself to blame. How could I have ever let this happen? These last three weeks have been nothing short of total madness. With my marriage bubbling like a pressure-cooker, on the verge of total combustion, I go and add fuel to the flame. I hired Gord to join the band on a 3-week tour all the way across the flippin' country. And then my husband decides to come along as tour manager and driver.

This is insanity. All I do is dream of escape.

The endless miles of prairie highway groan on and on. I am lulled into a strange submission even as my brain rages with fire. But then suddenly my attention is jolted into action as we approach a slight bend in the road. Not too many of those out here on this prairie highway. Something weird is happening. I can feel the van beginning to swerve. I turn the steering wheel one way. Then the other. Shit! There is no connection between where I am steering and where the van is taking me. It's like I'm skidding on a cloud.

Sliding, fishtailing, weaving a drunken trail. Seconds turn into eternity. My hands hold the wheel in a death-grip. Teeth clenched, panicked and fear-stricken, I scream to Hudson, "Hold on! This is it!"

At 60 miles per hour, that van takes flight and soars head-first over the eight-foot embankment to the ditch below. Rolling again and again and then BOOM! We come to a deafening halt.

I am completely disoriented. I feel like we are still spinning. Suspended, dangling upside down, blood rushes to my head. *What the hell just happened? Am I alive or dead?*

"Hudson, Hudson! Are you okay?" He doesn't respond.

Ever so gently, I begin moving my body parts. I can feel my arms and legs. I can hear the whirring of the motor. The gritty taste of dirt fills my mouth. It takes a few seconds for my addled brain to compute. I am definitely alive. My seatbelt is tightly bound around my left shoulder and waist. Shards of glass are everywhere.

Seemingly out of nowhere, Hudson appears and comes to my rescue. Obviously, he is okay. Everything is in slow motion. He carefully undoes my seatbelt and lowers me down. I shake all the tiny pieces of glass from my clothes and hair. Now I am shaking too. Uncontrollably.

## Chapter Thirty-Five

We check each other for injuries. Neither of us can believe it. Not one broken blood vessel. Not one cut. No broken bones. It is truly a miracle! The van is a mangled mess but we are okay!

Reality kicks in. My life literally just hit the ditch! It blew up but good. And damn, it's cold out here. Now what? We are in the middle of nowhere. It's 4 in the morning and we're in a dark ditch with a totaled van.

"Maybe we can flag somebody down," I suggest meekly, hugging myself tightly to stop the shivering that has enveloped me.

Hudson is shaking too but I sense he is also really annoyed at me, the driver who got us into this mess. "No one's going to be out here at 4 o'clock in the morning," he snaps.

"Well, we can't just stay out here." I am trying really hard not to cry.

"I'm sure someone will eventually drive by. We'll have to try and stay warm." There he is again – the manager. Taking over and taking control.

We climb out of the ditch and stand together on the shoulder of the deserted highway, shivering in the cold night air. Time is not our friend. My fingers and toes are already numb.

Thankfully we see headlights in the distance, drawing closer. I start bopping like a go-go dancer, waving my arms wildly and screaming. It works. "He's spotted us! He's shifting down."

The huge semi applies his brakes but slides right past us, quickly aborting his attempted stop. He knows instinctively what lies below. We sure found out pretty darned quick. The entire highway is like a skating rink. Nothing but black ice!

What we hoped would be our salvation just slides right on by. Literally. Our hearts sink as we watch the red taillights

fading into the distance. This was our chance at rescue! I can feel panic starting to rise. I now realize this is going to happen to every single trucker who sees us. None of them will want to attempt a stop on black ice and how can you blame them? Who knows how long we're going to have to wait out here?

Twenty endless minutes later, another set of lights cuts through the distant blackness. Sure enough it's another trucker. To our amazement, this one applies his brakes much sooner and is able to stop near us. Calling down from his window, over the roar of the engine, he brings immediate relief.

"Hey, you two doing alright?"

"Yeah, we're okay. Nobody's hurt." I am shivering so hard I can barely speak.

"The rig that drove by a while ago radioed me and said he'd call the RCMP. He wanted me to tell you someone will be on their way soon. The nearest town is Moosamin, about 20 minutes down the road."

"Thank you so much. We appreciate you stopping. Be careful." Hudson is most gracious.

Trucker #2 takes off and once again we are alone and freezing. But what can we do? We continue waiting. The big old yellow moon still high in the winter sky. Morning is a long way off.

Finally, flashing lights can be seen in the distance. Heading toward us. A young RCMP officer exits his cruiser and approaches us slowly. Undoubtedly, he's been summoned out of his bed. I swear he's still rubbing the sleep out of his eyes.

Still in shock and definitely cold, we explain what happened. After grabbing our personal belongings from the mangled van, we are grateful to settle into the back of his warm cruiser. Ever so mindful of the extremely icy conditions on the highway, the officer drives us into the little town of Moosamin, dropping us

## Chapter Thirty-Five

at the only local motel. He waits, making sure we have a room for the rest of the night.

Without many words between us, exhausted and dazed, Hudson and I devise a vague plan as we fall into bed. Lying in silence, I try to relax my shaken body enough to feel safe. My head isn't able to do the same. I stare up at the ceiling. My life is spinning out of control, and I just hit the ditch! I'm in a dumpy motel in some armpit of a prairie town named after a moose! I'm two thousand miles away from home lying next to a person that I no longer love and actually fear. And to top it off, our only mode of transportation is a sorry, crumpled mess, leaving us stranded.

Yet even in this present state, I manage to tap into the grateful overflow swirling around in the other part of my heart. I am alive! I have no broken bones. I walked away from that accident tonight without even a scratch. There must be a reason. There just has to be. *Thank you. Thank you. Thank you.*

After three hours of tossing and turning, fighting (and failing) to find any kind of decent sleep, we both wake up. Dragging himself out of bed, Hudson pulls the Yellow Pages out of the nightstand. He calls the Greyhound bus depot and by 9AM he is heading out the door to catch the first bus to Brandon, Manitoba. This is the closest place we can rent another vehicle. It's going to be a three hour round trip if the bus isn't on the milk-run. Better him than me going, that's for sure. I am utterly drained.

As the door closes behind him, I am up and out of bed in a flash. Peering through the curtains, I make sure Hudson is gone. I can't reach for the phone fast enough. I dial zero.

"Hello, Operator." Her voice is robotic.

"Yes, Operator, I'd like to make a collect call to Toronto." My heart is racing.

"Yes certainly, and may I have the number to which you are calling and your name please?"

She dials as I nervously perch myself on the edge of the bed. Someone picks up.

"This is the operator. I have a collect call from Kelita. Are you willing to accept the charges?" I hear his voice. My heart leaps.

"Yes, operator."

"Hey it's me." I half whisper.

"Kelita? What the …? Where are you?"

"Moosamin, Saskatchewan."

"How are you calling me? What's going on?" His voice is filled with fear.

"We were in an accident last night."

"Whaaat? Oh no? Oh my God. Are you okay?"

"Yes, I'm okay. Still in shock and a little shaken up. But I am okay. We're both okay."

"Where did you say you were?"

"In the middle of nowhere. At least that's what it feels like. Some dinky little town on the edge of the Saskatchewan/Manitoba border."

"I'm glad you're okay. I'm really sorry." He is sounding more like himself now.

"The van is totalled. Hudson had to take the Greyhound to get us a rental, so we can get home."

"Oh my God, that bad huh?"

"I'm afraid so. I just had to call you and let you know. I wanted to hear your voice, but more importantly I wanted to tell you … I have made up my mind".

Silence.

I go on. "I can't live like this anymore. I can't do it." There. I said it. I finally said it. And meant it.

## Chapter Thirty-Five

"I know you can't, and you shouldn't have to. Oh man, Kelita, I wish I was there with you right now. I'm so sorry you're having to do this without me. Stay strong, okay. I'll wait to hear from you as soon as you get back."

I don't want to hang up. There is such a tenderness in his voice. He has a way of making me feel at home. At ease. Loved.

As we end the call, tears well up. I feel the dusty streams of morning light blanketing me through the thin gap in the curtains. Shivering, head bowed, I am still. My body is frail. I am so damned weak. For a while now I have been dealing with all the symptoms of chronic fatigue syndrome. Always getting sick. So many sore throats. Tired and then more tired. I can never think clearly. I know it's all the stress.

I take a deep breath. The shock is sinking in. Strained, tired, shaken. It isn't over yet. In fact, it is just beginning. We still have another 24 hours of driving. One more full day with my husband, knowing what I am about to do and knowing how he will react.

I don't care. I am resolved.

And I cannot wait to be in Gord's arms.

## Chapter Thirty-Six

# Finally

Standing here in the light of day, staring at our totally wrecked van, I am stunned that we walked away. Unscathed! Anyone looking at this crumpled disaster would easily surmise the occupants were severely injured. It's a write-off.

*There must be a reason why we were spared.*

That's all I can think. There just has to be. God must have had his hand on this van. And on us! Why else? In spite of all the trauma I can't shake my deep sense of gratitude for being alive!

And so I pray. *Thank you, God. I know I probably haven't been in your good books for quite some time. But I am pretty sure it's because of you I am here today.*

The hair on the back of my neck stands up. I know that sense. This is familiar to me. No doubt in my mind. I know it. I feel Him. I know God's touch.

Much to our astonishment, there is hardly any damage to the musical gear. The drums and amps were packed so tightly, only a few minor things are broken. This big lug of a van has carried us and others many a mile. And we are so lucky it was just Hudson and me in it and not the whole band. God only knows what could have happened.

After transferring the gear into the rental, we set off. We drive for hour after hour underneath a dull, grey, wintry sky. When we hit northern Ontario, we feel the anticipation of a first snowfall. We stop for our first break of the day and the chill in the air is agonizing. But it can't possibly match the

## Chapter Thirty-Six

lethal chill inside the van. Today the atmosphere is positively frigid. We are back to silent détente.

Even with no conversation, I am grateful for the sound of wheels on asphalt, helping to drown out the deafening chatter in my overactive mind. The occasional AM radio station also provides a welcome reprieve. But hearing the strains of "If You Don't Know Me By Now" saddens me. I try not to cry. I want to weep buckets and watch all my inner pain wash away down the barren highway. I feel so many things and am unable to articulate any of them.

As the long hours drag on, the tension between Hudson and me increases. Like a worn rubber band, stretched far beyond its limit, every muscle in me is tense. My body is preparing itself for that inevitable moment when the band breaks and the jolt of the snap sends my heart flailing. We are just six hours north of our destination.

Finally – it happens. Hudson's band snaps and all hell breaks loose. He can no longer contain his rage and it spills out of him like molten lava. He is seething!

"I know something is going on with him! HIM! That damn guy. You can't tell me that it's not! Don't you dare lie to me!" His hands are on the wheel but his eyes are on me. I am terrified he will drive us right off the road.

"There is nothing going on. I don't know what you're talking about," I respond softly, trying my best to look sincere. "Please keep your eyes on the road."

The man is angry, exhausted and absolutely livid. He is losing it. Losing everything. Losing control over me. Over our lives. Our marriage. Our business. Losing his mind.

I know I need to protect myself. I need to stay strong. Maintain order. *Hold it together, Kelita. Hold it together. Hold it together.*

Hudson screams even louder. "Yes, you do! You know exactly what I'm talking about. You're making a fool of me. Kelita, don't lie to me!" He is driving even faster now, well over the limit.

"I do not know what you are talking about," I lie with false bravado. "I have told you, there is nothing going on." I cannot tell him the truth. Not here, not now. *Please God, let me get home before this all explodes.*

Hudson swerves the van to the side of the road, skids into the gravel shoulder and brings us to an abrupt stop. His face is beet-red and there is a vein popping out of his forehead. The man literally looks like he could burst! "Get out! Get out of this van right fucking now!" His bulging eyes pierce through me. "I don't want to see your face for another fucking minute! Get out!"

I recoil in silence and fear. Just like I always do. I say nothing. I just turn my head and stare out the window at the sign which says, 'Thank you for visiting Sault St. Marie.'

I send out a silent prayer that I won't be forced to visit this lovely town as I wait for Hudson to calm down and reclaim his senses. Finally, after what seems like forever, he takes a deep breath and puts the van into drive.

Calamity averted. For now. I recognize that the physical aftershock of the accident, the emotional drama and the extreme levels of tension are swarming over me like vultures wanting every last bite. My resiliency reserves have all but run dry. But I refuse to be eaten alive and I will not concede. This battle is tough, yes, but I am becoming tougher.

We finally arrive home after a grueling 1,600 miles in the confines of this rented prison. Climbing into our bed, I think it so strange and sad that I once thought this person beside me was my soulmate. So much has changed in us both. We were

## Chapter Thirty-Six

just two lost and wounded souls. Kids, really. Why has it come to this?

I sink deep into the mattress and even deeper into a quagmire of heartache and regret. This is the familiar wasteland I know so well. My body begrudgingly grants itself permission to leave the woes of the last few days behind. I fall asleep.

The sun creeps in through the blinds, announcing midmorning. We actually slept the entire night and part of the day. But now, like a young eagle whose mother gently leads her to the edge of the nest, I know without a doubt the time has come. I have been firmly nudged out of this place. It is time to take flight, all on my own. I now understand that even if I come close to crashing to the ground, there is something much greater than I, ready to catch my fall. I feel my spirit resonate. It is a deep knowing from inside and one I have experienced before. Sitting up in bed, words somehow begin filling my mouth. I don't even have time to feel nervous or scared. I cannot contain them. They just come tumbling out, a cascading torrent of truth.

"Hudson, it's over. This time it's REALLY over. I have made up my mind. I want you out of my life!"

*Finally!*

For one deafening moment there is nothing but stillness.

Alas, that peace is short lived. Hudson throws off the blankets violently and jumps out of bed. Enraged, grabbing our wedding portrait from the wall, he flings it across the room, sending shattered glass flying. He is a man possessed. Huge flames flare out of his head and spiky horns grow above his ears. He stares me down with beady eyes. This creature is pure evil and I feel like I have finally made acquaintance with the devil himself.

"I feel like killing you." His voice is blood-curdling. "I *should* kill you!"

My guts turn inside out. I am petrified. Who is this sinister monster?

Thankfully, without any more words, he storms into the bathroom and slams the door nearly off its hinges. I hear the shower.

*Come on Kelita, you can do this. Keep your head together, girl. Get yourself dressed. Think now. Grab your coat and don't forget your purse. Hurry, time's wasting, he's going to be out of the shower any minute.*

I fly out of the apartment and, running like a wild animal desperately fleeing its hunter, sprint for two blocks until reaching the nearest payphone. I frantically duck into the booth, catching my breath in giant gulps while rifling through my purse for loose change. *Please, please let there be a quarter!*

That simple treasure finds its way into my fingers and I drop it into the phone. I dial the number, panic filling my head and heart. I hear the ringing. I feel like I might faint. What if he's not there?

*Oh, please God, please pick up. Please, please pick up!*

# PART THREE
# Trust, Treachery & Truth

### Chapter Thirty-Seven
# No More Secrets

I hear his voice at the other end! "Hello?"

Relief fills my heart as words spit out of me like firecrackers.

"It's me ... please ... you've got to come! You have to come get me right away! He's gone crazy. He wants to kill me! Can you pick me up? He told me he wants to kill me! That he SHOULD kill me. Please come, please come!"

"Hold on. Just hold on." Gord's voice is calm and soothing. "Now Kelita, slow down." He pauses for a moment, assured by the sound of my breath. "Okay, now tell me where you are? It's okay, just breathe. Take your time." Gord is calm. Always calm.

"I'm at a phonebooth on St. Clair. I ran here as fast as I could."

"Are you alright?"

"Yes. Yes, I'm fine. I just need to get out of here. Fast. I can't let him find me."

"Okay, just try and calm down. He's not going to find you. You're safe now. You're going to be okay. I'm going to come and get you."

I am hearing his words but I'm not sure I'm comprehending.

"Can you come right now?"

"Yes, of course. I'll come right now. Just tell me exactly where you are."

I think fast. I know I can't stay in this phone booth. Hudson will surely find me here. "Okay, Gord, I will be just a block away but I'm going to hide. Off the main street. There's no way I can stay on this street corner in this phone booth. He will know where to find me. Somehow, he'll just know. I'll watch for you. Please hurry!"

I wait and I pace. A thousand thoughts taller than the Empire State Building pile on top of one another. My brain feels like it is going to implode. I knew this day would come. I just knew it. I tried so hard to not let it come to this. I didn't want it to end this way.

I always tried to talk and reason with Hudson. To end things in a peaceful way. But he never listened to me. Not really. He just saw things his way. He knew how to push my buttons and he liked to see me squirm and cry and be torn in two, suffering because I could never quite make the heavy decision. Always scared. Always just waiting for his temper to flare. To be attacked. Always living in fear. Waiting for this. For this very thing. For him to lose it. On me!

After what feels like an eternity, Gord pulls up. I jump into the passenger side and never have I been so glad to see that friendly face. But there is no time for niceties.

"We have to go to the bank right away!" I am yanking on his arm like a child. "Please! We have to get there before Hudson does. I am afraid of what he might do. We have a ton of cash sitting there from the sale of our house. It's in our joint account."

Gord's voice remains calm. "Okay, let's go there right now." He gently places his hand on my cheek. "Just tell me where, Kelita. I'll get you there and we'll get this done."

## Chapter Thirty-Seven

I spit out directions in a frenzy. "I know he is definitely on his way there. I know him. You should have seen him. He was so angry! I've never seen him like that before."

Gord continues to drive in silence. I pray for every red light to turn green. Please God, please let us get there before him. Please.

We finally pull up outside the bank and I jump out of the car. My adrenaline is off the charts. I force myself to act calm as the teller lifts her head and asks pleasantly, "Hi there and how can I help you today?"

"Hi." I stop and gulp in a few deep breaths. "I'd like to open a new account please. And then I'd like to transfer half from my other account into the new one."

"Sure, I can do that for you. We'll just need to take a few minutes to fill out a few forms for the new account."

I hand her my bank book, nervously looking over my shoulder, sure that I will see Hudson charging through the front door any minute. So far, so good.

I am bouncing on my heels as I wait for the teller to finish up the forms. I know I need to split the amount 50/50. I know what is fair. We have been married for nearly 10 years. I'm not about to try and do anything underhanded. I want to do the right thing. Hudson came into our relationship with the clothes on his back and not much else. It was my inheritance that made it possible for us to get into the housing market in Toronto and to record my first album. I thank God for my parents and have always been extremely grateful for their hard work and dedication. How I wish just one of them was here right now to help me with this mess.

I keep checking over my shoulder. I can sense the teller knows something is going on. Perhaps my nerves are more obvious than I think. Maybe she can smell the fear oozing from my pores? Thank goodness she is moving quickly.

Once the transfer has been completed, I make a mad dash for the car. Gord tears out of the parking spot like we're Bonnie and Clyde. It almost makes me laugh. I do crack a tiny smile as I breathe a small sigh of relief.

As we drive, Gord takes my hand. I feel our chemistry ignite.

And there you have it. Here I am, literally minutes after leaving Hudson, and now without missing a single beat, I'm with Gord.

Leaving my husband is such a huge relief, I have to pinch myself. Have I really done it? Can this really be true? How did I make this bold move now, having failed so many other times? Where did the courage come from?

It doesn't matter. I am overcome with joy, gratitude and love. Or maybe it's just lust? I don't really know. But I have to trust that I'm doing the right thing. For me – right now. Perhaps it's just all part of my survival. For this day. Just today.

I'm not sure exactly what to do but I know I cannot go back home. So, I spend the night in the arms of my new boyfriend.

My new boyfriend. Calling Gord that is just plain weird. My stress levels have calmed and now I feel safe and cared for. It feels right. It feels comfortable. I am so grateful for Gord.

But that doesn't in any way diminish my biggest fear: what will Hudson do now? This time he has truly lost control of me. His threats yesterday give me even more reason to be terrified.

Morning pushes through my foggy mind. As I awake, lying next to the man with whom I have fallen in love, my new reality hits me. As euphoric as it feels to be lying here beside Gord, I'm still in a state of shock. Everything that took place yesterday still feels surreal. And today? I'm not quite sure yet. I feel panic coming on. I need to find out what is happening with Hudson. As elated as I am to be free, a huge part of me feels sick inside. I can't help it.

## Chapter Thirty-Seven

I push back the covers and crawl over Gord to get to his phone. I call my friend Kathryn. She tells me that Hudson is moving out and it's safe to go back. She then picks me up and takes me to the apartment. I am elated to see that our two dogs are fine.

In the next two days I am a walking contradiction. On one hand, I am the lovesick teenager, overjoyed and filled with licentious hormones. On the other I am still that frightened young girl, riddled with shame and fear, worrying about what others will think. It's a wild cocktail of angst, pheromones and adrenaline with a bitter chaser of guilt. And I feel drunk. Seriously, I need a pill or something to slow things down. Numb me out. I have no desire to eat. Weed helps calm me at night so I indulge freely, desperate to take the edge off. God knows I can't imbibe during the day or I'd be a complete waste of space. I need my wits about me!

My heart jumps every time the phone rings. But I do choose to answer. There are many difficult phone calls with Hudson. On one he is sobbing from a payphone at the side of the road. He is a total wreck. Angry, heartbroken and distraught. All those times he accused me of being more than just friends with Gord, and all those times I lied. So many lies. But now, I come clean. This makes him even more hysterical. Because this time he knows I am not coming back.

I have never done anything so shamelessly, wantonly "in your face." Never have I been this rebellious. Never have I gone against so many rules. Never have I cast all caution to the wind. Never have I done exactly what I want to do, with no concern for anyone else.

I have always hidden. Existed in shadows. Tiptoed around the truth. At an early age I learned how to suppress and protect. And I was very good at it. It was my survival.

I guess it's what made me the strong one. But now I am tired of pretending, lying, cheating and living a double life. No more. This is it! I am totally done with being the keeper of all the deep dark secrets.

I don't want to be the strong one anymore.

## The Strong One 🎵

Cover photo of my bestselling album "The Strong One".
Photo Credit: Denise Grant Photography

# Chapter Thirty-Seven

My original lyric worksheet for "The Strong One",
my most popular song

## Chapter Thirty-Eight

# No Big Deal

I am feeling like a new race car driver, drunk on speed, danger and recklessness. Navigating between euphoria and paralyzing fear. I'm crazy in love with Gord and unbelievably relieved to finally be free of Hudson. But my rattled nerves are also real. Maybe it's because Hudson has, for so long, played every single care-giving role in my life. And now I don't have that security blanket. He was everything from lover to parent to friend to confidante to therapist to family to business partner. In the beginning I embraced them all. But time has passed, and I've grown up. I'm a hell of a lot stronger and I don't want to be controlled anymore.

So why do I feel all these mixed emotions?

There is still business to attend to and today's news adds further fuel to the flames. For weeks now I've been waiting to hear from Nashville about my deal with Capitol Records. Day after day and nothing. Until today.

The phone rings and it is Hudson. My heart automatically relocates to my mouth, but I take a deep breath and wait. He gets right to the point. "I heard from Capitol Records today."

"And?" I am anxious to hear. My gut is churning.

"Well, it's not good news."

"What? What do you mean it's not good news?" Now my gut has joined my heart. I feel ill.

"Well, it's just not. The president, Jim Fogelsong, was fired."

I lean against the wall to stop myself from crumbling to the floor. "Seriously? Who's the new one coming in?"

## Chapter Thirty-Eight

"The new president is Jimmy Bowen!" Hudson's tone is oddly flat.

"Oh no, that's not good, is it? All that terrible stuff we've heard about him."

"Yes, and it gets worse. He's already fired all the Capitol staff."

My knees buckle and I sink to the floor. "Oh my God! How awful."

"Apparently that's what he does when he moves to a new record company. He brings in all the people he's used to working with. Any deal in the works is gone!" Hudson is obviously upset.

So am I. "So, it really does mean the deal is dead. Dead before it even has a bloody chance?"

"I'm afraid so."

"Are you sure? Can't we audition for Jimmy? Can't we at least try?"

"I don't know. I didn't talk to Nashville. It was just the guys from here."

Damn.

What now? We have worked my entire career towards this one deal. We have lived and breathed this business. We have sacrificed so much. This was our one big chance! We were THIS close. And now, our dreams of Nashville are shattered. Just three weeks after my life literally hit the ditch, I am left with no husband, no manager and no U.S. record deal.

Hudson breaks the silence, his tone surprisingly matter-of-fact. "By the way, I've decided I'm moving to Nashville. There's no reason I can't still move down there. I'm going to do graphics and design. Besides, I've got to get out of Toronto. My life's over here."

"Oh ... okay." My voice is still shaky after the shock of

the news. "Sounds like a good plan for you. That will be great, Hudson."

What I'm really thinking is, *You're going without me?*

But of course he is. We're separated now. He is free as a bird. He can fly wherever he likes. Why not move to Nashville? But my gut tells me he's got an ulterior motive. There is no way he is going to let go of me that easily. Or my career!

The bright side is it's a relief to know Hudson won't be spying on us anymore. Showing up in parking lots late at night after Gord's gigs and confronting him. We'll both be able to breathe much easier once he's gone.

There is some good career news in all of this mess, and I decide to focus on that. I am going to Los Angeles! I have been chosen to represent Canada on the TV show "Star Search" with Ed McMahon. I auditioned several months ago but never got a callback for the regular show. Now here I am, getting ready to represent my country in a two-hour special - "Star Search International." Maybe it's a sign of better days ahead? This crazy music business actually working out? New adventures for Gord and me?

All I know is Hudson and I will be on opposite ends of the country. And that is a very good thing.

## Chapter Thirty-Nine

# Nashville or Bust

I find myself caught between waves of grief and deep sadness. At times I'm even fighting back the tears. Why on earth am I feeling so emotional? I'm the one who wanted out. I'm the one who's been trying to leave for at least two years. I just want to move on. So why am I feeling tortured like this?

I now realize my bond with Hudson is much stronger than I care to admit. There's a profound attachment I've never had with anyone else. Not like this. We grew up together!

Before him no one understood my overwhelming sadness. My deep, deep heartache. Hudson listened to every word, felt every emotion and comforted me when I finally began to unearth my gut-wrenching pain. He let me bawl my eyes out until there were no more tears. I can still picture us, lying on that single mattress, my whole body sobbing violently while Hudson just held me. Oh God, there was so much death. Mom, Dad, Jimmy. I never truly dealt with any of the losses. Not really. Not until Hudson.

During those years I just survived the best I could. Another starring role in the school musical, another mad boy crush, another weekend booze-fest. Another talk with Jesus. All I wanted was to be normal. When people you love just keep dying you can't make any sense of it. You just can't. And if all that death and grief wasn't enough, I was forced to navigate life in my stepfather's house of fear.

Of course, focusing on all the positive things Hudson and I had only makes leaving him more confusing. Like being in the

kitchen together and cooking a meal for friends. We loved that! Receiving beautiful handmade birthday cards. Being picked up after a tour and coming home to a sparkling house with clean sheets on the bed and dinner in the oven? Magical.

Then there's the artist thing. No one had ever believed in me more than Hudson. Nobody. Whether it was for the right reasons or not, right from the first time he heard me sing, he never stopped promoting me. Never stopped wanting to make me a star.

I know I've done some pretty shitty things. I'm not proud of them. I've hurt Hudson. We've hurt each other. I truly wanted a healthy kind of love and acceptance. Our love, if you can even call it that, always seemed to be based on my performance. At least that's how I felt. I was desperate to be cherished for just being me.

Towards the end I thought therapy might help, but Hudson wasn't willing. I think he was just too scared. I recognize now that, of all the hard things I have done in my life, leaving my marriage has been the hardest. I'm still terrified.

My new reality is no more certain. I don't know what I'm feeling with Gord. Is this true love? Is it lust? I know that our physical connection plays a big part. But he is also accepting of me. Easy to be around. He's not crazy-intense like Hudson. He lets me breathe. Gives me space. His expectations seem pretty normal. But it's too early to tell. Besides, what the heck is normal?

Now that Hudson has been in Nashville for a few months we begin to discuss (by phone) the possibilities of me doing a showcase there. After being this close to the Capitol deal (in addition to all the many years invested in my career) we both decide it would be foolish not to continue our pursuit.

Within days, the wheels are in motion to do a

## Chapter Thirty-Nine

showcase at the famous Bluebird Cafe, one of the world's preeminent listening rooms. As Hudson begins to network with record companies in Nashville, he also begins another kind of networking. The romance kind. I get wind he is dating someone. I am mortified to realize I am actually jealous! I guess it's a kind of self-protection. What IF he can be an amazing loving person with someone else? Is Hudson really changing? Could he be the man I have always wanted him to be? Might there be a glimmer of hope stirring? I am feeling strangely loving the more we talk on the phone. It's messing with my head.

The Bluebird confirms a date for my showcase. My flight is booked. Nashville musicians are hired and Hudson is busy securing the A & R reps from all the major labels. I'm impressed with what he's accomplishing. When Hudson is on a mission there's no stopping him. I do admire that.

Weirdly, I'm looking forward to seeing him. Even happy. I'm feeling a nervous excitement. Obviously, the whole idea of me going down to Nashville and seeing my ex again is not sitting well with Gord. How can I blame him? I would feel exactly the same if it were me. As much as I have kept my confused feelings about Hudson to myself, I know Gord's aware of what I have been experiencing the past several weeks. He's not a stupid man.

I fly direct from Toronto to Nashville. Luxury. I have made that 12-hour drive many times before. But money is tight, so I have agreed to stay with Hudson. I know, I know ... call me crazy! My understanding is that there are two bedrooms in his apartment. That should be okay, right? I rationalize that this is strictly business and it makes financial sense.

The plane lands and I spot Hudson off in the distance, waiting for me. With his long and lanky physique, he's not hard

to pick out. He's wearing a simple white t-shirt and blue jeans. His hair's a bit longer. He's looking healthy. Hudson has never been hard on the eyes. I feel my heart warming. I'm almost embarrassed. I'm a bit unsure about any old chemistry that might unfold. I walk toward him. This reunion is like seeing a long-lost friend.

Hudson speaks first. "Hi Kelita, how are you doing?"

Awkward. What now? Do I hug him? Shake hands? We do nothing.

"I'm great. Just great. Thanks. And you?"

He reaches towards my hand. "Here, let me take your bag." Always the gentleman.

I feel him in my space. I catch his scent. It's familiar. Christian Dior "Fahrenheit." I've always liked that one.

"Oh, thanks," I respond, surprised that I am reacting so positively.

"Yes, really good here too. I guess the flight was a bit late. I called before I left just to make sure. Good thing I did."

"Right. Sure. That's good. Sorry it was a bit late. Good thing you called. Thanks for picking me up."

So awkward. Hudson and me, doing small talk?

"Yes, of course." He flashes his smile. He is so handsome. My heart swells a little.

Together we walk down the long hallway toward carousel number 8. What now? What do I say? Part of me feels like we're twins who have never been separated. Another part, stiff and contrived. This whole thing is uncomfortable and bizarre.

On the drive to his apartment, he breaks the uncomfortable silence with business talk. "I have everything booked to rehearse at 3 tomorrow. You're going to love this band. Killer musicians. You won't need long with them."

"Awesome. Thanks for arranging all that. You've really done

## Chapter Thirty-Nine

a great job, Hudson." My thoughts are running amok. My palms are sweaty. I'm nervous. I feel like such a child.

More small talk is the answer. "It's so beautiful here. I just love Nashville and driving in the countryside".

"Yeah, it's pretty nice alright." Hudson puts his hand on my leg.

*Yikes. What now?*

THIS exact moment. Right now, in THIS car. I'm teetering precariously on a very high wire. I know this is dangerous. What if I fall? There's no turning back. Steady yourself, girl.

His hand remains on my leg until he needs to shift gears. I am frozen like a statue, unable to move or respond.

We arrive at his apartment and Hudson takes my bag down the hall while I stay in the kitchen. He's back in a heartbeat (and mine is beating very loudly) and heads for the fridge. "Can I get you something to drink? Beer, wine, a water?"

*Is alcohol a smart move right now?* "Ah, sure I'll have a beer. Thanks."

Maybe a drink will relax me a bit. I so need relaxing. Hudson pours us each a cold beer and I plunk myself down on the black leather sofa. My legs are trembling and I'm ready to guzzle this beer. It tastes way better than it should.

"This is a nice place," I glance around the room. "Great that it came furnished."

"Yeah, it's got everything I need, really. I lucked out I guess." Hudson sits down next to me on the sofa. He seems pretty relaxed. Not his usual intense self. Maybe he really has changed?

He moves closer. Much closer. I can feel his energy bouncing off my skin. I wonder about this woman he's dating. What is she like? Is he Mr. Perfect for her? How serious are they? I understand she works for one of the major record companies.

He would like that. Having an "in" right here in Music City.

"I've missed you, Kelita." He stares directly into my eyes, unblinking.

Oh God, here it comes. What am I supposed to say?

I stammer helplessly. "Yes, me too. I mean, not me, I haven't missed me, but…oh you know what I mean." We both have a little laugh.

"Yes, yes I do." Hudson takes the beer out of my hand and puts it on the coffee table. He turns his body towards me and leans in. It's confusing. Unsettling. I feel panicky. My armpits are damp. I hate this feeling. But I realize in this moment that even though I am putting it all on the line, I have to know if there is any possible hope for this marriage. Oh God, is that so wrong? But, I need to know.

Hudson leans in even closer and takes my hands in his. I'd forgotten how big his hands are. It's all so familiar. I'm not diving into his arms but my body is heating up way too fast. It's not that I can't wait to jump into bed with him. It's just that I suddenly realize I *need* to let this play out. Once. And. For. All.

He stands up and pulls me from the couch. I automatically do as I am directed. My mind is racing a million miles a minute. What about Gord? What about him? Oh crap, I don't know. I just can't go there right now. I can't.

As if I'm a little child, Hudson leads me down the short hallway. I stare down at my feet. I feel tiny. Not at all like a grown woman. What if I do still love Hudson? What if we really are still supposed to be together.

Maybe I've blown this whole thing? What is wrong with me? Maybe I made a huge mistake. Maybe, maybe, maybe? This can't be wrong because maybe it will be the answer, I've been waiting for all these weeks. This has to be it!

Old habits die hard. We both undress, but not each other.

## Chapter Thirty-Nine

The foreplay is swift and as always, Hudson is satisfied in no time. And me? Well, what about me? It's never really ever been about me. Even when he tries, it feels forced. Never natural, gentle or loving. We don't talk after the sex, but then we never really did. Besides, I have nothing to say. I really don't.

I sleep fitfully, only to awaken to Hudson lying next to me. My body immediately stiffens as he stirs. Lying beside him, I almost feel a repulsion. I feel trapped. Now I know with complete certainty that this is NOT meant to be. But what can I do? I am caged by my own fear, again. It's like Hudson is able to cast a spell over me and I am immobilized. His wish, my command.

I regretfully accommodate, allowing my body to go through the motions. What's left here is nothing but worn-out wishful thinking and an obligatory mandate from days gone by. There is no spark in his kiss. No passion in our touch. No heartfelt connection. I think he must feel it too. How can he not? We are just a couple of robots going through the motions. The very same motions we have endured for years. Except now we are enduring them as if we are strangers.

As the morning sun blazes even more brilliantly, I feel myself surrounded by darkness. A light switch has gone off. Inside of me. That elusive light that always belonged to Hudson no longer shines. The candle has been snuffed out once and for all.

But as the switch with Hudson finally turns off, another even brighter one is illuminated. I am awakened. I am becoming someone new. Someone beaming and radiant. Someone who can shine on her own. Someone who will shine on her own. I know now that I could never blaze fully with Hudson. Never. Ever.

I've changed. I really have.

~~~

The band is made up of some of Nashville's hottest session musicians. I feel spoiled to be playing with them. They sound amazing. The rehearsal is a breeze and my adrenaline is pumping in anticipation of tonight's showcase. This is a big deal!

I am dressed to kill. My black tights and hot pink jacket fit me like a glove. My make-up is done to perfection (I do have tons of experience after all) and my hair is teased and sprayed to the nines.

The club is packed. Hudson has done a stellar job of filling one of the most esteemed rooms in Nashville. There are seven representatives from the major record labels including Mr. Music Mogul himself, THE Jimmy Bowen, Capitol's new president. This guy has worked with huge stars like Frank Sinatra, Glen Campbell, Reba McEntire and George Strait. He really is the only one making me nervous because I know how influential he is. I desperately want to be on that label.

The band vamps the opening number as I walk out onto the stage. The lights hit me and I am immediately blinded. Somebody pinch me, please! I'm playing the Bluebird in Nashville!

The set goes exceptionally well. What a kickass band. They bring my show to a whole new level and my singing is strong and effortless. I can feel an enormous blast of electricity hanging in the air as I soak up the applause after the last song. *Did this really just happen?* I know I did a great job. My bones are tingling! The response is mind-blowing. I honestly could not be happier.

I really feel like this could be the beginning of something wonderful. The next big step in my career, nailing down an international recording contract in the U.S. My dreams are

Chapter Thirty-Nine

about to come true in spite of my separation from Hudson. Life is all coming together as it should.

As the crowd exits The Bluebird, adulation coming at me from all angles, Hudson and I celebrate the evening's success with a few close friends and some cocktails. We all sense that something very exciting is just around the corner. I am desperate to call Gord but I know that won't sit well with Hudson. It's been hard to have even a moment to myself. And after last night it's probably better that I do not even think about Gord right now. I want to enjoy the evening and thinking about what happened with Hudson just sends my blood pressure skyrocketing. Gord is such a sweet man and the thought of him makes me smile but I know I have to get through this night. Gord will have to wait until I am home. Very soon I will be able to tell him all the good news in person. And that other news? Well, I need to make a plan. But not until tomorrow.

Hudson and I return to his apartment and I immediately dart to the second bedroom. I don't quite know how to say what I need to say, so I do what I always do. I retreat. I just hope for the best and say good night. I'm still basking in the glow of the evening but I have the feeling my escape isn't going to go down well with Hudson. I know it's going to be bad. It is Hudson, after all. I just have no idea how bad it's going to get. I close my door and turn off the light.

Heavy footsteps come thundering down the hallway and straight into my room. He bolts through the door like a single-purpose firefighter coming in for the rescue. He flips on the bright ceiling light and starts shouting.

"What the hell are you doing in here?"

I shrivel under my blanket. "What do you mean, what am I doing in here?" I play dumb. I know exactly why he's screaming at me. "I'm sleeping in this room tonight."

Hudson approaches the bed, looming over me like a furious headmaster. "Oh no you're not! You're sleeping in my room. And you need to get your ass back into my bed right now!"

In one split second all my emotions are bombarded. My heart is pounding, my stomach is churning and my mind is a solid blur. Hudson is once again on the attack as I cower on the bed. I am too afraid to speak.

"What the hell?" he screams even louder. "You think you're just going to act like nothing happened last night AND this morning? What kind of a prick tease are you? Oh, all of a sudden you're feeling guilty because you're cheating on your boyfriend? What the fuck, Kelita?"

I wrap the thin blanket tighter around my shoulders. I can feel the tears welling up and my teeth are starting to chatter. But I refuse to give in yet again. Enough is enough. I may be weak and I may be confused and maybe I'm so used to capitulating to Hudson's demands, I don't know any other way. I just know that this time, this one scary, crazy time, I will NOT give in.

"I'm not sleeping with you again, Hudson. It's not right!" I stammer through my clenched jaw. Come what may, I will not allow him to win this one. "I should never have slept with you in the first place. I should have known better."

"You should have known better? You bitch! You're my FUCKING WIFE! If you're not going to fuck me, get out!"

"What do you mean get out?" *He's kicking me out in the middle of the night?*

Hudson points to the door and in a voice dripping with wrath spits, "Just that. GET OUT! There's no fucking way you're sleeping here!"

Now I am really shaking. "Oh my God, Hudson! Don't be crazy. Where am I supposed to go at this time of night?"

He doesn't answer. Just storms out of the room. But before

Chapter Thirty-Nine

I can catch my breath, he's back in the doorway holding the Nashville Yellow Pages.

"Find yourself somewhere else to sleep!" He yells, "GET OUT!" with so much hostility, when he hurls the book at me it catapults through the window, smashing it to bits. Glass flies everywhere.

Still, his rampage continues. He is even more irate. He turns and stomps down the hall, bellowing, "I'm phoning your boyfriend. Right now!"

"What? What do you mean you're phoning my boyfriend?" I call out after him, suddenly scared to death.

"Just what you think it means! I'm calling Gord. He needs to know what you've been up to."

"No, no he doesn't! Don't be ridiculous! Leave him out of it." I continue to cower in the bedroom. I can hear him dialing the phone. "Hudson, are you crazy? Don't you dare." I am screaming. "HUDSON, DON'T YOU DARE!"

It's very late and even later in Toronto but I can tell someone has picked up the phone.

Hudson grumbles in his condescending tone, "Gord ... I just want to let you know Kelita's been fucking me while she's been here. Just thought you might want to know that." He slams down the phone.

I feel like I am going to throw up. I'm a total mess. All the electricity and excitement of the night has just been sucked right out of me.

Hudson has obviously gleaned some warped degree of satisfaction from his phone call to Gord. He cools down and leaves me be. I hear his bedroom door close. There's nothing more to be said between us. At least not tonight. Once again, my husband has shown his true colours. If he can't have me, he will make damn sure no one else will want me either.

What's going to happen now? I'm just sick. Gord won't want anything to do with me. Why would he? How could I even blame him?

I draw the comforter around my head and curl up into a ball of mush. I replay the night's events so many times I finally cry myself to sleep. If there was any warped or unrealistic hope for my marriage it is most certainly gone. Forever. Hudson will never change and I will never again put up with his bullying. There will be no going back.

The morning sun bursts through the shattered window, waking me to a new life and a very large headache. My eyes are puffy from all the crying and my nerves are raw as bloody meat. I dress and pack quickly, dreading the drive to the airport. But it is dysfunctional business as usual. The silence between Hudson and me is welcome. No words of apology. No words of remorse or shame or even hostility. There is simply nothing left to say. Except good-bye.

Chapter Forty

The Crash?

The small plane lurches unexpectedly, causing my tiny plastic glass of water to explode all over my blouse. Great. More turbulence. Exactly what I need in my life.

At least I'm not drinking red wine.

I wish I was drinking red wine. Any wine. I am a bundle of jangling nerves and this bumpy flight isn't helping. Deep breathing isn't helping. Wine wouldn't help either. There is no help for me.

I attempt to mop up the wet mess with the equally tiny napkin the flight attendant served me with my peanuts. It doesn't do much good. The plane plunges yet again. I close my eyes tightly, as if shutting off the view will end the turmoil.

Unlikely.

I have just escaped from a disastrous hurricane in Nashville, and I am heading home to a potentially bigger cyclone in Toronto. There have been a lot of storms in my life. More than most, I figure. And I have weathered them all. And somehow, miraculously, survived. But all that past craziness happened to me. I didn't get a vote. So much unbelievable stuff just happened. But this is new. Yes, this is different. This was all caused by me.

Me.

My fault. My choice. My dumb decision. And now I will have to face the music, and that once-beautiful music may well come to a deafening end.

What was I thinking? How could I have been so reckless?

The empty water glass cracks in my hand as I choke back a sob. In less than an hour this stupid plane will land. That is if we don't crash first. A part of me would rather suffer this airborne pandemonium forever than confront the chaos surely waiting for me at home.

Fasten your seatbelts, says the voice from the cockpit. *This landing may be a little rough.*

My hands are shaking as I click the buckle into place. It's not the landing I am worried about. It's what happens *after* we land that has me terrified.

Have I completely screwed up my life?

Chapter Forty-One

The Return

I finally land in Toronto, expecting the worst. I try to prepare myself emotionally but how can I? I have a feeling that my life is about to implode. When I see Gord, my heart almost jumps out of my body. That's just what that man does to me. It's a physical response, yes, but it's more than that. With Gord I respond deep in my soul.

I feel crushed with guilt. This has been an extremely stressful time for him. We drive in awkward silence. I want him to pull over and stop the car. I want to hold him in my arms and feel his beautiful body next to mine. But I know how much I have hurt him. I fear this will be the end for us.

We arrive back at my apartment and Gord takes my bags up to the front door.

Are you going to come in for a bit?" I ask sheepishly.

"Yes, for sure. I planned on it." He gently places my bags on the floor, puts his hand on my shoulder and directs me into the living room. "Do you mind if we just sit down here?" he asks, sounding very self-assured.

"Of course," I whisper, my stomach now churning. His touch is enough to send shivers down my spine. But when we sit, he chooses the opposite end of the couch. I tuck my legs up under me and fold my hands on my lap. I need to feel less formal. My heart is bracing itself for what is coming. Gord reaches for his back pocket and pulls out a little piece of paper. It's been neatly folded. What the heck is this, I wonder? He opens it as I hold my breath.

"Before we discuss anything about your trip, I want to read something I put together this morning."

Oh gosh, what the heck is he going to say? Is he so nervous to tell me it's over that he has to read it?

"I have had a lot of time to think while you've been in Nashville. There are some things I think you ought to hear from me."

Now my throat is one huge lump. Breathe Kelita, just breathe. He never even let me explain. Anything. There's so much I need to say. Oh God, please don't let this be the end of us. I know what I did was just so wrong. But I needed to know. I really did!

As I look at his beautiful face, I can't help but think what a horrible mistake I made with Hudson. How could I have been so naïve to think he could have changed. To think that MY feelings for him could have changed so dramatically after all he put me through. Oh, Kelita! You foolish girl.

"I suppose you're wondering what this is all about?"

I cannot find a single word. All the words I thought I wanted to say are stuck in my constricted throat. The only thing I can do is nod.

He continues. "I thought it was important for me to let you know exactly what I think about our relationship."

Oh, dear God, please protect my heart right now. Please God, please!

He carefully unfolds the tiny piece of paper and begins to read. I brace myself for the worst.

"Well, first of all, I love that we share the same sense of humour. And we can be crazy together." I stare in silence. Where is he going with this? "We have a lot of common interests like exercise and eating healthy. We love to create music and perform together." Yes. Yes, we do. And …? "We share many

Chapter Forty-One

of the same goals. We're not afraid of adventure and we love to travel. And do a whole lot more. We love meeting new people." He is so good at meeting strangers. "We both would like a family someday." My heart is melting now. I'm trying to hold back but tears are trickling. "We dream of living by the ocean. We both believe something greater has brought us together."

I can't control the tears any longer. I start to sob, gently. Gord moves closer to me on the couch and takes my hand. He puts the piece of paper down and looks directly into my eyes. "And Kelita - we love each other."

Oh God, yes! I put my arms around his neck and give him a huge hug. Oh, how I welcome this man's touch.

My voice is soft and a little shaky when the words finally come out. "Gord, I can't even begin to ..."

"Hold on, I'm not quite finished yet." He takes a deep breath and stares boldly into my eyes. Is this it? Is this when I get the BUT? The reason why we can't be together. In spite of all those reasons we should be together. Is this it?

"Although there are many great things about us, we have to look at the reality too."

I nod without much conviction. "Yes, of course we do. I totally agree."

"You're still married to Hudson."

My heart sinks. Oh God, I know. How could I think Nashville could just be swept under the rug?

"And, at this point, I'm not sure if you still love him. In any case you guys still have a lot of things you need to work out, whether I'm in the picture or not."

I wait for Gord to offer more negatives. He stops talking. The air is thick with the truth.

I compose myself and brush the tears from my cheeks. I wish I had a tissue but I don't, so I just use my sleeve. I sit up

straighter. Part of me wants to crawl under this couch but I push through. I hold my head up. I swallow. I've never been one to embrace confrontation. But this is different. I have no choice. This moment could very well change my entire life. I need to be strong. To be and act like the woman I have become.

I break the silence. "Gord, what you just did was the most beautiful and heartfelt gesture any man has ever done for me." His face begins to flush. "I agree with every single thing you said about us and our relationship. And our future together." My voice is beginning to crack now. Tears are coming once again. "And I know I messed up royally in Nashville. I can't even find the words to tell you how sorry I am. I know I hurt you. I feel just dreadful, especially for that call. It was horrifying! I hope you'll be able to forgive me. I can assure you everything is over between Hudson and me. No question."

Gord doesn't move a muscle. He just sits and hangs on to my every word. Oh God, what is he thinking?

"The truth is, I didn't trust myself enough." I gently take his hand with both of mine. "I didn't trust us." I squeeze hard. "I guess I didn't trust enough in God either. I know that He's the one who brought us together. I know that now more than ever. I truly do."

Our bodies reunite in the most tender, loving embrace. "You make me so happy." I can feel the warmth of his sweet breath on my neck. My body can never resist his electrifying touch. "You're the only one I love." He draws me even closer. My hope is being restored as we savor this special moment. All my doubts and worries begin to dissipate as Gord holds me in his arms. I feel protected and cared for.

"I love you so much," I softly whisper.

"I love you so much too," he whispers back.

Chapter Forty-One

"Thank you for accepting me, and all my baggage. I don't ever want to lose you."

"Don't worry, you won't."

I believe him.

"Don't ever let me go, okay?"

"I've got you, Kelita, I promise."

We both pull away ever so slightly. Just enough for us to realize our lips are desperate for each other. What a kiss! God, I love this man!

It seems crazy that the evil Hudson perpetrated (and that I succumbed to) has instead drawn Gord and me closer together. There truly is a God and He is truly good.

Unfortunately, nothing good comes out of the magical night at The Bluebird. Nothing from our time, money and planning. Nothing from Hudson's efforts or my talents. Zero.

Jimmy Bowen at Capitol thinks I am very talented but quite honestly doesn't know what to do with me. His label is preparing to launch Garth Brooks within months. I guess Mr. Big has much more important things to think about than try to figure out what to do with a pink songbird from Canada.

Once again Nashville scorns me. And once again I try my best to understand why. I just can't get a break. I've been so close. So very close. I guess I just don't fit into a mold. Any mold. I am too unique. It's a blessing and a curse.

There is good news though. Very good news. The two things I went to Nashville to find out have most definitely been determined. Sure, the career one leaves me extremely frustrated and sad.

But the other? The other leaves me with more certainty and hope than I have ever felt.

When You Rewrote My Heart ♫

Chapter Forty-Two

Searching for God

Gord and I connect on a deep spiritual level. We are both on a sacred journey and it's one of the passions that really draws us closer. We love to curl up on the couch in front of the fireplace and talk about life; why we think we're here and why we think we've met each other. We both agree there is something far greater than the two of us. You might say we're seekers looking for a place to belong, to call home, and someone to journey alongside.

I've been through my own stages of seeking so I'm certainly no apprentice. I've always been attracted to the spiritual realm. Whether it was my family's Ouija Board or my fascination with channeling the dead (yes, I tried many times as a young girl!), the divine and metaphysical have always intrigued me. My brother Jimmy could transport himself out of his own body with self-hypnosis. He tried to teach me, but I never had much luck. Billy once visited an old, haunted house that belonged to his buddy's grandmother. He said the dead grandmother showed up and really spooked them.

What I've been experiencing since the accident is definitely spiritual. Now that I know for sure that Hudson and I are truly over, I finally feel free. FREE for the first time in my life! It's as if somebody has literally turned the cage upside down and dumped me out. Crawling out of that cold dark ditch without even a scratch was nothing short of a miracle! I knew that night I had to surrender every part of my life. I figured I must be here on this earth for something. Something much bigger than me.

Chapter Forty-Two

Every day I'm becoming more alive! In heart, body, soul and spirit. After being held prisoner inside myself, controlled by other relationships for so many years, I feel like I'm embarking on a time of transformation and rebirth. It's exhilarating and frightening at the same time. But I am okay because when I survived that crash, I surrendered to whatever is meant to be.

I've read the actress Shirley MacLaine's book, "Out on a Limb," about her journey with reincarnation, meditation and mediumship (trance-channeling). I've chanted with the Buddhist neighbours who used to live above me. I've been corralled by some 'nice' Church of Scientology 'friends' on Yonge Street in downtown Toronto. I have also been exposed to a plethora of other New Age practices. I've gone to psychics, palm and tea-leaf readers and had my numbers and horoscope done. I had a friend read my Tarot cards. Some of her findings were uncanny.

There isn't any question where all this awakening is coming from. A fire is being reignited. I've been touched by this familiar flame before. I recognize this Spirit. It's the same Spirit that manifested a life-changing impact on me at 11 years old, when I wrote my first song. The same Spirit that moved me as a young teenager, kneeling on a set of stairs, where I embraced the love and forgiveness of God. And the powerful Spirit that brought me comfort and strength as I watched my dying mother. That's the one. The Holy One.

I know God loves me. I can literally feel the healing taking place in my heart a little bit more every day. And forgiveness? God knows I have a lot of that to earn. It's coming. I know I also have to forgive myself. That's the hardest one and hopefully, in time, I'll find appropriate room in my heart. I do feel like a huge weight has been lifted. I don't have to carry all of this on my own any longer.

There isn't any question whether Gord and I believe in God. We do. So now what? Where do we go, what do we do? What does this all mean? How do we take the next step? We're anxious to find out and so we begin to start looking for a church. There is one just up the street, so I suggest we begin there.

As soon as we settle into the hard pews of St Clair Catholic Parrish, we discover we are by far the youngest people here. I mean seriously, it's just old people and their even older parents! Neither one of us has ever really been exposed to the Catholic church but we both sense immediately that this is not where we belong.

We give up. But only until we move into our own place. Yes. Our own place. Together!

Our friends Joe and Ruth have just relocated to my old stomping grounds at Avenue Road and Lawrence, the very same place where Hudson and I had owned a house for many years. Gord and I both love the area, so we ask our friends to give us a call if they get any leads. They call us the very next day! Their neighbours are moving out.

We visit the little bungalow and are greeted by a nice couple who are happy to show us around. They pass our information on to their landlord and the deal is sealed in no time.

Gord turns into a big kid when we learn that our landlord is Frank Mahovlich, former hockey great with the Toronto Maple Leafs. Soon Frank is receiving our autograph every single month. What a lucky guy.

Once we're settled, we get back to locating our spiritual home. We are both looking for the same thing – a congregation that resonates with our beliefs and our demographic.

Sunday turns out to be a beautiful spring day, so we decide to walk to the modern new church we've heard much about.

Chapter Forty-Two

Unfortunately, our walk takes longer than we anticipated, and we arrive at the church late for the morning service. We're greeted at the entrance by a very friendly woman.

"Good morning and welcome. My name's Linda. We're so glad you could join us today. I don't believe we've seen you here before. Would you be so kind as to sign your names in the guest book before going into the sanctuary?"

We do as requested and then quietly scoot in, trying not to draw attention to ourselves. We are the last to be seated. The organist stops playing and a middle-aged man in a white flowing robe appears behind the pulpit.

"That must be the minister," I whisper.

"Ya think?" Gord softly mutters into my ear. I give him a poke in the ribs. He likes to make fun of me. We sit closer and I snuggle into his firm body. I love sitting beside him. I love everything about this guy. The fact we're here in this church together just makes me adore him even more. Hudson would have never done this.

"Good morning, my good friends. Praise God we are alive and here to worship our Lord on this glorious spring Sunday."

Nice. He sure seems upbeat!

"Before we get started with our service we would like to acknowledge and introduce those guests in our congregation who are visiting with us today."

Gord nudges me. My morning brain isn't quite computing. Did I just hear him correctly? What does this mean?

The minister looks down at his notes. "We are so blessed to have Gord Lemon and Kelita Haverland visiting with us this morning."

Gulp! Oh my, he's really serious.

"Where are you folks sitting?" He scans the sanctuary looking for any sign from Gord and me. The other congregants

are eagerly looking with him. I give the minister a shy little wave.

"Ah, there you are. Would you stand for us, Gord and Kelita? Please."

Gord and I stand sheepishly. The whole church turns around to look. The minister continues, "Let's all make them feel welcome."

Everyone begins to clap. I grab Gord's hand and squeeze. Oh God, this is so uncomfortable. We both give awkward smiles. "Thank you so much for being with us today," he concludes with a big grin.

We slump down into the pew. We're both feeling very small as we settle ourselves. I do not EVER remember this happening in the churches I've been to.

The service concludes and the organist begins to play. The minister steps down from his pulpit. Now is our chance to hightail it out of here. Except the good Reverend is not leaving the same way he entered. No, he's now walking down the aisle toward the back of the sanctuary. Oh gosh, he's heading right towards us. So much for slipping out unnoticed. Like in a wedding, everyone is exiting their aisle and graciously following in perfect order. The minister takes his place at the entrance and begins his final ritual of the morning.

As we wait to exit, we observe every single person being personally greeted by him. For the men it's a hearty handshake. If you are a woman or a child, you receive a kiss! Yes, that's right, a kiss. Not on the lips of course, but nonetheless it does seem rather strange. We have no choice but to accept his salutation. I hold my breath praying he won't plant a kiss on me. He does not! We say our hellos and good-byes and decline the invitation for coffee in the church basement.

"Well, that was quite the personal welcome for our first time."

Chapter Forty-Two

"No kidding," Gord chuckles. "Rev Davies sure is friendly."

"Extremely!" I still can't make heads nor tails of what just happened.

The following Sunday we decide to go back for round #2. We're actually recognized by a few people. We almost feel famous. When the service is over several people practically beg us to go for coffee-time down in the basement. We decline as courteously as possible. After all the kissing is done, we leave the building.

"We really did give it a good chance, don't you think?" I ask, as we begin our walk home.

"Yes, we did Kelita." Gord reaches for my hand then turns to me. "But honestly I don't think we're feeling this place."

"I know. You are so right. Oh well, it's too bad because it is right up the street."

"Don't worry, we'll find the right fit for us." Gord is always so positive.

The following Sunday we decide to try another direction. We walk the other way and barely 300 feet from our front door we discover another church.

"Do you know that in all my years of living in this area, I have never seen this church?" I am astonished.

"Seriously?" Gord looks at me dumbfounded. "It's only five blocks away from your old place."

"I know!"

"How long did you say you lived in this area?"

"Hudson and I lived here for nine years!" I point. "And look, it's right behind the Post Office. We used to come here all the time. Sometimes even two or three times a day. I know it's crazy."

Crazy.

When we walk through the doors of Melrose Baptist we are

welcomed by another friendly greeter. We'll have to wait until after the service to find out just how friendly. Gord and I sit near the back and enjoy the white-haired lady tinkling on the piano. A small group of singers leads the rest of us in song. It feels so good to be back in a church singing an old hymn. Suddenly I'm transported to my childhood. I can almost smell the pages of that heavy old hymnal, full of songs written by devoted men and women. I've missed this.

A rather slight man with reddish-brown hair and beard, dressed formally in a suit and tie, welcomes his congregation. An air of humility flows from behind his timid smile as he greets his flock with loving words and caring eyes. His spirit is so much different than the kissing minister. Together, Gord and I read from the program handed to us. I point to the pastor's name. It reads Pastor Duguid. We look at each other and smile.

"Do Good!" I giggle under my breath. Gord squeezes my hand knowingly. It feels so good to be sharing in our search together and this is just plain funny!

Softly asking us to bow our heads with him, the pastor begins to pray. I am instantly engulfed by a tangible presence that washes over me from head to toe. A true reverence surrounds this meek and unassuming man. I can tell his heart is tender. As Pastor Duguid begins to read from his Bible and share his message, I feel I am the only one in the sanctuary. Every word is just for me.

How could he possibly know? I have never met this man before. He does not know me or where I have just come from. How does this Baptist preacher manage so easily to reach inside my heart, my soul, my very being? The message he shares penetrates with such a beautiful expression of love and hope.

Tears begin to roll down onto my Sunday best. My heavenly Father is wooing me. Wooing us. My heart knows there is no need to search for the perfect church any longer. God has led us to

Chapter Forty-Two

our new home. For nine years I lived only five blocks away, drove by this street hundreds of times and did daily business around the corner from its front doors. And now here we are, living less than a block away. How does that even happen?

Every week now, Gord and I are happy to get up on a Sunday morning and walk to our church, only steps away. Every week the same thing happens. We both feel like Pastor Duguid is speaking to just the two of us. I reckon God has plans for us and does His best through this humble preacher man to keep us coming back for more. What does He know that we don't?

Gord has been searching as have I, but he doesn't really have much of a "church" background. His parents sent him to the United Church Sunday school a few doors down from where he lived. That quickly ended the week the minister preached on tithing and then showed up the next Sunday with a brand-new car. Before Gord even met me, he was drawn to a group of fellow musicians who intrigued him with their peaceful demeanor and overall spirit of generosity and kindness. He saw something special in them and wanted what they had. He recognized an emptiness and longing for that untapped fulfilment in his own life.

Somewhere in the weeks and months that follow, Gord makes a commitment to God. For him there is no crazy conversion. No bolt of lightning and no emotional alter call. Simply, through the consistent messages of Pastor Duguid and the love and acceptance showered on us by our new Melrose church "family," Gord surrenders himself to a life following the teachings of Jesus.

Together this is where we will forge our newfound love and our faith.

My Sweet Lord ♫

Chapter Forty-Three

Change of Life

It is a given that Gord and I will be married. Our love simply cannot be contained without an official union. As soon as my divorce is finalized, we get right to it. Our engagement party is set and just before guests begin to arrive, Gord spray-paints a huge heart on the outside of the dilapidated green garage at the back of our property. I am thrilled. He actually does have a romantic bone in his body!

Everyone (including our church family) is excited to hear our news. We do receive some counsel from Pastor Duguid who expresses concern about our living situation. He feels that, as Christians, we shouldn't be living together before we're married. Well, we're a little too late for that and moving into separate places for a few months isn't practical. But, out of respect for God and our church, we decide to abstain from sex.

Yes, you read that right. No sex. None. Zippo.

An interesting exercise since we share the same bed. But we believe our desire to do the right thing in the eyes of God will help us find the discipline and strength we need. I'm sure some might think we're more than a little crazy, so we keep this secret to ourselves. Since beginning our new faith journey, I'm sure our friends already think we've gone over the edge. Most of them don't really understand.

Since this is my second marriage, I'm not needing a traditional wedding. However, this is Gord's first. I know he wants to be greeted by his bride in a flowing white gown. And so does his mother. He's an only child so I acknowledge there

Chapter Forty-Three

will be certain traditions intact for our wedding. I want to be fair. Our neighbours Joe and Ruth agree to stand up for us. I borrow Ruth's wedding dress and it fits me perfectly. The man responsible for us meeting, John Allen Cameron, agrees to walk me down the aisle. Gord and I have written a love song, and I will sing it to him during the ceremony. Sure, it's a bit cheesy but we are very much in love.

Nobody from my family attends the wedding. Perhaps they think *Here she goes again!* The truth is I don't know and I'm not bothered. Living so far from family for so many years, I've become used to very few visits. I am sad my sister Vian isn't coming. But she has so many struggles in her life right now, in addition to being a full-time nurse and mother to two kids, with another on the way. I've come to accept I can't expect much from her. It doesn't mean I love her any less. Probably even more because I hate the horrible situation she finds herself in. I still worry about my baby sister.

We have a beautiful, simple candlelight ceremony on Canadian Thanksgiving weekend. Sunday is chosen so that our musician friends can attend, as everyone will be working on Saturday night.

So many of our church family from Melrose witness the happy celebration. They embraced us that fateful day we walked through the doors. We're grateful to be a part of an exceptional group of Godly people. They have prayed for us, invested time in getting to know us and modeled what a loving Christian family looks like. We love them and they love us.

After the ceremony and stand-up reception at the church, a small group gathers for a lovely dinner at the Bradgate Arms Hotel. Afterwards Gord and I head up to our room for a romantic celebration *à deux*. Our honeymoon suite is only steps away. Thank God, because I am beat. Weddings are hard work!

Romance doesn't come naturally to my new husband, but I insist he carry me over the threshold of our boudoir. Gord is much steadier than I am, thank goodness. I'm afraid I've had a bit too much wine and my energy is waning.

"Now for the special champagne!" Gord announces with great anticipation. His grandfather, who passed away at 98, left a bottle of very old champagne (circa 1969), for his only grandson's big night. Gord wastes no time as he pulls the chilled green bottle out of the silver ice bucket.

"It's been waiting patiently for us," he chuckles. "Heck, it's practically been waiting a lifetime." We laugh together as Gord readies himself to pop the cork and I eagerly position the two champagne glasses.

"You set?"

"Okay, I'm ready."

"Brace yourself. Here we go!" Gord carefully pulls the cork. Nothing happens. No pop, no fizz, no nothing.

"Oh no!" I moan, disappointedly. We do not have a backup.

Gord gingerly pours a little of the yellowish-brown liquid into one of the glasses.

"Oh gosh, it's so old it's completely gone flat." I haltingly take a sip. Big mistake. "Oh yuck. How old did you say this was? We can't drink this!"

Oh, come on. How bad can it be?" Gord never likes to waste anything. He sips and his face says it all. "Yup, you're right. Pretty bad."

So much for our romantic champagne toast.

We laugh together and then embrace, falling into a beautiful kiss. A nice long romantic kiss. But much like the ancient champagne, there is not much pop here either. We're exhausted from an extremely long day and our bodies simply

Chapter Forty-Three

fizzle. We both land on the bed and fall asleep fully dressed. So much for a wild night of matrimonial bliss!

Arriving back at our house the next morning, we discover lipstick scribbled notes on every window and mirror. We should have known better than to leave our keys with our neighbours Joe and Ruth. Such pranksters!

We pull out of our driveway with rattling tin cans dragging behind us. The same culprits have written, "Honk if you're horny!" on our back window. We both laugh. We are officially now husband and wife so the sign we are displaying is quite apropos, especially after our months of abstinence.

Our honeymoon in the breathtaking countryside of New Hampshire is lovely. I feel blessed and very grateful. Gord has changed my life and he has changed me. I wish for our love (and this honeymoon) to last forever!

However,… my darling husband has talked me into coming home early. So that he can play hockey! *I am not kidding.* I am so in love with this guy that I agreed to cut the honeymoon a few days short so he can play on the ice with the other boys. I do my best to understand that it is the finals, after all. But come on … it's not the NHL. It's a beer league! And this is our honeymoon. But I am so madly in love, so I acquiesce.

After our romantic getaway, it's back to life as usual. Our physical relationship returns with gusto and thank goodness. Because now that I'm Mrs. Lemon I'm feeling my clock ticking. At the ripe old age of 33 I am physically aching to have a baby. The timing is perfect since I'm in between albums. That might sound funny, but for a recording artist, it's reality. The time is right to start a family. For my hormones, it's definitely time.

We visit Pastor Duguid and ask for his blessing. He prays for us, asking for God's will in our decision. God's will is pretty resounding.

"I'm pregnant!"

First time's the winner.

"Wow, that was some prayer!" Gord reacts, a bit stunned.

"I know! It all happened so fast, but we prayed and God answered. If that's not a sign, I don't know what is. This is obviously meant to be!"

I am over the moon excited! Being caught up in my own world of emotions, I naturally assume that Gord is every bit as excited too. But right now, he just looks like he is feeling the weight of all the responsibility. That's it.

I try to assuage his fears. "Honey, you're just a little bit shocked, that's all. I have no doubt you'll be an excellent dad. You'll be amazing."

He doesn't sound convinced. "Yeah, I'm sure I will be."

"I know exactly where and when," I gloat.

"You do? How do you know that?"

"When I drove to meet you when you were on tour with Frank Mills. The Red Carpet Inn? Remember?"

"Oh yeah," Gord smiles ever-so-slightly. "Guess we'll be able to tell our first-born their conception got red carpet treatment."

Indeed. Not that the carpet in our room was red but I did get a good look at it when I stood on my head that morning, after sex, while Gord showered. My little gymnastic display must have done the trick.

I have an excellent pregnancy and love the whole experience. Never sick once, I am constantly craving fresh fruit. Showing off my belly, I even make a TV appearance, as a presenter at the Canadian Country Music Awards. I am glowing with my baby growing inside of me. God has taken my life and completely flipped it around. With all the positive reinforcement, many old wounds continue to heal. My heart is in a safe place. Even

Chapter Forty-Three

with the many frustrations of the music business, my life is truly blessed. For the first time, my career isn't the most important thing to me.

While waiting for this baby to be born, Gord and I are busy recording demos of all the new songs we've written. We are trying our best to come up with a memorable name for our makeshift studio in our little dark and dank basement. We decide on KGB Music. Aka Kelita and Gord's Basement. *"You vill record here and you vill like it!"* Not a very glamorous name but neither is this basement. Every time it rains, we get an inch of water and have to use old newspapers to sop it up. And when we need to record vocals and it's cold outside, I have to dress up in full winter gear because we have no choice but to turn off the loud, oil-burning furnace.

But we're happy creating and making music together. For me, along with the baby growing inside of me, this is a dream come true. We have already picked out his name. HIS. The way this baby is moving around, I am quite sure it is a boy. And he will be called Keldon. Kel from my name and Don from Gordon. Much better than Gordita!

Keldon is quite happy to take his sweet time entering the world, but enter he does after over seventeen hours of labour. My happy world is now complete. Our sweet baby, Keldon James Lemon, is in my arms. Our beautiful child has finally arrived to fulfil that deep longing that only a woman truly knows, and he is perfect in every way. We are madly in love with our precious gift from God.

How could we possibly be any happier? I cannot imagine life being more perfect.

Nor can I imagine the heartache that is waiting on my doorstep, preparing to barge into my sublime little world and annihilate this hard-earned bliss.

The love birds, Kelita and Gord with matching 80's hair!
Photo credit - Denise Grant Photography

Chapter Forty-Three

Here I am with baby Keldon, I was so thrilled to be a mom.

Photo credit - Denise Grant Photography

Chapter Forty-Four

Rejected

"Do you really have to take that gig tomorrow night?"

I follow Gord in my housecoat as he drags his hockey gear into the car. I am disappointed but I refuse to nag. I make a concerted effort to sound loving. "You only just got home and you've been gone for two weeks. It would be nice to have some time with the three of us. Keldon needs that." Heck, I need that!

"Well, you know I don't really have a choice," he explains, heaving his heavy hockey bag into the trunk. "You know I need to take this gig, Kelita. Plus, I'm playing with some new guys so it's a good connection for me to have. It could lead to more work." He gently closes the trunk. I love that this man always keeps his cool.

"Okay. I know. You're right. I get it." I wrap my housecoat tighter around my shivering body.

"I'll see you later today." He kisses me tenderly on the forehead.

"Later? You're not coming home after hockey?" I pull back, surprised.

"No, I have a session. Then I have to go to Long & McQuade's. I thought I told you?"

"No. You didn't." I know I am starting to sound a little ticked. Mostly because I am.

Gord says nothing. He just gets in the car and drives off like he's a normal husband off to work for a normal day at a normal office. But there is nothing at all normal about the life

Chapter Forty-Four

of a musician. Even one who is also a husband and a father. I totally understand about the gig, I really do. A musician never turns down a gig! Never! It's always feast or famine. So now, Gord is out on the road touring for weeks at a time. Most days I feel like a single mother. But Gord loves playing and he's the one who is supporting our little family. He is doing what is necessary.

It just doesn't seem fair. To me! I have been home with Keldon on my own for two solid weeks and Gord just continues living his life like he always has. I need the three of us to be together, as a family. Keldon needs his Daddy. Why can't he get that? He just doesn't seem to want to make the time these days. I get the work thing, but hockey too? Shouldn't his family take precedence over that?

I hate to admit it, but I am starting to feel something very unsettling. A feeling I don't like one single bit. It's like a stringy piece of spider's web stuck in my hair. I have tried to brush it away. I have tried to wash it out. But this unwelcome 'thing' keeps invading my personal space. And as time passes, I can no longer ignore this silent creeper.

Something is not right. I do not want to go there so I am fighting this. But that old niggling feeling in the pit of my gut will not be ignored.

Lord, I can't bear the thought of more fear, more anguish, more pain. But the signs are all here. They've been playing like an old black and white movie in the back of my mind. I can't shut them out any longer. Am I back to hiding and pretending all over again?

Another day, another night and Gord is still distant. But this time I must wake him from a deep sleep. "Gord, Keldon is really bad."

"Huh, what? He's bad?"

"Yes, his cough. It's gotten worse." Our son has been sick for a few days now. Maybe Gord hasn't even noticed.

He doesn't sound at all concerned. He just sounds sleepy. "Okay, well I'm sure he'll be okay. It's just a cough."

I sit bolt upright. "No, I think he's got croup. It's not just a cough. He's having a really hard time breathing."

"Oh, really?" Gord is still half asleep. "Can't you give him anything for it?"

"I already have. I've done everything I can do. I think we need to take him to emergency." I truly am very concerned. Why is my husband not? "I just had him outside in the cold to see if that might help, but it didn't."

"Okay, well …"

"Well, what?" I'm getting seriously annoyed now.

"Well, it's 3 o'clock in the morning. The gig went late and I've got to get up early."

"Yes, I know what time it is. And your son is sick!" I'm yelling but I can't help myself. Doesn't he care about his son?

"Can't you take him?" He pulls the duvet up over his eyes, as if to block me and my words completely.

"Are you kidding me? You want me to take our baby to the hospital by myself at 3 o'clock in the morning while you stay in bed?" I'm ready to really lose it now. Gord remains silent. "FINE!" I yell as I stomp out of the room.

It's freezing outside so I bundle up Keldon and throw on my coat. The poor little guy continues to struggle as his cough deepens. He sounds like a barking dog. What the hell am I doing?

With Keldon in my arms, I head back to our bedroom and angrily flip on the light. "Gord, you need to get out of bed and take us to the hospital. I am not doing this on my own."

I am seething. But more than angry, I am hurt and sad that

Chapter Forty-Four

my husband can only think of himself and his frigging lack of sleep. Can we talk about my lack of sleep, just once? Can we talk about co-parenting and partnership?

Finally, he drags his guilty butt out of bed, gets dressed and off we go. Thankfully a run of antibiotics does the trick and Keldon is fine. If only there was a pill that could fix my marriage!

Our little family is disintegrating. Many times, Gord will insist that only one of us go shopping and run errands while the other stays at home with Keldon. Practical, maybe, but this means the three of us rarely go out as a family. When Gord is home, he immediately escapes by doing long runs, playing hockey, watching mindless TV, practicing bass, writing music and performing as many late-night gigs as he can possibly handle. Where is the family time, the couple time, the fun times? What happened to the conversations that we used to have? The laughter? The connection? Am I overreacting? Am I making too big of a deal out of this?

Sadly, I don't think so. Gord's selfishness was there from day one. But when you're crazy in love with someone you tend to ignore these things. Looking back, I'm sure I was blinded by infatuation. You see, Gord is an only child with a doting mother and I'm sure that played a huge part in his development. He's used to getting what he wants when he wants it. Don't get me wrong - he's not some horrible, demanding person. He's just used to things going according to his plans, fulfilling his needs and his desires. He doesn't know how to give unless there's something in it for him.

I realize now that we were only about four months into our marriage (around the time when I got pregnant) when the distancing began. At first it was the lack of sex. Any interest in my developing body was gone. I simply chalked it up to

a normal response to a pregnant wife. I tried not to take it personally, but that's a hard thing to do, especially in that delicate condition.

Once Keldon was born and I was a nursing mother, things weren't much better. One cry and everything went downhill. Gord had never really experienced babies or small children so nothing about parenthood comes easy for him. Whereas me, being a mother is second nature and I love it. But I am also still very much into my husband. I love him. I adore him. I love his body and I want to have sex!

We don't. We just keep spinning on the hamster wheel and I just keep giving Gord the benefit of the doubt. I have to assume it's all part of being a new husband and father. But I am feeling the rejection. It's scaring me. My heart is breaking, piece by piece. It's brutally painful.

Have you ever shaved your legs and nicked the front part of your shin or the back of your ankle? And it just won't stop bleeding? You dab a tiny piece of toilet paper on the cut. It stops for a while but when you check on it again, the blood has trickled all the way down your leg. Sometimes that tiny cut will bleed and bleed and you wonder if it's ever going to stop. Two days later, after you have forgotten all about the cut, you nick the same spot, because it's not quite healed yet. And the bleeding starts again.

That's what my heart feels like. I thought that after leaving Hudson and my former life, things would be different. I thought all the healing had taken place forever. But now the old wound is reopened. And this pain is even worse.

God is the only thing I can hold on to right now. But I desperately miss the feel of flesh and bones wrapped around me. I need my husband, not just the Holy Spirit.

I could grow bitter and angry towards God, but I do not. I

continue to run to Him. I don't always understand the power of His magnetic pull but it has been there since I was a kid. Yes, I wandered far away for many years, but I came back. I have to believe that all things are possible with God. I have to believe that I will get through this challenging time. I sit in my favourite rocking chair and pray constantly. There's a beautiful scripture I'm really holding onto these days: But those who trust in the Lord will find new strength. They will soar high on wings like eagles. They will run and not grow weary. They will walk and not faint. The eagle will not only rise but, soar.

I have a big FAITH, I really do. When I close my eyes, I can see the word in large capital letters burned into my mind. I hold on to God with every ounce of strength I have. I honestly don't know what else to do but keep trusting and believing. I've learned over the years the only way to become a survivor is to just BE one! Admit the truth, face the pain and walk through the fire. Step by step. Denial only prolongs the inevitable. The only way is through.

I am getting through with the help of a few supportive girlfriends. There's also a small group from our church who drive out from Toronto every week to do a bible study and pray with me. We are now living in the suburbs and I miss my old church family. How lucky I am that they are willing to come to me and offer me a safe place to pour out my heart. I am extremely grateful for their support. Being in a new city in the middle of winter hasn't allowed many new friendships to develop.

I have found one dear new friend, Lenora. She's really been here for me through this tough time. We met each other through the country music scene; she is a wonderful musician and amazing singer. Lenora and I became fast friends when we discovered we had so much in common. Our voices blend

really well, and we love singing and recording together. She's also a great sounding board for some of the new songs I'm writing to help cope with all this stuff going on with Gord. It's incredible to have a friend who is also a creative partner. We're a perfect match. You might say we're like sisters. Surely, God is in this. He is looking out for me by giving me such a special friend, especially at a time like this.

Sadly, we also have another thing in common: she and her husband are struggling too. We spend hours on the phone. There's nothing I can't tell her. It all just gushes out like oil in Alberta.

"Oh Lenora, it's nice to have someone else who can understand even just a little of what I'm going through. I try to make sense of it all, but I honestly don't know. Maybe I'm just imagining more than what's there?"

"What do you mean, exactly? What's there?" Lenora asks gently.

"Well, every time I ask him what's wrong, he just shrugs it off. Says there's nothing wrong. I just don't get it because it sure doesn't feel that way to me."

"Maybe you are reading too much into it then," Lenora offers.

"I don't know. Maybe. What about you guys? Do you talk to Bobby about how you're feeling?"

"No." Lenora pauses, like she's not sure how much to tell me. "He's not very good with talking about anything that's too deep. We don't go there. It's kind of always been like that."

I'm surprised. "Really? Gee, that's not good. Do you and Bobby ever fight?"

"No. Hardly ever." Another pause. "Do you?"

I laugh, even though this is in no way amusing. "Funny, we don't ever really fight either. Except lately I have been getting

Chapter Forty-Four

so frustrated. I don't know if screaming and yelling would help, although I feel like I want to. He just seems to be lost in his own world or something. He doesn't share much of anything. Not like he used to. Not even close."

"Oh wow," Lenora murmurs in a hushed tone. "That's tough."

"Yes, it definitely is." I take my time before I ask the next question. "Can I ask you something really personal?"

"Sure," she responds, a bit hesitantly.

"What are things like for you and Bobby in the way of physical intimacy?" There's silence at the other end and I quickly apologize. "I'm sorry, maybe I shouldn't have asked that. You don't have to answer."

"No, it's okay. We don't really have much of that going on."

"Is that because of you or him?" I am peppering her with questions, and I know this is really personal, but I just need to find out. I need something to compare us to!

"I'm not really interested anymore. I haven't been for a long time now." Lenora sounds quite matter-of-fact.

"I'm sorry to hear that. Must be hard." Why is she not interested? I sure as heck am still interested. I don't get it. "What about Bobby?"

"Sometimes, yeah, and then I have to do what I have to do. Not very often though."

This all sounds just like Gord and me, only in reverse. "Do you still love him?" I have to ask. Only because I have no idea if Gord truly still loves me.

Lenora responds quietly. "I love him but I'm not in love with him. There's a big difference."

I remember. I felt the same about Hudson and it was literally poison for our relationship. "I know. Of course there is. But isn't it hard being in a marriage where you don't feel that passionate kind of love anymore?"

It's hard for me, this I know for certain. Except I am on the receiving end of indifference and it's killing me.

"Bobby and I probably should never have gotten married. We were just kids. Not much more than friends, really."

"Oh, wow. Just friends? Never like madly in love even at the beginning?"

"No, not really." Poor Lenora sounds so resigned. And sad.

But I just cannot wrap my head around this. How can you marry someone you aren't in love with? "So why did you marry him, do you think?"

"I wanted to get out of my house. And away from my mother. I felt trapped at home."

"Oh, okay, well that makes sense. No one likes feeling trapped. I know what that's like." Boy do I ever!

I feel very bad for my friend. She never loved him that way. And then married him? How sad is that? "I've been praying for you guys," I tell her kindly. And I mean it.

"Thanks, Kelita. I appreciate that." I know she means it too. Lenora always sounds sincere when I talk about my faith and how much it continues to help me.

"If it weren't for God, I honestly don't know what I would do right now. Ever since my car accident my whole life has turned around in so many ways. I hope you can find strength in God, Lenora. It's helped me more than I can ever explain. You just have to trust Him and let Him guide you through all of this. That's what I'm doing. As tough as it is for me right now, I am totally trusting God will change Gord."

I can tell she is really listening. And absorbing. I love that about my friend. I truly want her to know what I've experienced since becoming a Christian.

~~~

## Chapter Forty-Four

As the months pass, Gord and I become more and more like roommates. There is very little physical contact and all emotional intimacy has vanished. It seems that, ever since we got married, I have been chasing my husband. He always seems to have one foot out the door and I'm always reaching for his coat tails. I can just never grab on. He keeps running away. Over and over again. In every sense.

I can't help but feel like there is something drastically wrong with me. Why else is it that people can't just love me? Why is there never a sense of peace in my soul? Why am I being tortured by someone that I have chosen to love, to invest in, to make a home with and together, bring a child into the world? It's impossible for me to understand why this is happening.

While Gord continues to run away, I continue to hang on tightly to God. What does that look like, you might ask? How does one hold tightly to the almighty Creator, the Holy One, the God of the universe? How can one hold on to a Spiritual force? I focus on my strong belief that the supernatural power I am tapping into will empower me with a strength that is far beyond anything on this earthly plane. I will endure this phase Gord is going through. We will come through this difficult time. I have to believe. I simply have to. My very existence depends on it. God will turn my husband around. Gord will take responsibility for Keldon and me and we will be a happy family once again. He will love me and desire fervently the marriage we dreamed about. He has to. He just has to.

Prayer keeps me going. A constant dialogue. Dear God, I am desperate to be loved by my husband, to be desired by him and for him to want to be a family. I ask you, Lord, what am I to do while waiting for the changes to take place?

Navigating through these murky waters leaves me bewildered and helpless. I think Gord simply needs to have

more faith, more God, more Jesus in his life. I believe that if he just surrenders all of himself like I have he will wake up and see what he has, right in front of him. Doesn't he look at my life and all the dramatic changes that have taken place? Doesn't he know that these radical changes are because of my total submission to God? Submission of absolutely everything? Why is he not getting it? I am so frustrated. Gord says he is a follower of Christ. We go to church together and he confesses his faith. Why is he not acting like it?

Please God, please give me patience and continue to lead and guide me every single day.

I come across a little book called "Lord Change Me" by Evelyn Christenson. It helps me realize that trying to change others and the way they treat us is always going to prove difficult, frustrating and probably impossible. I can only change myself and only with God's help. And so I pray some more: Lord, change me. Help me to find a way to live with the rejection I feel from my husband, to continue to love him even when that love is not being reciprocated. Please Lord, I beg you to help me change and to find the strength to walk this painful road. And, while you're at it, please change Gord too!

I know I shouldn't ask that, but I can't help it. Like a good country song, I still think I can change my man. Okay, not really. I know I cannot change my husband.

But maybe God can?

**Change My Man** ♫

## Chapter Forty-Five

# Double Denial

Days turn into weeks as we continue to endure this relentlessly unforgiving personal journey. However, life and music do carry on. Thankfully, Gord and I have won the bid for the Canadian National Defense Headquarters to produce an overseas show, like the one we fell in love on. This time it's for the Canadian UN Peacekeepers serving in the Bosnian war. I'm excited. Maybe this is the exact boost our marriage needs.

"You're not going to be able to be in this one, Kelita." Gord doesn't dare catch my eye. He just continues changing the strings on his bass.

I am completely taken aback. "What do you mean – not be in this one? Excuse me?"

"I just don't think it's a good idea." He remains calm and detached.

"Not a good idea?" I walk over to the kitchen table and stand right in front of him, my voice louder. "What are you talking about?"

He does not look up. "There are lots of reasons, okay. Let's not make a big deal about this. I've made the decision."

I do not budge. My voice turns to ice. "I am co-producing and writing the show Gord, and now *you're* telling me I can't be in it?"

Gord sighs as he sets his guitar back in the stand. He still won't look at me. "We're performing for a regiment from Quebec, so we need a bilingual cast and you don't speak French, so ..." He trails off.

"So … so what? Not everyone we've hired speaks French! And they're all Canadians, so they all speak English!" I am really irritated now.

"Look Kelita, this tour is different." He finally makes eye contact. "We're going in with a small group to a country with an actual war going on. I don't think it's a good idea for you to go. Besides you should be here with Keldon. He needs you." The resolute tone of his voice is undeniable. The conversation is over. Gord has made up his mind.

I remain cool and silent but inside I am fuming. I turn for the door and head for our bedroom. I need space. I fall back onto the bed, gutted. I wasn't expecting this. Not at all. I understand about staying home with Keldon, but we have left him before. We have our good friends Joe and Ruth who we know will help out. My gut is telling me that Gord's concern for our son's wellbeing is not the primary reason for his decision to leave me behind. I feel sick.

It is profoundly heart-wrenching to say good-bye to my husband as we both go off to war. He is thousands of miles away without any communication, travelling for hours over bumpy dirt roads in the back of army vehicles, wearing bulletproof protection and listening to the sounds of missiles firing at night. I am on the home front, caring for a toddler every day, spending all my nights alone and many hours down on my knees, fighting for what is left of our collapsing marriage.

For me, Gord's two weeks in Bosnia are the most agonizing of our married life. With our relationship already dangling over the precipice, this time apart could be fatal. With each passing day my nerves become more frayed. I am alone with our boy while my husband is conveniently on tour with another woman. Yes, a female musician who, in recent months, has appeared awfully chummy with a man who is not hers. My fears have

## Chapter Forty-Five

been growing in leaps and bounds. When the three of us are together, I'm the one who feels like a fifth wheel. One look at their body language and anyone would think they are the ones who are married. And now here they are, together, without me, halfway across the world.

I lose weight, sleep too much and turn into a frazzled mess. Looking after Keldon (a very busy 2 1/2-year-old) is the only thing that keeps me from becoming completely unhinged. Because of him I drag myself out of bed in the morning. Because of him I force myself to eat, no matter how little. I know I must keep going. God has miraculously instilled in me the strength to remain sane at a time when going crazy could be much easier.

With face washed and teeth brushed, I sit on the edge of my bed ready to climb in for the night. I have been counting days since Gord left. Tonight is number 13. My solo act will soon end. By this time tomorrow Gord will be back in this bed. Our bed.

I sit in the silence listening to my nerves quietly shatter. I have completely exhausted all that was left in me. I look down at my legs. I feel my arms. I have grown frail. These two weeks have drained all the life out of me. I slump down the side of the bed and melt into the carpet. I don't even recognize my own voice as I whimper, *Lord God, I so need to know what is going on in my marriage. Please, I am begging you, show me what is wrong. I need to know the truth. I can't stand living like this any longer. I must know. Please God, please, have mercy and show me.*

Patiently I wait. I wait some more. My eyes begin to burn and then well up. The tears come. Heartsick and grief-stricken, I plead again, *God I need to know the truth. Please show me. I so need to know.*

It is unclear at first but gradually a vision begins to appear.

It's coming into focus. I see my husband. Yes, it's him. He's in a passionate embrace. But wait, it's not with me. No, he's with another woman. She looks familiar. My breathing stops. The picture is much clearer now.

Oh God, it's Lenora!

I bolt up. Blood rushes to my head. NO!! I silently scream. *God, please don't let it be true.*

But my suspicions have been verified. I sit in shock as the realization sinks in. This is not just a bad dream or a false premonition or a delusion. It is the truth. I must admit it. I have been in denial. I don't want to believe what I'm seeing but this must be true. Why would God reveal such a picture to me if it wasn't?

A memory flashes back. I had come home unexpectedly and walked into our recording studio to find Lenora giving Gord a neck rub. She stopped immediately. No one knew what to say. You could cut the air with a knife. Later Gord made some lame excuse. I wanted to believe it was innocent. Of course, I did. Lenora was one of my best friends!

Gradually I pull myself up off my knees and fall into a heap on the bed. I stare at the ceiling. Clearly this is a confirmation from God. He's allowing me to see the truth. I trust in God's presence and that He is communicating with me for a reason.

Somehow, I manage to sleep until, at the first sign of light, my waking toddler needs me. I fetch Keldon from his room and we enjoy a cozy cuddle in my bed. Thank goodness he has no idea what's really going on between his mommy and daddy.

"Today is the day, Keldon." I kiss his forehead gently. "Soon Daddy will be flying back to Canada on the big airplane."

The night has granted me just enough rest to refill my empty tank. But as I think about what lies before me, I want nothing more than to stay right here and sleep forever.

## Chapter Forty-Five

The time comes. I buckle Keldon into his car seat and off we go to the pick-up location. Other spouses and children are milling around. There is a buzz of expectancy in the air as we all await the return of our loved ones. My head is spinning. Knowing what I know now, how can I greet my husband as the dutiful wife, grateful for his safe return? What makes it worse is SHE is returning too. Lenora is the female musician allowed on the tour when I was not! *How very convenient.*

Keldon and I watch the troop step out of the bus, one by one. Finally, Gord appears. Keldon sees his Daddy and runs off to greet him as I stand immobilized. I want to wrap my arms around my husband and never let go. But I also want to fall at his feet, wailing, for the pain that is crippling me. And then there is still another part of me that wants to scratch his eyes out and banish him from my life!

I take a deep breath and just succumb to the pain. I force the anger to retreat. This is no doubt a very good thing, for Gord's sake.

Lenora's husband Bobby is waiting by their car. I give a little wave and he waves back. Lenora steps off the bus but we don't make eye contact. I cannot and she will not.

Gord walks slowly towards our car. He puts down his suitcase and offers me an obligatory hug. Keldon is still holding his other hand so it's more like a half hug. No kiss. I'm doing my best to hold it all together, but I feel like a dam ready to burst. There is an ocean of despair waiting to spill all over this parking lot. I love this guy so darned much, but he is killing me.

While Gord collects his gear from the bus, I catch a glimpse of Lenora and Bobby. Thank God they are far enough away that I don't have to talk to them. I feel like I'm going to vomit. *I thought she was my friend. My best friend.*

Once we arrive home, Gord focuses all his attention on

Keldon. After the boy is played with, fed, bathed and put to bed there is no happy reunion for his parents. No romantic candlelight dinner. No cuddling up on the couch. Not even any catching up on the past two weeks here at home or in Bosnia. Any talk is trite and trivial. Gord is cold and distant, perhaps even more so than before he left. I have just spent fourteen of the worst days of my life, alone, terrified and nearly going out of my mind and his frostiness is a cruel icing on that bitter cake.

I despise him and his dismissal of me as we crawl into our loveless bed. I know he is jetlagged and can't wait to fall asleep, but don't I deserve something? Anything? Can he not even throw me a measly crumb of affection or attention? It is painfully obvious he is not happy to be home.

He quickly nods off. I lie awake for hours. I can feel the warmth of his body next to me and even though I can reach right over and touch him, I feel more alone than ever. The vision I had keeps haunting me. I can only hope we will talk in the morning.

I am up early with Keldon while Gord continues to sleep. My sweet boy is happily situated in the family room, watching Barney, when Gord finally makes an appearance. The heaviness surrounding him hangs dead in the middle of the room. Even though I am on edge, I pray under my breath, *God, help me. I need to know what to do. What to say.*

"Good morning," I croak, forcing the words out of my parched throat. "Did you sleep okay?"

"Yeah, not bad." His voice is emotionless.

"Must feel good to be back in your own bed." How trite can I be? I hate this.

"Yes, always good." He seems uncomfortable.

I need to hear something from him. He has to tell me what

## Chapter Forty-Five

he is thinking and feeling. The suspense is literally killing me. My heart is beating so fast I fear I will collapse at any moment.

He joins me on the sofa and we sit at opposite ends, both staring into space as if the other doesn't exist. And then ... the words come.

"Kelita, I don't love you. I don't know if I've ever really loved you. I don't think we should have ever gotten married. Having Keldon has ruined our marriage." He does not look at me. He does not feel for me. He is a cold, hard statue, spewing unthinkable words with no remorse or empathy.

I am stunned. I was expecting many things, but this is far beyond my worst nightmare. The arrow that my husband has so effortlessly shot straight into my heart has hit its mark. I am destroyed. My world stops.

*Is that it? Is life as I know it over?*

I cannot stand to look at him. The room is thick with silence. I can hear Barney in the next room and even that seems surreal to me. What am I supposed to do now? What am I supposed to say?

After what feels like a lifetime, I find my voice. "Are you and Lenora ... are you and Lenora having an affair?"

"What?" He glares at me, shocked. "What are you talking about, Kelita? Of course not." He actually sounds sincere. "Whatever made you say that?"

My voice is quivering. "Two nights ago, before you came home, I was crying out to God. I was down on my knees praying." I am weeping now and swallowing my own tears as I continue. "I desperately needed to know what was wrong with our marriage, Gord." My words feel strangled as I force them from my lips. "And I saw a vision. It was you and her! And you were very much a couple. Together!"

"What? Lenora and me? What are you talking about?"

"It's what I saw, Gord. Plain as anything."

"Well, the answer is no. Like I said, no."

The shock has overwhelmed me as I stare at my lap, trembling, trying to maintain some composure. "That is what I saw. It's what God showed me. I'm not just making this up." I look up and clasp my hands tightly together. "I just really need to know the truth, Gord. I know what God showed me. I know what I saw."

He is unruffled. "We're good friends. You know that. Come on. Lenora and I work together. That's all." And then, as if to insult me, "You should know that, Kelita. Don't be crazy."

In a flash I second-guess myself. Maybe he's right? How can I possibly be accusing them of such a far-fetched thing? Maybe I am crazy. Foolish. She is one of my closest friends. I must be reading too much into their relationship.

Now I feel guilty and ashamed. How could I have conjured up such a despicable entanglement between our good friend and my husband?

I hear little footsteps in the kitchen. Keldon dashes into the living room bringing his toddler energy and some much-needed levity. Oh, how I love that little boy! He's managed to help keep Mommy sane these past two weeks. I honestly don't know how I would have survived without his company. He runs to Gord and snuggles up beside him on the couch. Seeing these two together does my heart good. It's a healing balm after this tumultuous explosion. I try to compose myself for my little man.

This whole thing is not just about me. How can Gord not see that? I can't possibly bear the thought of our little boy growing up in a broken home. With God's help I am going to do everything in my power to change the way Gord feels about me, about our marriage and about this family. I will never become another statistic. NEVER!

## Chapter Forty-Five

Over the next few days, I stagger like a tiny sparrow with a broken wing, not sure I will ever fly again. I am too wounded and weak to move. The emotional and physical turmoil entwine and wrap around me like a python. This is unlike any heartache I have ever known. My body is wracked with such a heaviness I can barely pull myself out of bed in the morning. Keldon becomes my only purpose.

I have come to realize that for us to move forward, I have to trust that Gord is telling me the truth. I must believe there is nothing romantic between him and Lenora. I convince myself that what I saw absolutely cannot be and that I have manifested the whole deranged vision in my own mind. Call me paranoid or even delusional. Perhaps spending those two long weeks alone without much adult company did make me a little crazy.

Still, nothing can eradicate Gord's poisonous words of rejection and the assault on our relationship and our family. No, none of that can be denied. Some days I feel like my heart is dying, slowly bleeding to death. Life, draining out of me, drop by drop. I wish my mother was still here. I long to lay my head down on her lap and feel her strong yet gentle hand stroke my hair and rub my back. I need her to soothe my worried mind with tender words like, "You'll get through this, Honey" and "I'm always here for you, you know that." I crave her warm motherly kisses and gentle hugs. I need her unwavering strength to pick me off the floor and prop me up. I need her love which is so connected to my heart my pain becomes hers.

What I want more than anything is for someone to acknowledge this excruciating agony. Funny how the absence of my mother has left me gasping for breath, even after so many years. The deep loss continues to impact my life profoundly, especially at this impossible time.

I awake on a beautiful, sunlit morning and make a choice. There is a strength rising up in me. I have decided. I will not fail at making this marriage or this family work. I will keep trusting and believing in something I cannot see. My unequivocal faith in God is reviving me. This unseen power in my life is catapulting me forward. I will pick myself up off the ground. This sparrow will fly once more.

As time passes, I find myself feeling guilty about accusing Gord and our friend of having an affair. I call her. "Lenora, I'm really sorry but I have to apologize to you."

"You do? Whatever for?" she asks innocently.

"Well, when you came back from Bosnia, I accused Gord of having an affair with you." There is silence at the other end. I wait for a response, but there isn't one, so I continue. "And so I need to say, I'm truly sorry for having ever thought such a thing."

"Well ... thank you." *That's it?* I wait for her to say more but there is an awkward silence. The call is very short, unusually short for the two of us.

"Okay, well I'm sure I'll see you soon. Talk to you later."

"Sounds good, talk to you soon. Bye."

I am dumbfounded. But filled with resolve. I will trust and I will believe!

Life goes on. I am a loyal friend, so Lenora and I soon slip back into our old relationship. We continue to confide in each other more and more. In fact, there is nothing I don't tell her.

I am desperately in need of a counselor who can help me navigate through the emotional carnage. I start seeing a woman in Toronto every week. She is a Christian, and all for keeping this marriage intact. Gord isn't abusing me so why would I ever leave? Plus, we have a child and that puts an entire different perspective on things.

## Chapter Forty-Five

Lenora's marital situation isn't getting any better either and she too is looking for a counselor, so I give her the name of mine. Now we are both making regular visits into the big city. I have managed to move past the doubts and accusations. It's just what I do. I have always been an accommodating person.

Months go by and there is no sexual contact between Gord and me. After his heartbreaking confession it would be foolish to expect anything physical. I am seeing his words in action, which means there is none. I am distraught and brokenhearted, unsure whether Gord will leave or stay. For my own protection I go into full denial mode. For me to even function I have to play games in my own head - *Gord and I are okay, at least for the time being.* Sometimes when you're in the middle of a war, staying crouched in the trenches in one place, even in all the muck, is still safer than standing up and exposing yourself.

Gord is clearly staying in a situation he would prefer to vacate. He remains cold and unfeeling towards me but is he a good father and provider. I am certain, like me, he does not want to be a single parent. At least we have something in common.

I continue to get on my knees every single day. I will not give up hope. I will not be defeated. I have BIG FAITH.

**My Faith** ♪

## Chapter Forty-Six
# The Confession

My life has never been this big a mess. My relationship with my husband is abysmal and my career is beyond frustrating. No matter how hard I try, I just cannot catch a break. And even though I love being a new mother and feel privileged to be at home with Keldon, the recording artist/performer in me is aching to get back out there.

My work has been in a complete holding pattern with all these big life changing events. Divorce, new husband, new house, new baby and now a new manager. I've been releasing singles to radio, but I very much need a new album. In this business you're only as hot as your latest release. Radio holds all the power and you need to keep giving them new music. If not, you vanish.

But finally, now, there is a breakthrough. I am ecstatic! With the help of my new manager Val, we've secured an independent record deal, with Sony Music as the distributor. I can't wait to record all my new songs, make some videos and be back in the saddle again.

There is initial talk of using a well-known producer but that's not coming together so my record company and management team decide to hand the producing duties over to Gord. Since the beginning of our relationship, Gord and I have done a lot of writing and recording together. But this is a huge step up. He is now being entrusted with a fair-sized budget and a ton of responsibility. I believe in him and am thrilled we get to do this together.

## Chapter Forty-Six

As we begin working in the studio, the new music is leaning towards country. However, with my newfound faith seeping in, some of the sounds take on gospel and inspirational overtones. As for the lyrics, I'm really putting myself out there. My spiritual journey, my painful childhood and even my struggling marriage have all found a path into these songs. Exposing my vulnerability is darn scary. But I feel as though God is compelling me to face my own truth. I pray He'll give me the strength I need because I sure can't do this on my own. Huge parts of my heart and soul have been suppressed. But God continues to heal me and I am learning what it means to truly let go and to trust Him. As each old layer of shame is stripped away, I am finding more courage to embrace the real me. It's terrifying, invigorating and healing all at the same time. *Thank you, God, for this beautiful gift of music. It has literally saved my life.*

After the band tracks are completed, we start to record the vocals. My favourite part, of course. Lenora lends her voice and talents to the background vocals and she coaches me on a lot of my leads. She and I have always worked well together in the studio. It's exciting now with everything almost completed.

Working with Gord is so good for us. We love what we're doing. We have always collaborated well. From the day we met, music has been a huge attraction and major part of our relationship. He is so supportive of my talent (and I of his). His words are like tiny gifts, so welcome in this desert of emotion. "That was great, Kelita. Your pitch is always so good. That was an energetic performance. You nailed it."

Inside I am beaming. I want to turn around and give him a gigantic hug, but I hold back. I cannot chance further rejection. Physical contact has been rare these days.

I do reach out to touch his hand. "You're doing a great job,

Gord. I can honestly say this is the closest any producer has ever come to making me feel this good about my music."

He squeezes my finger gently. "Thanks for that, Kelita. Finally, you're going to have some new music out there. You deserve to be heard."

My heart skips a few beats and I enjoy every one. It's moments like this that give me the hope I am desperately craving. I can feel a taste of our love for one another. Thank you, God. I keep praying for a miracle and leaning on His strength every single day.

While Gord and I are in the final stages of mixing the album, we hear some exciting news. Lenora has made a decision to surrender her life to God and follow Christianity. We are both thrilled for her. But, considering how close we are and the many conversations we've had about faith, I am rather hurt that she doesn't personally call to tell me the news. Somehow Gord knows and I'm not sure who told him.

We receive an invitation to her baptism where we happily gather with her family and a few close friends. I am so excited for her and even more excited to learn that her husband Bobby is headed in the same direction. Lenora never gave me any indication that she and Bobby were both leaning towards Christianity. I guess we just haven't had as much opportunity for some good talks but still, I am surprised she didn't share something this important. I'll admit I've been so wrapped up with this recording project, maybe the fault is mine? I try not to take it personally, but it sure seems strange. Something's just not right.

After the baptism I rarely hear from Lenora. She is distancing herself from me. I'm confused as to why she is pulling away and a little hurt too.

For Gord and me, that brief honeymoon in the studio ends

## Chapter Forty-Six

and we're back to being roommates. He goes out of his way to avoid any kind of serious conversation. For days on end, I have no idea how he is feeling and if I'm honest, I don't want to know. I'm too scared. We exist as mother and father to Keldon but there is barely a hint of "married couple." Like a cloud, the thick black veil of sadness hangs over us. I can feel myself being sucked back into that vortex where I've dwelled for nearly two very long and drawn-out years.

This morning, I am up early, even before Keldon. I hear Gord rustling in the kitchen. I quickly close my journal (where I have been pouring out my heart to God). Keldon will need his breakfast.

As I fill his bowl with Cheerios, I muster up the courage to speak. "Gord, we need to talk."

He grabs his protein shake. "I have to go out today," he brushes me off. "I'll be gone for most of the day."

We're at the point now where I don't even ask where he's going or when he'll be home. I hear the car start up and then watch him pull out of the driveway. I take my familiar position on the couch, still in my pajamas. No point in getting dressed today. Keldon plays with his cars on the living room rug while I stare out our large picture window, trying not to cry. Something needs to change here. I am at the breaking point. Should I admit defeat? Is it time to do something drastic?

The day passes with me in a complete fog but, after Keldon's bedtime story and prayers, I smother him with hugs and kisses. I tuck him in and make sure his nightlight is on. That's what he likes. I then fold a load of laundry, lock up early and get ready for bed. Before climbing in I slip across the hall and sneak in one last peek at my sweet sleeping boy. He truly is the best thing that has ever happened to me. So full of life and his heart is sensitive and pure. I know with all my heart that we should

now be thinking about having a baby brother or sister for him. We have always planned on more than just one child. I try not to go any further in my mind. My poor heart just can't take it tonight.

I wonder how many other depressed people are going to bed this early. I try escaping into the pages of a book but I can't retain one single sentence. I've done nothing all day but care for my boy, yet I haven't one ounce of energy left to focus on what I'm reading.

All is still until I hear the key in the door. My body quivers. I pull up the covers. He's home. The clock radio says it's 10:21. I hear the door close behind him and footsteps coming down the hall. He opens the bedroom door and without missing a beat, moves toward the foot of the bed. His voice fills the darkness. "There's something I need to tell you."

I sit up and switch on the bedside light. My heart is in my throat. In milliseconds I prepare for the worst: is he finally going to tell me he's leaving? That he still doesn't love me? Or … or … that he's gay? Heck, I don't know. As crazy as it might sound, it has crossed my mind! Nothing would surprise me at this point.

"Lenora and I have had an affair."

There it is. The words I have dreaded and yet always known would come. I am stunned into silence even while a nuclear bomb is going off in my brain. NOOOOOO, the voice in my head shrieks. I cannot hear anything else. This sound alone is crushing.

Dead silence surrounds us. This is exactly how I feel. Dead. *Oh Lord, come now. Send your angels.*

I remain speechless. Time does not move.

A million thoughts vie for supremacy. I saw this coming, right? I had my suspicions. He denied it! She denied it! Am I

## Chapter Forty-Six

blind? Or stupid? Or both? I knew this was a possibility. Why didn't I see the truth?

I finally find my tongue as broken words end the stillness. "How long for? How long has this AFFAIR been going on?" I whisper.

Gord does not move from the foot of the bed. He looks sheepish and contrite yet still finds a way to explain himself like he's giving me directions to the mall. "The physical affair lasted over a year but that's been over for a year now."

He can't look at me. He just stares down at his feet. "We've tried to break it off many times. Honestly."

My disbelief is now shifting to anger. *Oh, isn't that kind of you both? How sweet.*

I am finding my strength as my voice becomes bolder. "And what about HER? What about Bobby? What's happening there?" I look straight at him.

"Lenora is telling Bobby right now too." He still cannot look at me.

I throw back the covers and cross my legs. "Okay, so now what? Are you guys leaving Bobby and me to be together and ride off into the sunset? Is that why you're telling me this?" Reality is starting to hit but so is my resolve.

Gord looks like he might throw up. He wipes his eyes but continues to focus on the floor. "I don't know. I don't know, Kelita. I honestly don't. We just knew we had to come clean."

I sit up straight, pushing the hair off my face. My eyes are boring straight into his.

"Really? After two years you needed to come clean, did you? Two f-ing years?"

Gord turns and quickly closes the door. I'm sure he's scared that Keldon will wake up and hear his mother spewing profanities. I don't want that either, so I draw in my venom and

speak icily. "Why? Why now, Gord? There must be a reason. What, what is it? Why the hell now after lying for two bloody years do the lovers choose to tell their spouses the truth?"

He puts his hands in his coat pockets and leans against the door. He still doesn't have the guts to look me straight in the eye. "We just didn't feel right before God. We knew it was wrong. We couldn't live like this anymore." His voice is weak and it's plain his nerves are shot.

I am livid. *How do you like these feelings, buddy? This is what you have put me through for two years!*

I move to the edge of the bed and get up in his face. "So ... finally, you were feeling guilty, were you?" Sarcasm is dripping from my mouth. "Your girlfriend was one of my best friends. How could she do this to me? I trusted her." I stand up and start pacing, waving my hands wildly. "Do you have any idea how much I confided in her?" I point my finger directly at him. "Did she tell you that? Did she tell you? What the hell is wrong with her? How could you be with someone like that? What the hell is wrong with the two of you?"

I am afraid my head might burst. I am suddenly desperate for Tylenol and a drink.

"I'm sorry, Kelita." He finally looks at me. "You have to believe me when I tell you that. I never meant to hurt you. I really am so sorry." His hand reaches toward me but I back away like he's got the plague.

"I can't look at you anymore. Just go. Get out of here." I open the door to usher him out, refusing to touch him or make eye contact.

As he leaves the bedroom, head hung in shame, the weight of his deceit crashes over me like a tsunami. My mind has been spinning out of control for more than two years, but this true confession sends me into a new and ugly dimension of

## Chapter Forty-Six

madness. I am starting to imagine all the sordid details of every secret liaison. Whose bed were they in? Hers? Ours? Where did they meet? Was the sex great? Was she better than me?

My worst nightmare has come true.

I crawl back up onto the bed and bury myself under the covers. I want to curl up and die. But I can't. I am much too angry.

As I try to calm myself and get some sleep, I grasp for the one positive realization. The vision God gave me was real. I did hear from Him. He did show me the truth. I whisper out loud, *God you answered my prayers. You were with me. I knew you were there. You knew how desperate I was to know the truth. I WAS NOT CRAZY! Thank you, Lord, thank you. You are the one true saving grace in my life.*

## Chapter Forty-Seven

# The Separation

I toss and turn in the bed. I roll over and try to rest on my other side. I pull the covers up to my chin. Then I kick them off completely and lie there freezing. I simply cannot get comfortable. This horrid polyester nightgown is twisting all around my body, making me crazy. I hate nightgowns. I hate pink, girly, virginal, polyester nightgowns. I have got to stop wearing these stupid things.

I turn again to face the door. Closed. Silent. Empty.

I wonder how early it is. There is no sun streaming today. My hand reaches across the bed. It's cold. Where is he? Where is Gord?

Reality punches me in the gut. My nerves burst free from their catatonic state. Suddenly I am wide awake! Gord's savage words from last night assault me as if brand new.

Affair. Lenora. Two years!

My wakeup switch is fully flipped as I am thrust violently into a most painful present. Where's the waste basket? I'm going to be sick. Right now.

I jump out of bed and run to the bathroom. Just in time, I lean over the toilet and vomit.

I sink to the cold tile floor and feebly grab the toilet roll. My mouth is dry and vile and disgusts me almost as much as my husband. I wipe the corners, but it does not help. I thought this only happened in the movies. But this is very real. Too real. I stand up and reach for my toothbrush. But no matter how hard I scrub, nothing can get this revolting taste out of my mouth.

## Chapter Forty-Seven

The shock of Gord's confession has invaded my blood like a deadly virus. The more I go over everything in my head, the more I feel the spikey shards of glass grinding deeper into my heart.

Two whole crazy years!

I don't know if I should scream, cry, punch a wall or just lay down and die! I glare at myself in the mirror. I take a deep breath. The anger burning in me is making my head explode.

He lied to me. My beautiful, sweet, once-loving husband lied to me! And not just once but over and over again. One year ago, I accused him of having an affair with her and he lied! And then he lied again. So many times. I can't even imagine how many. And I thought I was the crazy one!

But now the truth is finally out. And I am the one facing the wrecking ball, wondering if I should duck or run or just let it smash me to bits.

I pick up my hairbrush and run it through my tangled hair. I really am a mess. Why is this happening to me. Why me? Why more bloody pain. Why me again?

I drop to my knees in tortured supplication. Oh Lord, what am I to do? I whisper softly. Help me, God. I need to know. What do I do? What about Keldon? He can't know what's going on. How do I protect his little heart? I don't want him growing up like this. Oh God, oh God!

A strong urge to escape suddenly overwhelms me. Is this an act of God? I immediately think of my good friend Judy in Ottawa. I can go there. Yes, I can get away from this madness and try to get my head back on straight. Judy will take care of me.

Judy will let me fall apart. And then she will help me pick up the pieces and figure out my future.

I tiptoe into my office and dial her number. She answers

right away. I don't explain much except that I need to come and I need to come NOW. After hanging up I call the train station and check today's schedule. I can catch the next one to Ottawa if I pack quickly. I book a taxi. Then I grab a small suitcase from the closet, throw in what I'll need and zip up the case. My adrenaline is pumping madly; I can feel it surging through my veins like gasoline, fueling my every move. My shoulders are up to my ears. I know I am stressed to the max, in serious fight or flight mode. But I also know that today, at this moment, flight is my only answer. I take a deep breath. And I keep on praying.

Gord is stirring in the downstairs bathroom. He is trying to be quiet, obviously fearful of what he will see when I finally emerge.

God, how I hate him.

God, how I love him.

God, how I don't want to love him.

He has been cruel and deceitful and conniving. He has destroyed our marriage and our family. Did he not think about Keldon for even a minute? Did he not think about what this would do to me, the woman he vowed before God to be faithful to?

I feel helpless. I am so angry and so hurt. How could I have been so stupid all this time? Why didn't I trust myself? Why didn't I trust my gut?

I slump back onto the bed and stare at my feet. The truth is I'm not stupid. I did know there was something going on. I did know! I just chose to not know. To ignore. To hope. But how could that woman do what she did to me? How could you do it, Lenora? Are you some kind of psycho? I mean, who does that to a friend?

I guess she never really was a friend. And what about Bobby? He must have had his suspicions about his wife. He

## Chapter Forty-Seven

had to. Did he know about them? One time he called me, both of us wondering where our spouses were. Our guts were telling us something then. And what about the band they both played in? Did those guys know all this time? Or were they just suspicious? Did other people in the music industry know? Was I just poor little ignorant Kelita, at home changing diapers and baking cookies while her husband made a public mockery of his marriage?

There are just so many questions. But really, what the heck does it even matter? What's been done has been done. And it's time to face the music. Maybe not the whole song but at least the intro.

I stumble into the kitchen just as I hear Gord coming up the stairs. He has obviously spent the night downstairs in the spare room. I sit quietly at the kitchen table as he walks in, looking frightful. His hair is disheveled and he's as pale as a ghost. I hide a tiny smile. I'm glad he is looking horrid. It's good to know he's finally feeling something, maybe even some guilt. I keep wondering if it was she who wanted to come clean. After all, she is a Christian now. Maybe he had no choice in the matter? I honestly wouldn't doubt it. I don't think he's telling me the whole story. How can I believe anything he tells me anymore.

He sits across from me and looks into my eyes. His are puffy and rimmed with red. I don't care. There will be no sympathy for his pain. None. My voice is cold and emotionless. "I have to get out of here. I'm taking the train to Judy's. You're going to have to look after Keldon. I just can't take care of him right now."

A part of me wants to scream, "Now YOU can try being a father for a while instead of an adulterous bastard!" But Keldon is awake so I need to remain in control. I feel horrible

for deserting him, but I know I am incapable of caring for him in this state. I just can't. I need to get out of here. I need to get away from Gord. And Gord needs to man up with his son!

He stares at the table sullenly. "Okay. No problem. Of course I will." He sounds very contrite and understanding. Looking up, he adds, "I'll drive you to the station." It's more of a question than a statement.

No, thank you. You are not a knight in shining armour. And I am no longer a damsel in distress.

I stand up defiantly. "No. I've already arranged a ride." Gord looks back at the table as I continue, "You need to call your mother and tell her exactly what's been going on here. I will not pretend and lie to her any longer. I've saved the image she has of you long enough." My anger is intensifying. "I'm done, Gord! No more. You need to tell her the truth. You at least owe her that. And you owe me that too." I love my mother-in-law dearly, but I can't protect her from knowing the ugly reality of her son any longer.

"Yes, I will, of course," he agrees timidly as the taxi honks from our driveway.

I grab my bags and leave. No hug, no kiss for Keldon, no words at all. Gord will have to deal with our little boy. Right now, it's all I can do to breathe.

I settle into the back of the cab and finally catch my breath. So much faking! All this time I faked a perfect little family. I painted the picture expertly so that I wouldn't lose face. So that we wouldn't lose face.

All I've ever wanted is a nice little family that is not a dysfunctional mess. Different from the one I grew up in. A safe place where people can be honest and real. Is that too much to ask? Maybe. Because the new life I dreamed of after leaving Hudson is blowing up in my face. Maybe God is punishing

## Chapter Forty-Seven

me for being unfaithful to my first husband? Or maybe He is punishing me for being unfaithful to Gord WITH my first husband?

My train is on time and I head to the back of the last car. I want to be as alone as possible. The sun streaming in on my face comforts me as I pull out my Bible. For the next four hours all I do is read. It's instinctive. I honestly don't know what else to do with my mind and I'm frantic to glean any kind of comfort to soothe this death-like anguish. I read the scriptures. So many of them speak to me.

*"But they that wait upon the Lord shall renew their strength; they shall mount up with wings as eagles; they shall run, and not be weary; and they shall walk, and not faint."*
*Isaiah 40:31 (KJV)*

*"From the end of the earth will I cry unto thee, when my heart is overwhelmed: lead me to the rock that is higher than I."*
*Psalm 61:2 (KJV)*

Even in all of this turmoil, I do sense God is near. He is the only thing giving me strength right now.

The rhythmic sound of the train diminishes as it makes its way into the station. I am finally in Ottawa. Away from Toronto, away from Gord. As I stand to gather my things, I can see Judy through the small crowd, also waiting. My heart is warmed. Oh God, how it needs some warmth. When I step off the platform I fall into my friend's caring arms. She knows. Women just know, don't they? She grabs my suitcase and together we walk arm in arm to her little blue Datsun.

Judy's cozy apartment is a welcome sanctuary and the first thing she does is outfit me with a pair of fuzzy warm socks.

I tuck into her well-worn couch as she hands me a hot cup of herbal mint tea. It feels so good in my hands, like a cup of liquid comfort. Chloe, her sweet black cat, purrs and sometimes swirls her tail behind me as I pour out my heart. The words tumble out of me like a rain-drenched waterfall until all the gory details have been revealed. I am once again drained.

My friend attempts to sooth me with delicious homemade comfort food. "Kelita, you need to eat something."

"I know I do but I have absolutely no appetite." I have lost weight and know my body needs nourishment, but food really doesn't interest me right now. That does not deter my friend. She is a born caregiver and won't take no for an answer. She goes to the kitchen and returns with a small plate of her shepherd's pie. It smells divine and tastes even better. I devour my meal surprisingly quickly and then wrap my arms around the chef. "That was delicious. Thank you. I so appreciate you, my friend."

And I do. To be with someone so loving and nurturing after living with Gord's rejection for so long is a most welcome change. Judy disappears to light scented candles and then leads me to her oversized tub for a healing soak. I find a pleasing sense of calm in the warm water and sink to my earlobes, allowing the stillness to envelop me. When I'm done, she wraps me in her fluffy white bathrobe and we resume our positions on her couch.

A beautiful glass of cabernet is soon placed in my hand and it warms my belly much like her shepherd's pie. My friend is such a good listener. I continue to divulge the entire torrid mess and by the second glass I become increasingly animated as I process my disdain for Lenora.

"She had the audacity to start using MY therapist when she's having an affair with MY husband! And listen to this.

## Chapter Forty-Seven

She handed down a negligée to me. Her negligée! Of all the things. Why the heck would she do that? Seriously! Is that not weird?" I shake my head in disbelief and finish the last sip. "I just do not get it."

Judy allows me to rant and rail and wallow and wail for the next four days. The woman is a saint and I finally feel my nerves settling and my heart opening. And the wider it opens, the heavier my tears fall. The initial shock has dissipated and my immense love for my husband has returned.

"I love him so much," I sob, trying to catch my breath and my running nose. "I don't want to, Judy, but I just can't help it." I sob some more as the pain pours out.

She wraps her arms around me. I lean in accepting her comfort. Her voice is soft and gentle. "Of course you do. I know that."

"I should hate him! After what he's done to me - to his family? I can't even understand it myself, but the love I have, it's just not normal, not after what he's put me through. I don't want to love him, Judy. I shouldn't love him." I take a deep breath. "He doesn't love me. He said those words. I won't forget them. Not ever!"

That memory and the realization of what it means slams into me like a runaway truck. My heart shatters into a million little pieces all over her living room floor. I am so grateful to be in a safe space to cry, to wail, to be a complete hysterical mess.

After another long day of soothing herbal teas, glasses of wine and deep conversation, I feel some of my energy returning. This crazy stress has completely wiped me out. My faithful friend is helping me to regain my sanity and find my level head.

Still, it comes as a complete shock when she calls out to me, "Kelita, it's Gord on the phone."

My heart begins to race. I feel like I'm getting ready for

a first date. "Do you want to talk to him?" Judy has appeared in the doorway, hand covering the phone's receiver. "You don't have to, you know."

I don't even waste a beat. "No, I know, but I will."

"Come take it in the bedroom." Judy hands me the phone and closes the door to give me some privacy. I sit on the edge of the bed. For a second, I feel like a schoolgirl. I am bathed in nervous energy as Gord and I exchange surface greetings. Then I ask, "How is Keldon doing? Does he miss me?"

"Of course he does!" Gord replies emphatically, "but we're doing fine. We've been going to the park a lot. You know he loves the swings. It's hard to get him off them."

His voice is gentle. Soothing. As if he is holding his breath. Just hearing him confirms how much I still love him. All I want is to keep speaking with him forever. But my gut reminds me of the cold, stinging truth: he might not be mine for much longer. I feel such a deep, overwhelming ache. I know he's a mess. I can hear it in his voice. My heart breaks for him and the pain he must be feeling. I give my head a shake. Isn't it just like me to want to comfort the person who hurt me. I used to be like that with Hudson.

"You know, I hate all of this," he whispers. "I have never wanted to hurt you. You've got to believe me. I've detested all the lying and hiding. Every part of it. And I've hated myself too."

I say nothing. I don't know how to respond. The wounds are so raw and open. He continues, "I care about you. I hope you can believe that. I love you and Keldon."

Excuse me? "That's not what you told me a year ago." How could I ever forget those words!

"I know. I know." He pauses but I refuse to fill the gap. I want to hear his words with no prompting from me. "That was

## Chapter Forty-Seven

harsh and I'm really sorry. I am. I'm just so, so sorry. I've been messed up. I never should have said that. I didn't mean it."

So now he tells me that? After a whole year of me believing he doesn't love me, now he's telling me he does? He's been having an affair but he still loves me? I honestly don't know what to believe or think.

"I think you're really confused, Gord, but I just can't have any more lying. From now on everything is out in the open. No matter what happens, no more lying. I can't deal with it anymore. I just won't."

"I know. No more. I get that." He sounds hopeful.

I decide to change the subject. Maybe beating a wounded horse to death in this moment is not the best idea. "I miss Keldon like crazy," I admit as I try to end the call on a bit of an up note. "Can you please give him a big hug for me and lots of kisses?"

"Of course I can." There is another pause and I immediately start to panic, wondering what final injury he might inflict. "Before you go, do you have any idea when you think you might be coming home?" His voice is again hopeful which lifts my heart considerably.

"I'm not sure right now." I truly am not. As much as I long to see my son and sort things out with my husband, I don't feel quite strong enough to go there yet. "Maybe in a few days. I'll let you know."

"Okay," he sounds relieved. "Just give me a call when you decide and I'll come and pick you up from the train."

Funny, I don't really want to end the call. I don't want to stop talking. I don't want to lose my husband. I just want to wake up from this nightmare and have my beautiful family back, with no affair and no lies and no cheating and no suffering.

We say our good-byes and hang up. I lay back on the bed.

This is just all so ugly and heartbreaking and I hate everything about it. But I can't lose him. I can't lose this little family. I just can't. I will not fail at this.

After a few more days in Judy's good care, I feel I have enough strength to leave the safety of her cocoon. It's time to face my new reality. So much is unknown, but I have to continue to trust and believe that God knows what He is doing. He will find a way to save my family.

The rhythm of the train is soothing. I am definitely in a better place than when I left home. I know now for certain that I want this marriage to work. The love I feel for this man can only be a gift from God. There is no other explanation. How else would I be able to even think of forgiving him – and so quickly?

As soon as I am home, a therapist/friend comes over. Gord and I are put through some intense crisis counselling. This is in your face therapy, asking the hard questions. I am literally shaking when she bluntly asks Gord, "Do you love Lenora?" There is a pause and I brace myself for the worst.

"Yes ... yes I do."

Oh God help me. It's so hard to hear these words.

"Do you want to be with her," she asks.

"I ... I ... I don't know," he fumbles. "Yes ... maybe I do. I think so." He drops his head into his hands. "Oh God, I'm not sure," he whimpers, obviously confused.

"So, Gord, what I hear you telling me is that you love Lenora and think you want to be with her. Where does that leave things with Kelita?"

"Well, I care about Kelita. I care about my family."

She continues to drill him. "Yes, I hear you, but do you love Kelita?"

"Yes," he responds emphatically.

## Chapter Forty-Seven

"Are you wanting to remain in this marriage?" This woman is relentless.

Gord is getting uncomfortably flustered. "I ... I don't know. Sometimes yes. But I'm just not sure right now."

The therapist turns to me. "Kelita, you've already said you love Gord and you want this marriage to work. Correct?"

I am feeling weak but in control. "Yes, more than anything. But not if he doesn't want it. I can't deal with him faking it or lying about it or pretending. I cannot handle any more pain. I just can't. If his love is not real and true, then I do not want him."

Finally, the walls are coming down! No more lies! We are punching a hole through the dark side and as difficult as this is, I think I even see a glimmer of light.

The session ends with the mutual conclusion that Gord is confused and doesn't know how he feels or what he wants. He believes the right thing to do is to be a husband and a father. However, his heart doesn't feel like being my husband right now. He doesn't love me the way he thinks he needs to. He is still in love with the other woman.

These are hard truths for me. Really hard. They are not what I want to hear. Not even close, but God is giving me immense strength. I feel like Samson with a full head of hair, ready to take on every tough challenge and win.

"Kelita, what would you like to see happen right now then?" The therapist looks directly into my eyes. "What would be the best thing for you and Keldon?"

I take my time responding, looking down at my feet. I have been working up my strength for this response and now I can finally verbalize my thoughts. My palms were already sweaty but now my whole face is on fire. I take a deep breath, look up and speak with firm resolve. "Gord needs to move out. I don't

want him living here, especially knowing how he feels. He has to make a choice. I can't live like this anymore. I won't live like this anymore."

It's terrifying for me to imagine Gord not living here. What if he loves being on his own? What if he decides to leave me for the other woman? What if he doesn't want to be married to me anymore? So many what-ifs and I hate them all.

But it is the only way, this I know. If my husband doesn't want me and our family, if he chooses someone else and something else, well ... so be it. Keldon and I will move on.

A few days after our intensive therapy session, Gord finds a furnished basement suite about 10 minutes away. It's our first night at home without him. Keldon and I snuggle up for his bedtime story. It's hard to keep my mind on the story but my son's sweet prayers jolt me back to the present. "God bless Daddy and Mommy and me and Grandma too. And cars and trucks. And Jesus. Amen."

My heart aches for this little guy. I don't want him growing up in a broken home. I'll do almost anything so that won't happen to him. Almost.

I pull my baby close and wrap my arms around his small shoulders. "Keldon, Mommy and Daddy love you so much. And God loves you more than anyone."

He plants a big kiss on my lips and I give him a huge hug. He reciprocates by wrapping his little arms around my neck. My eyes well up and I can't help but squeeze him just a little tighter. As I turn on his night light and close his door halfway, he blows me a kiss. "Sweet dreams Keldon. See you in the morning."

I sit in silence on the same couch where I've sat so many times before, alone and brooding. I can't believe it has come to this. But I realize that the truth does feel better than the not knowing. Doesn't it?

At least there's that. I whisper, God, please work quickly in Gord's heart. If he wants out of the marriage, then please don't let this drag out. I have a little boy to think about and I can't spend another two years wondering if this man can ever truly love me. I've lived with his rejection long enough and if we aren't meant to be together then I need to get on with my life. Amen.

I lock up the house and head for bed. Alone.

**What Kind of Love** ♪

## Chapter Forty-Eight

# Homecoming

Well, here we are. What was once my greatest nightmare has now become my living reality. After only five years of marriage, dwelling apart is certainly not what I imagined. However, despite everything, Gord and I appear to be adjusting quite agreeably.

The images of my husband and Lenora continue to burn into my psyche daily. Knowing the 'other woman' personally makes this even more difficult to manage; the betrayal is twofold! How can I turn to my best friend for support when she is the cause of my pain? I have nowhere to go for comfort and advice. And my constant obsessing over our future makes me feel like a madwoman.

But I am not. I am a mother with a pulse and a responsibility to take care of my boy. Thank God for that.

Most days, I purposefully welcome the mundane. Cleaning toilets, folding laundry, listening to my chatty neighbor. I need this sanitized sense of normalcy. I know that without it, the over-analyzing and fixating will truly drive me mad. So, I put one foot in front of the other and just keep marching.

It works. I am getting much better. Plus, I have a new album coming out, which is a good diversion and honestly quite exhilarating.

Even though Gord and I are residing in different spaces, there is a silver lining. With the recording studio in our home, it's necessary for Gord to work here most weekdays. Over the past month Keldon and I have seen him a lot. I'm grateful that

## Chapter Forty-Eight

our son still has a lot of Daddy time. I keep praying for his little heart to be protected from the bitter truth of his parents' relationship. So far, he doesn't seem to be affected by Gord's half-time presence. It's just like Daddy being away on tour. This is what Keldon has grown up with and so it's nothing new for him.

And me? Well, the truth is I'm happy for my Gord time too. Whenever I hear the car pull up, my heart goes all aflutter with excitement. In spite of the immense hurt I am living with, the unconditional love I feel for my husband is transcendent. I know I've said it before, but I truly mean it; this is nothing short of a miracle. The love and grace that fill my heart make me want to fight for this man that much harder. And the shame from another failed marriage? That's a powerful motivator too.

It's been another long day in the studio and, as Gord is about to leave, he calls up the stairs to me. "Oh gee, that sure smells good up there. Is that your famous spaghetti and meat sauce?"

"It sure is, and it's going to be sooooo good." I can't help but rub it in. He loves my cooking and hates his own.

I surprise even myself when I call out, "Would you like to stay and have dinner with us?" Wow. Where did that come from? I'm either very comfortable with our current status or very confident in my culinary talents.

His response is that of a starving 16-year-old invited to an all-you-can-eat buffet! "Of course, I would. You know me! I always love your cooking."

That meal goes surprisingly well, with amiable chat about everything BUT the status of our relationship. Still, Keldon is delighted to have Daddy at the dinner table and so am I.

Gord starts sharing more and more dinners with us and

we talk excitedly about the progress of my new album as well as the other recording projects he's working on.

And we enjoy our son, the glue that still binds our little family together. Watching him tear up the sidewalk on his bright yellow plastic three-wheel bike brings gigantic smiles to both our faces. Oh, how good it feels to laugh at his silly little antics. Together. Like we are connected again as a family. We celebrate with a round of popsicles, Keldon's favourite summer treat. "You sure have a sweet tooth," I grin, wiping popsicle juice off his face with the end of my tee shirt. "No Mommy," he slurps the last morsel of purple ice. "All of my teeth are sweet!"

Gord bursts out laughing and my heart warms enough to match the July sun. The shroud of sadness that's been hanging over our home for so long is slowly lifting. But we are nowhere near home free. Gord and I still avoid talking about anything personal or serious. The reprieve from the months of stress has been a welcome relief. But I still have no idea what Gord does when he leaves Keldon and me. Where does he go? Who does he see? Does he sleep alone? Is he with her? Lenora and I have not spoken a word to one another and that is exactly the way I want it. I keep believing there will be a miracle with this man. With my husband.

And then it happens.

It is a warm summer night. Gord is just about to leave after dinner. We are by the back door and I am standing on the landing, a few steps higher than him. I am fully expecting him to thank me for dinner and leave but he just stands there, staring at me. And then he gently reaches for both my hands and pulls me just a little closer. His beautiful brown eyes are locked onto mine. I almost lose my balance as my body melts into his gaze. Then in the most soft and loving voice

## Chapter Forty-Eight

he whispers, "Kelita, I don't want to live apart from you and Keldon any longer. I'm ready to come home."

Just like that, my heart is sent soaring. Before I can say anything he quickly adds, "That is, if you'll still have me."

I am taken aback, although perhaps not entirely. I've seen Gord's genuine care for Keldon and me growing and solidifying as his after-work visits get longer. I have hoped for this moment. Longed for it. Prayed for it. And now, here it is.

But I am no fool. Not even for love. My voice remains calm and self-assured. "Do you really think you're ready?"

It's a simple question demanding an honest answer. He must be certain. "I can't be hurt again, Gord. I won't let you hurt Keldon or me. Not again."

He squeezes my hands tighter, holding his gaze with complete confidence. "I understand. I know I've already done enough of that." He tenderly pushes a strand of hair out of my eyes. The intimacy of that simple act makes my heart ache. "I've had enough time and I've made my decision. My family is the most important thing to me."

My mind jolts for a split second. Family? I am hyper-cautious of his choice of words. Family is his son and our unit. What about me? Me his wife? Me the woman? Is he ready to make us work?

I can't help but feel hesitant. This man has put me through hell. I will not go back. Not if only half of him is returning. I send a silent prayer to heaven: Oh God, is this you working? I guess this is where the real trust comes in. I need you, God. I need you here to help me.

I shake myself out of my dream-like state and respond, "You know that's what I want more than anything." I pause. Take a breath. Stare past him into the ether. Stare at my feet. A huge part of me is elated but I cannot reveal too much enthusiasm.

I need to take my time to let this sink in and to make him understand how serious this decision is.

After what feels like an eternity, I exhale and speak. "If you're serious ... then ... yes."

A relieved smile engulfs his face as I continue, "But in order for this to happen we need to find a counselor." I am adamant.

"Of course," he agrees, squeezing my hands again.

"We need someone to help us get through where we've been and where we are going. And we need to have that in place first."

Gord nods his head enthusiastically, sounding almost too agreeable. "Okay then, we'll make that happen."

I feel a little uneasy, like this is all too good to be true. I know I still need to be guarded. Cautious. I am proud of myself for setting up some healthy boundaries. "I'm going to do some research and see what I can find."

As soon as Gord leaves, I begin my research. Tomorrow I'll call some people I trust, get some referrals, and find the right person for us. After tucking Keldon into bed, for the first time in months I am truly able to rest my head on the pillow and allow my body to relax. My heart is singing on the inside. Tonight, I might not sleep at all, but this time it's for a good reason. Oh God – I am so thankful you are answering my prayers. He wants to come home! I can't believe this is happening.

Morning dawns bright and sunny and when I call our church, I learn that one of our members has a counselling practice and his office is at the church. I recognize the name and know he has a lovely wife and several kids so I figure he must know something about marriage. I immediately book us an appointment.

Gord arrives early afternoon and I am surprised to see his car loaded down with all his belongings. Wow, he really IS

## Chapter Forty-Eight

serious. He still has two weeks left on his rental, but this must mean he's coming home today! I'm a bit stunned. As he walks down the hall to our bedroom, everything seems surreal. He's hanging up shirts and putting clothes back into their rightful drawers. Making himself right at home. And home it is. Our home. It's almost like he was never gone.

Our family dinner takes on a totally different vibe. We really are a family now, living and loving under the same roof. I glance over at the sweet face of our boy and his handsome daddy. My heart is overflowing with deep love and gratitude. Here we are, just our little family, totally intact. I have spent hours, days, even weeks on my knees praying for this moment. I have clung tightly to my banner of FAITH and tonight I wave it proudly. Today, no one can deny the power of belief and the grace of God in our lives. This momentous day! It's been one crazy ride and yet my faith has grown in ways I could never have imagined. Perhaps you just have to experience true brokenness to see how strong you really are?

After dinner, Gord and I tuck Keldon into bed. Together. Tonight, both Mommy and Daddy will read the story and witness the innocent prayers of our four-year-old.

Oh, my heart.

The day is now waning. I am drained yet excited. While Gord closes down the studio, I step outside, breathe in the night air and sit on our front steps. The setting sun has painted a dusty rose streak across the sky. Almost like a shy smile. The cool evening breeze feels good on my face. I need this moment to catch my emotional breath and gather my thoughts.

The big question lingers: how is our new commitment going to play out at bedtime? Are we ready for physical intimacy? Would it be wiser to keep some distance until we begin counselling?

I have no idea. I don't want to put any pressure on either one of us.

Pressure? Geez, I have no idea what I should wear to bed. Something sexy? Something cute? Something new? Something he's seen before. I pull out a pair of cute little PJs. Hold up the top while looking in the mirror. Cute, yes, but he's never seen these before and he might think I'm trying too hard.

How about this plain old white oversized t-shirt? Gord has always preferred the comfy look on me. Maybe this is the best choice? Back to our old comfort zone.

How can there be an old comfort zone? We can't just erase everything that has happened, can we? Pretend like that was a Twilight Zone moment and now we're back to reality? I don't think so. Whatever zone we are now entering, it is brand new. And frightening.

Still, I can't believe my bedtime wardrobe is taking this much thought! I finally decide on a simple silk nightie and slip quietly out of the bathroom. All the lights in the house are out. He must have snuck by me.

And there he is. In bed. In OUR bed.

I think he's asleep.

I am actually relieved. That answers THAT question.

Careful not to wake him, I slide into my side of the bed. And then I feel it. His touch. The touch I have longed for every day since the day he left. My body responds involuntarily. I have no choice. I mean, how long has it been? And it has always been this way. This man could touch me anywhere and my body would dissolve instantly into his hands. Like it is dissolving now.

He places his hand on my shoulder and gently grips me. His other hand reaches between my thighs and softly pulls me in. I submit completely to his welcome embrace. His warm

## Chapter Forty-Eight

breath on my neck leaves me tingling as he wraps his arms and legs around me. I reach for his hands and squeeze. He squeezes back. I feel safe in his cocoon. We fit together perfectly.

My husband is home.

**Because of Love** ♪

## Chapter Forty-Nine

# Answered Prayers

Two days later we're at our church, sitting in our first session, ready to talk truths. Our clean-cut counselor, in his white, button-down shirt and neatly pressed jeans, greets us with a gentle smile and calm demeanor. He leads us into his austere office. No fancy decor here. The less distractions the better, I guess. I do notice the Kleenex box as I take a seat beside Gord on the plain gray sofa. I've been to enough therapy to know there is always a box.

I am feeling anxious and with no wonder; we haven't talked about anything heavy since Gord left. I've been purposely avoiding "the big talk" because I so desperately fear rejection. As much as I rejoice that he's home, I am still in full-on protection mode.

But just sitting in the safety of this counselor's presence, I feel my emotional wounds begin to open. It truly does feel physical. As if bandages are slowly, torturously being removed. All those months of living in fear of the truth have impacted me more than I realized.

Chad, our counselor, is a kind and spiritual man. He seems about our age, maybe a bit older. He immediately puts us at ease, asking questions and nodding his head in affirmation, without judgement or rebuke.

"So, tell me, Gord, how do you feel about being here? Have you had any therapy before? Are you ready to be brutally honest?"

Gord breathes deeply before answering. "Yes, I actually had a few therapy sessions." He stares down at his feet.

"And how did that go for you?"

## Chapter Forty-Nine

Gord looks back up, his eyes clouded in fear. "Well, I never told him that I was having an affair." He squirms in his chair. "So I guess it's reasonable to say I was never really completely honest with him."

Ya think? I am trying to be non-judgmental but it is hard!

"Why do you think you weren't able to tell him?" Chad asks softly.

This time my husband does not miss a beat. "I was embarrassed. I had a beautiful wife and son, everything going for me. I was ashamed, I guess. I think I was going to see him so I could somehow justify leaving Kelita."

Ouch. That smarts!

"So, why did you want to leave Kelita?" Chad digs even deeper.

Gord shakes his head. "When I met Kelita, I was a single guy. No responsibilities for anyone but myself. After we got married everything just happened so fast. Keldon came a year later, we bought our first house and moved. I was just feeling overwhelmed about everything. I felt a lot of pressure. Kelita wasn't working so I was the only one bringing anything in."

Chad, with all his sensitivity and considerate nature, keeps the tough questions coming. "Why the affair Gord? Did that not complicate matters?"

Gord's vulnerability is now emerging without hesitation. "Yes, of course it did. But you see, before in my life, like before Kelita, when things got too serious or stressful in my relationship, I would just go find someone else. It was kind of a pattern I guess." He pauses, rubbing his hands on his jeans before continuing. "I don't think I was emotionally mature enough to handle all this responsibility when before I had hardly any. The easiest thing was to find a diversion. That was my pattern, I see it now. I might have thought it was a valid

reason but now that I'm hearing myself say it, it all sounds pretty pathetic."

This is hard for me to hear but at least he is finally being honest. He's saying things that he could never bring himself to say to me. I guess it was just easier to lie - until it wasn't.

This hurts. Mostly because I can't help but wonder how I contributed to all of this. Why didn't he feel comfortable enough to be able to tell me when he was feeling that pressure? I thought we were best friends. A team. Partners.

Hearing his confession truly is heartbreaking. Was I too wrapped up in getting pregnant and wanting to be the perfect wife? How could I have not seen through his insecurities and his fears? I am beginning to understand how our inability to communicate honestly became a landslide that tried to wipe us out. We didn't have a standing chance.

The intense session ends but as I sit in silence on the way home I am already anticipating the next one in a week's time. There is a sense of readiness building within me.

Our dinnertime with Keldon is quiet and afterwards, I am more than ready to let go, just a little. As Gord reads our son a bedtime story, I run a bath and slowly slide my weary body into the tub. I can always find comfort in a pool of hot water. But it's really my mind that needs relaxing. I'm happy that Gord is back home but I'm also realistic. There's no guarantee we're going to make it. When I dwell on this indisputable fact, waves of anxiety crash all around me. The pressure in my head is pulsating. I know now that living in survival mode these past two years has been far more debilitating than I realized. My whole being is a bundle of nerves.

Gord gently taps on the door. My response is timid. "Come in."

I pull myself up to a seated position, bringing my knees to

## Chapter Forty-Nine

my breasts so that I can lean over my naked body, protecting myself. He sits down on the floor beside me. The air is full of unspoken weight. Even without words, so much is being said.

I instinctively place my hands over my face. That unmistakable prelude to tears is gnawing at the back of my throat. Is it wrong to feel sorry for myself? Wrong to feel deprived of all the joy I should have experienced with my husband during these first years of being a new couple and new parents? Wrong to feel absolutely all alone and cheated out of so much, while being cheated on?

The more my heart digests all this pain, the more weight I feel pulling hard at my chest. And then the tears arrive. Weeks and weeks of stockpiled grief pours out from the pit of my gut, with my cries of agony adding an excruciating soundtrack. It's like giving birth. All control is lost as my body responds with a release I haven't to this point allowed. At least not in front of him.

Together we sit in the bathroom. In the muck. Me in the shame. He in the guilt. Both in the betrayal and deception. Both in the fear of what comes next.

I continue to purge with heaving sobs. Gord just sits, unmoving and quiet. I have not let him see this ugly side of my pain. He has only seen the patient wife waiting for her husband to come home. Always strong. Never showing any sign of weakness. I have been the consummate actress for my own safety. For my own preservation. But I can act no more.

Apart from my wails, the room is devoid of sound. My mind is racing through an intense obstacle course at warp speed, and I feel like Gord is right there with me. Like we are engaged in some unspoken dialogue that we both comprehend.

He leans in over the tub and whispers, "Come here."

I allow him to wrap both his arms around my wet body. He

just holds me as I continue to cry. I know that I must come up for air. I must find the will to just speak my truth.

"I ... I love you so much Gord. I ... I ... I never stopped loving you. Even through all the – through all the crappy shit." I slowly break the hug but remain close. I look up into his eyes. "God just continues to give me more and more love for you. If not for Him, we would have been done a long time ago. It's really all because of His love."

He responds gently, "I know. I know that."

And I believe him.

I climb out of the bath; Gord wraps a big white towel around me and sweetly kisses my forehead. I am chilled to my core and waste no time falling into bed. I am completely exhausted. My head feels thick like when you come out of anesthesia. But I know the release has been cleansing. There's something so healing about crying, allowing the body to purge all the tension and pain. Thank you, God, I so needed that.

Just as I am about to doze off, I feel Gord climb into bed. I welcome his warm body wrapping around mine. I am taken back to the first night we slept in the same bed. I know this love. It feels so good and I feel safe.

Each week we continue our counseling sessions as we work at reestablishing daily life in our household. I can't say it isn't difficult because it is. Our fragile physical relationship is fraught with uncertainty and mind games. I constantly fight the temptation to imagine the two of them together. Honestly, it is impossible. I do my utmost to be present, but I soon come to understand that this aspect of our relationship isn't just going to change overnight. I can't help what I can't help.

The mind is a powerful vessel. I keep praying that these horrifying mental images will diminish over time. I have promised myself that, except in our therapy sessions, I will

## Chapter Forty-Nine

not throw anything back in Gord's face pertaining to her. I have to move forward. I don't want to prolong the agony any longer than is necessary. Forgiving Gord has come easy for me. I know that might sound totally ludicrous, but it's the truth. I give credit to the power of God's love and grace.

Forgiving Lenora is another story. With Gord, at least I knew there was something unmistakably wrong. But with her? We were close. She was my confidante. She knew how heartbroken I was. I truly want to hate her. Forever. But I am slowly learning to forgive. I won't be her prisoner. I refuse to be controlled by her betrayal. I know without a doubt the only way forward is to recognize her pain and forgive her for playing such a huge role in mine.

Gord and I continue the work of building a new foundation. We're learning about our individual modes of communication and the necessity of keeping God at the centre of our marriage and home. We read books about love languages and how best to fulfil our partners' needs and the practicalities of not being able to fill them all.

After two months of therapy and hard work, it seems like we should be getting out of the woods. I guess it's just not that simple. Even after making good progress, I am left wondering. How can healing come when, at times, it feels like I am the only one pushing this giant boulder up the mountain of heartache? Gord just seems like he's still not all here. Heck, I don't know. Maybe it's just me. Maybe I'm just not being patient enough. He's probably still struggling with losing her. Grieving over such a huge loss. Dealing with his own heartache while trying to mend mine. Maybe he's having second thoughts and thinks he's made a big mistake? After all, it wasn't just a one-night stand, was it? Two whole years of a 'relationship' plus all the years of friendship before the affair. Then there's their musical

kinship and all their work together on stage and in the studio. The tours, the camaraderie, the laughter. Everything between them - GONE!

I am trying my best to put myself in his shoes, I truly am. I know that sounds weird, but it's what I've always done. If I can put the focus back to the other person's pain, I can sacrifice my own. For the sake of their comfort. Maybe after everything that has happened in my life, I don't feel like I am worthy of pain. I do not deserve to hurt. To feel betrayed. I must fix all the problems, even at the expense of my own well-being. I want very much to do this for Gord. To fix him. Even after everything he has done to hurt me.

But we are both hurting. Enormously. And this is the kind of anguish that can annihilate a relationship very quickly. No one can physically endure interminable amounts of harrowing turmoil. Gord and I are suffering both mentally and physically and I just don't know how much longer we can do this.

It's time for a serious conversation. No therapist, just the two of us facing reality.

Gord is in the kitchen finishing up a protein shake. I sit in the rocking chair in the living room and wait. I am surprisingly unafraid. My resolve is firm. What will be will be.

He walks in, slurping on a straw.

"Can we talk, Gord?"

"Sure," he responds as he sits on the loveseat. "What is it?"

I just lay it out. "What are we doing? I mean, in all honesty, what are we doing? Shall we just call it quits and work on getting a divorce?"

He sets his glass on the coffee table. "Whoa. Hold on here!" He is obviously surprised. "What are you talking about?"

My voice is firm. Solid. I am no longer a tiny, frightened little wife. I feel my burgeoning strength in my bloodstream.

## Chapter Forty-Nine

"I'm just not feeling like you're in this for the long run. There's just something not right. I'm stronger now. I'll be able to do this. Keldon and I will be fine."

There is a very long and uncomfortable pause while we just stare at one another. After what seems like an hour, Gord stands up and comes over to sit at my feet. I am taken aback.

His voice is shaky and filled with remorse. "I'm sorry, Kelita, but I've been keeping something from you." My heart sinks. Here it comes. What now? "I know I said I wasn't smoking anymore but it's not true. I've still been using pot. But I promise I am really done now. That's it. No more after today. I know it's been holding me back."

Wow. I really had thought he had quit. For Gord, pot has always just been another means of escape. But what really kills me is what a good liar he has become. Almost as good as I used to be.

He continues. "And I'm sorry, Kelita, for not caring more about us. About this marriage." He takes both of my hands in his. "I am just so, so sorry. Sorry for all the pain, for all the lies, for all the crap I've put you through. I'm sorry for not being the husband you deserve." He begins to tear up. "I can't lose you now. Not now. You and Keldon are the most important things to me. I love you. And I love this family." He wipes his tears with the back of his hand. "I love you so much. Will you ever forgive me?"

He begins to really cry.

"Gord, I've already forgiven you. You know that." He places his head on my lap, muffling his sobs. "It's okay. It's okay," I tell him as his cries grow stronger.

And then he completely loses it. This is the first time I have ever seen Gord display any kind of deep remorse. Somehow this emotional breakdown cracks something wide open in him.

It's as though the vast ocean of tears I've cried and every single pleading prayer I've recited have finally culminated in this moment. Could I be witnessing a true transformation in my husband's heart?

After five years of marriage, I believe we are finally in a place to begin ... again.

Thank you, God.

This is the real miracle I have been praying for.

## Miracles ♪♩

Chapter Fifty

# Testimony

I am back in the saddle again! Finally, I have new music flooding the airwaves and the excitement continues to mount. The first single (and video), "The Strong One," is receiving substantial airtime on Canadian radio and CMT (Country Music Television). The record company reports that sales are going well.

I can't tell you how amazing this feels. It's been a crazy ride getting here but maybe this will be the one to take me to the top. I still keep believing I was meant for stardom. Believing and hoping.

But that's not all I am now believing. In the midst of focusing on my personal life and prepping for this new release, I've been invited to branch out from country music. My new friend Michelle (a beautiful soul who is also a pastor) has put together a group of Christian artists to perform church concerts. We each do a 20-minute set. I'll tell you; it's been quite a transition from selling beer to selling Jesus. A whole new world for me and I'm learning a lot!

Today will be an even bigger learning curve. I have joined our small church group to help lead the music for a service at a local men's prison. The first (and only) time I've ever sung in a prison was years ago, with my full band. An unforgettable experience. In the weeks prior to arriving, the prisoner liaison kept mailing me long pages of handwritten letters. I'm sure he had a crush on me. It was all rather flattering, that is until I found out he was in jail for murdering his wife. Our pen pal relationship ended rather abruptly.

Today will be quite different. The music leader has asked me to share one of my original songs. I do and surprisingly it is well received, so much so that the prison Chaplain asks if I will come back on my own to share my testimony.

Alone. No full band to back me up or church group to hide within. It will just be me, my music and my story.

I am apprehensive yet also feel a strong calling. A divine pull to get out of my comfort zone and do what I can to help. Even though I've been starting to tell snippets of my story in different churches, I know this will be completely different. An entire hour on my own? Is my story that worthwhile? Can I be compelling while not being funny? This is a brand-new level of performance and I'm not sure if I'm ready. God, please help me.

I have exactly one week to prepare and soon my big yellow notepad and pen are my constant companions. As I work at writing down my story, I pray constantly - *God, if this is what you want me to do, then please help me to find the courage to be transparent and real.*

Transparent and real. Two words not exactly synonymous with the kind of entertaining I am used to.

For most of my life I have hidden all the trauma inside. It's what you do to survive. Of course, it does eventually seep out of you in many different ways. You make poor choices. You lose your boundaries. You're sick all the time. And then there's the self-medication with drugs, booze, sex and even attention-seeking. No one gives you a handbook on how to deal with family trauma or incest or suicide, or crippling shame or death and dysfunction. Somehow, by the grace of God, I have been able to navigate by pure gut instinct. The truth is I didn't know any different. This was my 'normal.'

But it wasn't normal. Not even a little. Now that I'm being asked to share my truth, I realize how utterly abnormal my

## Chapter Fifty

childhood was. And my first marriage. Even parts of my second marriage. My entire life has been a constant fight to escape chaos and achieve peace. Contentment. Serenity. Normal.

That thing that most people take for granted, I have been striving for since birth.

And now, as I continue to write and pray, my only hope is that the story I tell will somehow be inspiring to these men. That it will help them to see how much God has changed me.

Gord and I arrive at the heavily guarded facility, both ablaze with jangling nerves. Before opening the car door, I take a deep breath. With eyes closed, I mentally prepare to stand naked (figuratively speaking) before a room full of sexual predators, thieves, murderers and God knows what else.

The pungent institutional smell hits me in the face the moment we enter the heavy metal doors. It's a cross between animal clinic and Mr. Clean. I am hyper vigilant as we pass through all the security measures. My nerves are on red alert as we are given our visitor tags, like we're attending some sort of convention.

And then the balding, puffy-stout Chaplain greets us. His cologne is overpowering. I guess he doesn't like the scent of 'Eau de Institution' either. As we follow him past locked door after locked door, I feel like we're starring in an episode of "Get Smart." Finally, he opens the last one which leads us into his cramped office. "Shall we pray, before we go into the chapel?"

"Yes of course. That is definitely a good idea!"

I need lots of prayer! My anxiety is bouncing around every cell in my body. The three of us bow our heads. In his gentle Irish lilt, he invokes: "Dear Lord, I lift Kelita up to you and ask that, as she shares her music and testimony with the men, you go before her. I pray you give her the right words to say and that she feels comfortable and safe. You know each one of these

men and their individual stories. I pray for your love and grace to penetrate their hearts as Kelita shares today and that you be glorified. Thank you for bringing her and her husband Gordon to us today. In Jesus name, Amen."

Gord and I chime in with a hearty, "Amen." But all I am really thinking is *I must be crazy for saying yes to this!*

My husband manages a very quick sound check on the antiquated system and then the men in grey begin to file in. The low buzz of their babble starts filling the empty room. To call this room a chapel would be a stretch. It is cold and stark. No stained-glass windows, glowing candles or purple velvet. Just grey and more grey.

I nervously pull out my handwritten notes and place them on the piano's music stand. Time for a few more deep breaths while the Chaplain gives a short introduction. Now my palms are wet, exactly like they used to get for those awful piano exams I was forced to take. My brain feels as thick as molasses. Part of me wants to crawl under this rickety old piano bench and hide. But I cannot hide. Even though I am way out on a limb, I know that I have been called to this service. All I can do is pray that my audience can't sense my vulnerability.

My hands are trembling as I place them on the keys and begin to play. I am terrified that my voice won't cooperate, but it does. And when it does, I feel a supernatural power taking over. I feel strong and confident because I know God is guiding me as I sing.

> Be brave and walk on
> Don't I know it well
> I'm not lookin' for your sympathy
> This is just one woman's story to tell
> You see my father took his life

## Chapter Fifty

> When I was just eleven
> After that day I wrote my first song
> It was a gift that I was given

I sing from the depths of my own heartache and loss and yet my heart swells at the song's conclusion.

> Must have been from heaven
> 'Cause look at where I'm standing
> I've got my feet on the ground
> Must have been from heaven
> 'Cause I know where I'm goin'
> I've got my feet on the ground
> Oh I've got my feet
> On the ground

Once the applause dies down, I read from my notes. The hardest part of my story is next.

"My oldest brother, Jimmy, was a wild child of the 60s. He was someone who lived on the edge. He was daring and charismatic. But my brother had a darker side that not everyone saw. He loved his drugs and he abused many. He took sexual advantage of me when I was a preschool girl. When he was 27, he died of a drug overdose. After his death I started to remember things. This song I wrote about him has helped to set me free from the shame. It was also the beginning of finding forgiveness for the innocence he stole from me. It's called "Unusual Child."

> So many times I wonder
> What Jimmy was all about

> He was sweet, he was crazy
> And he was inside out
> He was a Western James Dean
> He was a rebel he played wild
> He was the first born in my family of five
> He was a most unusual, most unusual
> Unusual child

As I sing these poignant words about Jimmy, I feel the energy in the room intensify. I sense many can relate in one way or another. As the song concludes with an emotional plea: I realize my voice is ringing out with a sense of power and control. It's a feeling that is purely mine and I love it!

And then, with song ended, there is an awkward silence. But I am no longer surprised by this response. I'm beginning to learn that this song literally stuns people into quiet. But then gradually, one by one, hands join in unison as applause fills the room.

The hour passes and I feel even more empowered. Being this exposed is frightening but it is also giving birth to a new kind of freedom. The enormous measure of shame that has penetrated my life forever seems to diminish. This must be what healing feels like.

I know now that my purpose today is to encourage these broken men to surrender to Jesus so that they too can experience all the forgiveness, love and freedom that's been given to me. I swear I can feel their collective love wrapping around me like a warm blanket. Most of these men appear so hardened on the outside, but like me they are simply wounded souls with their own traumatic stories of survival.

Finally, I sing my last note. I am embraced with sincere and hearty applause as the men all rise to their feet. Without

## Chapter Fifty

realizing it, I have gone over the hour, so the guards waste no time in ushering the large group out the back door and to their cells.

One older, grey-haired man lingers behind. As he walks over to the piano the smell of cigarette smoke floats off his clothes. I sense his hesitancy, so I speak first. "Hi there. How you doing today?"

His hushed voice is deep and raspy, probably from years of smoking. He nods and whispers, "Thanks for singin' for us today."

"You're welcome," I reply softly as my eyes gravitate to his large, weathered hands. A working man, I suspect, with forearms covered in faded tattoos. I wonder what he did to land himself in this horrible place.

"I just need to tell you something," he continues, very seriously.

I immediately put down my bag and give him my full attention. I notice the ragged scar on his left cheek. Did he get that in here? Or on the outside? I have so many questions, but I understand that's not my job today. My job is to listen.

"Sure, please go ahead." I wait.

"Your songs really struck a chord in me today. What you're doing is very brave. Don't ever worry about being rich and famous because what you're doing will bring you way more rewards than you could ever imagine. Just keep doing what you're doing. You're going to touch a lot of lives."

A tiny lump starts forming in my throat. This battered old man has totally caught me off guard. As have his beautiful words. Perhaps this complete stranger is an angel in disguise, sent down to encourage me on this new path?

"Thank you. Thank you for sharing that with me," I choke out the words, filled with gratitude and awe. As the stranger bids

me farewell and walks away, my heart swells with a beautiful new affection I am learning to embrace. It's called Grace.

I am learning that it is okay to love me. I am worthy.

This is a truly sacred moment. I now know that my own healing journey is going to change. Because I have changed. My goals have changed. My soul has changed. My heart has been changed by God. My path is new and vital, strengthened by my profound willingness to serve Him through the telling of my story and the singing of my songs.

I am becoming whole.

I flash back to when a young, painfully distraught 14-year-old was about to lose another parent. There she was, kneeling on the stairs and surrendering her life to Jesus.

Now here she is again. But she has grown into a fully realized woman, with a different, brighter heart, overflowing with love for the One. I whisper quietly through my tears, "Lord, I hear you. I hear you calling me. I am yours. I commit my career and all my future to you. Take these gifts you've given me and then let them be used for your glory."

I revel in this moment of pure acceptance. Tears of joy stream down my cheeks as I stretch out my hands and reach toward the heavens. I am so very grateful for my gifts because I now know my purpose.

I am whole.

And wholly available.

As for me, I will serve the Lord.

> Here I am, wholly available
> As for me I will serve the Lord

**Must Have Been From Heaven** ♪♪

# Epilogue

**Daddy:** For years after my father's brutal suicide, I struggled to understand the depths of inner turmoil that compelled him to end his life so violently. We all knew he was prone to depression, but no one suspected it would lead to such an agonizing conclusion. Many years ago, long after my mother died, I finally asked my stepfather, "Why?" He had known my father as a colleague and even friend and my slimmest hope was that he might possess some information which would clarify things for me.

Indeed, he did.

With no fanfare whatsoever, Mike informed me that my mother had discovered my father and another farmer, who was a very close friend of the family, in a homosexual relationship. *Wow.*

Was I shocked? Of course. But was I totally surprised? We all knew this man. He was part of our lives and had been part of my father's life since they were both young men. The two of them went hunting together, assisted each other on their farms and shared in family gatherings. He never married so he became our favourite uncle who wasn't an uncle. So many times, Daddy, with Vian and me in tow, would drop in for a visit. It all made sense.

It also occurred to me that we never heard anything about Daddy's involvement with other women, prior to life with my mother. There were no old photographs or stories about past relationships. Was that normal?

Turns out that on that fateful day, Friday October 17th, my

parents had arranged to meet for what would become the last time. My stepfather told me my mother not only turned down a birthday gift from Daddy but also requested a divorce. Oh, my poor, fragile father. As troubled as he was, I do believe he loved my mother very much and was desperately hoping they would reconcile. But it was not meant to be. My mother was allegedly adamant that, if he didn't comply with her request, she would expose him.

Back then homosexuality was still a criminal offense, punishable under Canada's criminal code with up to fourteen years in prison. Ironically, this law would stay in effect until 1969, the very year Daddy died.

Mike's story shook me to the core. I desperately tried to substantiate it through conversations with other family members. There were absolutely no clues from anyone, only disbelief. Could my stepfather be lying? I honestly could not see why. Could my redneck Texan stepfather even have thought up such a story on his own? I don't think so. Nor could I see any motive on his part. Still, I was hoping for more positive proof.

A few years ago, I came across an old black and white photo of Daddy and a male friend. His stance is casually aloof, yet one arm is comfortably flung over his friend's shoulder while their other hands grasp each other. To this day I don't remember how I found it or where it was hidden all these years. Yet when this photo showed up, I couldn't help but study it like a detective. Could this be the missing clue to my father's sexuality?

Even so, it is still difficult to grasp what compelled Daddy to leave us so dramatically. Was it my mother's ultimate rejection? Was it the possible exposure of his deep dark secret and all that would entail? Was it an inner self-loathing or deep conflict that was just too overwhelming to bear? I guess I will never know. I have come to accept that whatever the final straw

might have been, my father was unable to face his own truth. That was simply not an option.

A family suicide leaves an indelible mark. From that first song I wrote only weeks after his passing, to the place where I have now stood for many years, I have learned there wasn't anyone who could have saved him. In time, I was able to forgive him for leaving us. But I still grapple with the pain of knowing how he must have agonized over his life. And how he chose to brutally end it still breaks my heart to this day.

But that very first song, inspired by my 11-year-old grieving heart, began a lifelong journey of pouring my deepest soul into music. MY pain, in that moment, was paramount. But as time went on, my music became my own personal lifeline for survival. An expression revealing my deepest hurts, longings, fears and passions. I have my father to thank. He remains my angel, forever guiding this most generous gift from God.

**My Mother:** After all these years, I still feel cheated for losing my mother so early in my life. That void never gets filled; you just learn to live with it. When I consider the milestones – my graduation, my weddings, the musical achievements and the birth of Keldon, I ache at the thought of her imagined presence.

I have often envisioned the wisdom, advice and support I might have received throughout my first marriage had my mother been around. Maybe, if one or both of my parents had still been alive, I would have endured less hardship in that relationship. Stood up more for myself. Left sooner. Or perhaps never married at all. Having that strong, parental guidance in my life could have altered many things.

My mother's absence, especially during those devastating years with Gord, left a deep longing in me. I pined for her touch.

A mother's love and support during the most heartbreaking time of my life was what I needed most.

But I also grew to understand what my mother braved. To this day I hold great empathy for her. I can't even begin to imagine the gut-wrenching experience of losing two husbands to suicide, much less the agonizing years leading up to their tragic deaths. The shame would have been crippling. And then to endure the aftermath of rejection, humiliation and even hatred from certain family members? It must have been an excruciating experience and one she tried desperately to hide from my siblings and me.

I now can understand her anguish at leaving her children behind. She must have believed she was doing the right thing having Mike adopt Vian and me. If she had any misgivings, she never breathed a word to anyone.

And then, that final battle she faced alone against her own body. And time. I honestly don't know how she did it.

I do know my mother passed down her tenacity and inner strength to me. She was always the strong one. I also know that, as grateful as I am for those gifts, they did not come without a price. It was she who instinctively taught me how to hide behind masks. I learned from the best. Even with her own deep longings, she never ever allowed herself the luxury of vulnerability. She couldn't. She needed to survive.

I now believe that, in the end, her secrets found a way out of their dark hiding place in the form of a disease; an insidious illness that we now understand can be greatly exacerbated by trauma and stress.

When Keldon was born, I was adamant about raising him in a healthy environment. I have worked hard to give him a home with stability and love. One where secrets were never given a chance to take root and flourish. My own family was proof that secrets can be deadly.

Life has also taught me that when we are hurting, we often don't fully see the needs of those around us. The people we love are sometimes the most neglected. For that I have forgiven my mother. I know she did the best she could while she was here. My God, I wish I could have known her in her golden years. To just sit with her and ask the hard questions and learn about not only the wife and mother, but her, the woman. To gain a solid understanding of her choices, especially the ones that so greatly impacted my own life. I console myself with the knowledge that she was responsible for taking me to that little church where I was introduced to the love of God and a church family. Perhaps she somehow knew deep down that one day, *this* is the family I would need.

I will always be indebted.

**Vian:** In early life, Vian and I were undeniably connected in a powerful way. We understood each other like no one else. When I adopted the role of little mother, the responsibility I felt for her was fierce, as was the love. I know she felt the same way.

However, when I fled home at 18, Vian's own story began to take independent shape, and not in a positive way. Her struggles started in her mid-teens when her first boyfriend physically abused her and she found herself in some minor trouble with the law. Unfortunately, she also found a new confidence in vodka. I knew nothing about these troubles. My sweet baby sister never ever wanted to disappoint me.

Vian fled the clutches of our stepfather once she turned 18 and received her inheritance. That is when the real party started. For the next few years, I answered calls at all hours of the morning, when big-sister mode would once again kick in as I talked her down from some drug-induced high and told

her to kick all the freeloaders out of her apartment. When she visited me in Toronto, she was lost to the nightlife on Yonge Street. Out all night with no fear of public transit or the Big City, that was my sister.

I believe that Vian was constantly on a mission to fill the void left by the immense trauma of our early lives. By 22 she was married, with a baby boy. That still wasn't enough to satisfy her deep longings. She found solace in extra-marital sex, booze, drugs, shopping, eating and her newfound profession – nursing. A natural caregiver, highly respected by her patients and their families, she was the nurse who always went beyond the call of duty. That's just how big her heart was. She filled her own needs by caring for others.

When Vian fulfilled her dream of moving to the country, she gave birth to another boy and then a girl, both from different fathers. She secretly wed the latter after his release from prison. This "husband" took my sister to new personal lows over seventeen tumultuous years.

I was there for her as much as possible. I made annual visits with Keldon and while apart, we kept in close contact. The abuse she was suffering pained me deeply and even though I realized she needed to find self-love, I had no idea how to help her do it. And so the toxic and vicious cycle continued. Countless times she would leave and countless times she would go back. It was infuriating! And heartbreaking.

For several years I withdrew from visiting. Call it tough love or self-preservation, I don't know. But to this day I still regret that I just couldn't do it any longer. Her path to self-destruction was killing me too.

During one of the many separations from her husband, my sister self-diagnosed and then confirmed with a visiting psychiatrist that she was bi-polar. She was immediately put

on the appropriate medication. Finally, she was doing better. Better than she had done in years! When Keldon and I flew out for a summer visit, the changes were obvious and most welcome. Not all unicorns and roses but still, she seemed more at peace.

A mere ten days after that visit, I received a call at 3 in the morning. Vian and her two youngest had been in a car accident. Both my sister and niece were airlifted to hospital. My 11-year-old niece survived. Vian, sadly, did not. She succumbed to brain injuries, and we were forced to take her off life support.

I literally screamed at God over the injustice. Why did she have to go? Now, when her life was on the upswing? How was this fair? Now her kids didn't have a mother, just like she and I didn't have parents at such an early age. It was almost like history repeating itself.

And then I finally gave up screaming and started wondering if she had finally found the peace she had searched for her entire life.

Vian was my sister, my daughter, my companion, my soulmate, my friend, my confidante and my connection to the past – our past. I was gutted. But I ultimately found my own peace with the best comfort I knew - my Heavenly Father. He was the pillar of strength I needed. He was absolutely the only ONE who could possibly understand the great void Vian's death left in my life. But he was also absolutely the only one who could possibly know what Vian needed. I must believe that. I choose to believe that.

Vian's legacy lives on today in her five beautiful, healthy grandchildren. These precious little ones are her gift to us all.

**Jimmy:** Jimmy had a huge impact on my early life. For years, my feelings for him were mixed and confusing. I loved him

and yet had a hard time understanding why. I definitely had an unhealthy attachment to my brother. My research now tells me our relationship was a form of trauma bonding. I believe I also experienced this with Hudson and possibly Mike, my stepfather.

It's difficult to delineate how the very early sexual abuse I experienced at the hand of my brother specifically affected me. There was so much other trauma in my childhood. It was all interwoven. But I do know it was Jimmy who initiated me into the world of secrets.

Years ago, I was flying over the Rockies from Vancouver Island to Vian's home in Calgary. Memories flooded back about the time she and I visited Jimmy in Victoria. I could hear my Grannie's voice saying, "He was such a holy terror." It seemed Jimmy was destined to be the difficult one right from his first breath. I grabbed the only thing I had to write on - my boarding pass. I scribbled down these two words. Unusual child.

The next day, I sat at Vian's piano and wrote that song. The emotional release was immense; I bawled like a baby. But it was good. It was hard. It felt like something new was taking place. The gift of music was once again allowing me to express my deepest grief. And it wasn't just about Jimmy. What I felt was the river-rushing release of colossal stores of heartbreak. For whatever reason, Jimmy was the key. This 'unusual child' was a symbol of everything my messed-up childhood had stolen from me. I found another layer of forgiveness. That was a monumental breakthrough for me. I'd been protecting my heart for a very long time, wrapping it in armour and keeping secrets even from myself. Writing Jimmy's song marked the beginning of my healing journey.

After I began sharing my story in public, I learned that

Jimmy had also sexually abused other family members. His own adopted son, Shawn, was also given drugs and alcohol by his dad and his Satanist 'friends'. God only knows who else may have suffered because of my brother's deviant behavior and crazed mind. I shudder to think.

I know that I should perhaps hate Jimmy to this day, but I don't. I only have sympathy for his utterly tortured soul. I have tried to find answers. Who abused him? Where did he learn this kind of behavior? Why was he never protected? What made him want to worship Satan and not God? So many unanswered questions.

I have learned that forgiveness and mercy keep me free from bondage. Although I will never forget what Jimmy stole from me, I do not hate my brother. I continue to learn that healing and wholeness only ever come by surrendering to LOVE. I do my best to practice it daily. It is the only cure. And I know that God loves all his unusual children.

**Frankie:** Frankie was an enterprising kid. He was the wheeler dealer of our family, buying and selling cars before he was barely old enough to drive one. He was a competitive public speaker, often opposing his older brother, Jimmy. They were both good talkers.

After Mom passed away and Frankie's first marriage ended, he dropped out of university and flew the coop. He ended up completing his studies in New Zealand and Australia and then settled there for about ten years. No matter where he was, I'd often receive a calendar or an interesting gift in the mail, with no return address. I always knew it was from Frankie. He never forgot my birthday either.

Frankie was always generous about sharing my music

tapes and CDs with friends and even donated a large sum towards one of my projects.

In later years, Frankie made homes in both Canada and the US, still ranching. He's been married four times and has never had any children. He currently resides in Australia.

**Billy:** My dear brother Billy was the youngest of the three boys. This meant he was caught firmly in the middle of 'them' and 'Vian and me.' Jimmy and Frankie were always at each other's throats and my sister and I were the spoiled little girls who had the attention of Daddy and Mommy. I think Billy got lost. He was most certainly the neglected one. Even when suffering unbearable pain from the excruciating headaches we now call migraines, poor Billy didn't get much attention. His agony was so severe he'd be vomiting and bedridden. I now believe the inescapable tension in our home manifested itself physically in my brother.

Just like Frankie, Billy escaped from Canada after our mother passed away. He made his way through South America, indulging in large quantities of drugs, alcohol and some pretty exotic (or would that be erotic?) adventures. He actually worked as a houseboy for a group of women who owned (and worked!) a brothel. He also traveled to Southeast Asia and the Middle East until the bombs started flying in Beirut.

When Billy finally settled into his work on the oil rigs he was stationed out of Singapore. This is where he met and married his wife. They went on to have two children, but the marriage didn't last. Billy took full custody of his kids and moved them back to Canada. He found a job in Calgary and went on to raise his son and daughter on his own. He never remarried.

## Epilogue

We saw a lot of each other in the ensuing years, whenever I was singing in Alberta. This made me very happy.

When Gord and I moved from Toronto to Vancouver, I was really excited about getting back 'west' to my roots and family ties. Although not my home province, BC was close enough. We had been settled for about six months when Billy informed us he was coming for a visit. But first he was going to Vancouver Island to see Frankie and his wife. The dates were perfect as I would just be finishing up a little tour around the Toronto area. A catch-up with Billy was something I had been so looking forward to. It had been a few years since we'd seen each other.

I had one last concert to give in Ontario when I got a call from Frankie's then-wife. She told me that Billy had fallen into the river on the edge of the property. He was missing. Search and rescue were out in full force along with a crew of volunteers. They were doing their very best.

The news stunned me. All I could think of was, "Not again! Not another one. Please God, no!" Of course, we were all hopeful that Billy would come walking through the back door alive and well at any minute.

I performed my last concert that night. Only the grace of God got me through. I caught my flight to Vancouver early the next day and then immediately travelled by ferry to the Island to be with Billy's kids (who had already arrived at Frankie's). For several days we all waited and prayed. And prayed and waited some more. Then search and rescue called off the mission and said there was nothing more they could do. We had to accept the fact that Billy was gone. It was unbelievably surreal.

Six weeks later, a fisherman found Billy's body miles away, downstream. They needed dental records to identify him. The

miracle that we had hoped and prayed for did not happen. But we had closure.

Another family member – gone tragically, much too soon. Billy was only 58. And to this day we don't really know what happened on the water's edge the night of Friday, April the 13th. I guess we never will.

I think that, of the five siblings, Billy was the one who kept the pain most hidden. On the outside he was cool and laid back. But I believe that, on the inside, everything haunted him. Did he blame himself for sending that deadly envelope to Jimmy from Thailand? I can only hope that if so, he was able to forgive himself.

It pains me deeply that Billy and I were denied the opportunity to be closer adult friends. His kids are beautiful people and he truly did a great job of raising them.

**Mike:** Mike never gave me away at either one of my weddings. My grandmother walked me down the aisle for my first and a friend for my second. He also never sent a telegram or gave any kind of gift. Being that he was the only parental figure in my life, I was extremely hurt. I longed for some kind of parenting, anything. But I came to understand that he was incapable of fulfilling that role.

To my dying day, I will never understand what my mother saw in Mike, besides an escape from my troubled father. I believe that, out of all the trauma I experienced as a child and teen, living under this man's roof was the most damaging. I existed in perpetual fear. I learned to hide, manipulate and lie. I never learned how to stand up for myself or voice an opinion. Neither was tolerated. The anger that oozed from this man was toxic. Sadly, I still deal with some of the aftershocks all these years later. My nervous system has been negatively affected

and I know he played a huge part in that. With emotional abuse, the nervous system becomes conditioned to exist in a state of fear. Confrontation can still paralyze me. I can literally feel physically ill. Loud argumentative voices are upsetting. The fight or flight response is always lurking underneath the surface of my everyday life and even the smallest of things can set it off.

I will never forget Mike's son saying to me at his funeral, "He was the meanest man I ever loved." Wow. Sounds like a song title right there. I suppose I could say the same. Although old age did soften him a tiny bit, even his own daughter chose not to attend his funeral. I chose to go, and I also chose to speak. By the time Mike passed at age 80, I had long forgiven him. I knew that deep down he was just a hurting soul; someone who didn't like himself. I travelled a long way to be at his funeral and pay my respects. I guess I loved him but I did not like him. And that, I have learned, is perfectly okay.

**Hudson:** Scared, wounded, naïve, needy. That was me when I met Hudson. I only knew one thing for certain - I wanted to be a star! At 18 I had escaped Mike's clutches and moved over two thousand miles away. You might think I would have chosen someone who was not a mini-Mike. But no ... I chose Hudson. Because he wanted to make me a star and I believed he could do it! And he was also my first love.

People who knew us back then probably wouldn't think of their friend Hudson as an "abuser." He was charming, hardworking and attentive. Did he ever strike me? No. Did he cause me emotional and mental harm? Oh yes.

He was controlling and manipulative. There was gaslighting, without question. And the verbal abuse was soul-crushing. Hudson annihilated me with deadly words at every turn.

When I finally ran from him after nearly ten years of marriage, my spirit had been broken too many times to count.

I came from an abusive household, and you might think I would have known better, but we just didn't call it out back then. Even if I *thought* I deserved better, fear held me hostage and Hudson totally played into my insecurities.

Finding the courage to leave him was one of the most difficult things I've ever had to do. Despite his horrific treatment of me, I never wanted to hurt him. My people-pleasing gene kicked in even when I was in grave danger myself. It took a long time for me to realize that it was okay to save ME.

They say it takes the average abused woman seven tries to finally leave her mate for good. For me it was three. I am grateful for that.

Many years after our divorce, I heard from Hudson's new wife. She wanted to talk with me about his ten years of infidelities (three of those with her personal assistant) and discuss whether I thought he could ever be faithful. I agreed to text and answer some of her questions. She told me she would be discreet about our communication. I'm not sure what her definition of discreet is but … she told Hudson. I then received a text from *him* explaining that he was now in Romance Addiction therapy. I guess he had some kind of epiphany.

Hudson was my first real love. We were two young, messed-up people who had some talent and big dreams. But how could it ever last when he already had me leaving him before we were even married? I think I just outgrew the qualities that had initially attracted me to him – confidence and control. And once his insecurities took centre stage, his bag of tricks was suddenly empty. I started spreading my wings and all he could do was try to clip them.

# Epilogue

Every several years I'll get a simple "hello" text on Facebook but other than that, Hudson and I do not keep in touch. He lives in Nashville and has done so since we split up over thirty five years ago. I understand he has endured some major health problems and is divorced for the second time. I take no joy in any of his misfortune. Much like Mike, I have found my way to forgiveness and peace. I can only hope that Hudson has done the same.

**Lenora:** Before Lenora, I had never been betrayed by a female friend. To this day, she is still the only one. Now and then I run across an old photo of her and Gord together; they did work together after all. Sometimes I find one with the three of us. It's funny how after all this time, she still has a way of popping up. But the truth is, I have chosen to keep some of these pictures (especially the ones where I look really good). They are a reminder that my husband and I weathered all of THAT and somehow managed to survive. I also cannot forget the fact that Lenora and I were close friends and amazing singing partners. We were even quite funny together, like two peas in a pod!

The anger and pain aren't overwhelming anymore but, no matter how many years have passed, the betrayal can still sting. Whenever I watch a movie that involves infidelity, the cruel reminder cuts straight to my heart. It's just there, under my skin, like a most unwelcome souvenir of a time long ago. A time when my best friend chose not to be my friend anymore. And was willing to decimate me in the process.

That distasteful memento stayed with me for years. I had to fight off jealousy and its ugly friends (fear and distrust) whenever Gord was working in the studio with a female client. Can you blame me?

Many months after Gord and Lenora exposed their two-year

affair, I couldn't shake her presence. She was constantly in my thoughts and dreams. Finally, I gave in to The Messenger and sent her an email. I asked if we could meet. She agreed.

As our 'date' drew nearer I came to understand why I was being led to meet with her. She had already written me a letter, apologizing. And I had forgiven her (even though she was much harder to forgive than Gord). But now, I felt the need to pardon her, face to face.

I was nervous but also trusting; I knew The One leading had a plan.

We met at a restaurant. She was far more nervous than I. It was awkward at first as we read menus and talked about steak and the weather. But we settled in and ultimately enjoyed a nice meal together. There were even a few moments when time stood still. It was almost as if nothing untoward had happened. Just two old friends catching up. I truly did miss our friendship and seeing her only magnified that.

Over dessert I was able to look my betrayer in the eyes and tell her that I had forgiven her. We both had tears streaming down our cheeks as something lifted. A weight, a burden, a mistake – call it what you will. I felt a million pounds lighter.

For a split second I even thought we might be friends again.

No.

I came to my senses and realized there was far too much (turbulent) water under that bridge.

Lenora remained with her husband Bobby, but not for long. Eventually they divorced. I heard she remarried but that the new union didn't endure either.

I hope she's been able to find healing. Back then, when I was her friend, I knew she had some deep issues. I would like to believe that her journey has brought her understanding, accountability and self-forgiveness.

I have come to know that every time I surrender to the Messenger, He teaches me something important. My lesson from Lenora was gargantuan. The more I grew and evolved and became sensitive to the Spirit, the more grace I was granted. When it became my turn to extend that grace to my old friend, I knew I could not hesitate. Grace isn't always easy but it is always worth it.

**Keldon**: My son is truly my life's greatest accomplishment. Yes, I know all I did was birth him, and I know he's become a stellar young man quite independently of his mother, but I can't help feeling immense pride. I never thought I'd only have one child but, when Gord and I should have been working on growing our family, we were busy keeping the one we had intact. For years I grieved not having another baby, but Keldon has proven to be the only child I was meant to nurture.

He has a beautiful, natural talent for playing the piano, a photographic memory and continues to blow me away with his insatiable hunger for knowledge. Even as a child he chose to watch "How It's Made" over every other children's program. I am constantly learning so much from this man. He is a good teacher and wise beyond his years.

Keldon and I have a very special bond and I'm extremely blessed to have this bright, sensitive soul in my life. I will always be his mother and biggest cheerleader, but I am proud to say that now, I am also his friend and a kindred spirit. I am thrilled that he and his beautiful fiancé Kelly are actually our neighbours. We love hanging out with them and their amazing group of friends.

My great hope is that Keldon will read this book and not only gain a further understanding of his mother's early life, but also come to understand the complexities and challenges of

human relationship. Learning along the way that yes, even his own parents are human. And it is God's grace that inspires us to always learn, live and … love.

**Gord:** The man who helped save me from an abusive relationship is the same man who caused my greatest heartache ever. That's my husband. What a dichotomy.

Over the years many women have asked, "How did you ever get through the betrayal?" I tell them it is a choice. A choice to move forward and a choice to NOT dwell on the past. I don't mean *forget* what happened. Do the work you need to do in order to heal but then work on the present. It is vital that both parties are willing and wanting to make the marriage work.

The other question is, "Do you trust Gord now?"

The answer is "Yes!" A confident, no-holds-barred AFFIRMATIVE! I have trusted my husband since the day he returned.

Many couples don't survive an affair. The pain is excruciating (even for the betrayer). The doubt, the insecurity, the loss of trust and the breaking of a bond that only one person held sacred – it's a noxious recipe for failure. My marriage is the hardest thing I ever fought for. But it was worth fighting for.

Do we have a perfect marriage? No, of course not. There is no such thing. Does Gord drive me crazy at times? YES! As I'm sure I do him.

But what Gord has given me over the years is a gift. And that gift is the freedom to be myself. To be exactly who I am – while I'm still trying to figure out who that even is. He accepts me, idiosyncrasies, faults, weaknesses and all. I know he trusts me and loves me unconditionally (as long as I keep him fed because he hates the kitchen)!

We still talk about how crazy we were to marry each other.

Two musicians with no steady job or financial security. No benefits. No pension or dental plan or retirement package. But we have followed our hearts and over many years we have made a lot of beautiful music together. And along with raising our son, that music has been the joy of our lives.

We've both had to recreate ourselves a few times, but Gord has always been a rock-solid provider no matter what obstacles have come our way. At every roadblock, raging river or high hurdle, we continue to lean into one another and hold each other up. We're good teammates.

I feel so blessed to have such a strong partner at my side, sharing this twilight leg of our journey. I envision us growing old together, with old-folk-habits creeping in, annoying us and making us laugh! We can still crack each other up, we love sharing a healthy lifestyle, keeping active and hanging out with good friends. We are still adventurous and enjoy taking chances. We share our faith in God and are grateful every day for our many blessings.

Life is good with Gord. I have every faith that our love is here to stay.

**And then there is me:** After I left my country music career, I pursued my calling within the Christian music community. For twenty-five years I have shared my personal story interwoven with music and comedy. I have sung everywhere from soup kitchens and prisons to state-of-the-art theatres and arenas. I've travelled to many parts of the world and have been heard and seen by thousands across the airwaves of radio, television and the internet. I have partnered with some of the largest Christian-based organizations like World Vision, Salvation Army and Power to Change.

I did pursue a record deal with Christian labels in Nashville

but ended up creating my own - Heart & Soul Music. I have released six original CDs and handled all my own publishing and management for many years.

Now here's the funny thing: I always believed I would be a star. From my childhood through the Hudson-era and even after Keldon was born, my absolute belief in my talent and my ability to scale the highest heights of the entertainment world never wavered. Even now, after all these decades, that belief has not gone away. The difference now is my focus.

When I entered this new arena, I had to transform myself from being self-centered to being God-centered. I went from selling beer, sex and good times to selling God and the power of His love, healing and transformation. That was a very sharp learning curve. I fumbled my way around at first but soon understood that I was no longer singing for myself, for money or for accolades and stardom. I was singing for Him. The truth is I *needed* to be humbled. And I was.

I learned how to be of service with the gifts that had been bestowed upon me. God was most gracious with me and so were those who took the chance on hiring this "new" Kelita.

I believe that God started using my ministry to inspire and bring healing, hope and encouragement to a hurting world. Over the years I've used those gifts to advocate for women and children through personal mentoring and life coaching. For several years I used my music's platform to direct a project that helped educate the public and raise funds for young girls rescued from human trafficking in Cambodia. This is still something very near and dear to my heart.

Adopting a Christian lifestyle and becoming a 'minister of music' transformed my life and my career. It has brought me blessings too numerous to count. Do I own a mansion on a hill, drive an expensive car or have millions of followers? No. But

what I have received is much more meaningful than material objects and fame. When I hear from those who have been transformed by my story and music, *that* has been my greatest reward.

And that is also why I knew I had to complete this book.

The truth is, this literary effort has been a lifetime in the making. And I don't just mean the living and enduring and fighting and surviving, I mean the actual writing down of it all. There were many times I just wanted to pack it in. Especially after my brother Billy drowned. It just seemed like all the pain and tragedy couldn't possibly be real. I wondered if my life sounded like some over-acted soap opera. A melodrama that couldn't possibly be true.

It was hard enough to live through it all the first time. I wasn't sure I could bring myself to live through it again. On paper.

It has been difficult to dredge up the old heartaches and wounds and get in touch with those raw feelings and emotions once again. But there has also been an upside. Throughout this writing process I've been compelled to greater healing and deeper insight and compassion. Not only for my family but for all the other people who have left their mark on my life, positive or negative. I have a new appreciation of the tenacity and resilience I have been granted over my lifetime. I am proud of the years of personal work I have done which have led me to a most welcome place of truth and transparency. And yes, I have finally learned to love myself.

When I realized I could help other people by sharing my story, I finally knew my purpose. Since then, there has been no turning back. My greatest desire has been to help as many people as possible find the freedom and healing that I have experienced. Owning your truth is a continuous journey and

it's not always easy. But when you make the choice to forgive (including yourself), face your greatest hurts and fears and surrender to the Great Navigator, all things are possible. They truly are. I am living proof.

My faith journey has taken me down some new routes these past few years. I question organized religion now more than I ever have. My relationship with God is personal. I feel that God has expanded my heart to recognize that we are all human, even those we have put on pedestals. We mere mortals will continue to make mistakes, hurt others, cause pain and survive heartache. But by keeping my eyes fixed on the Creator, I can move forward with conviction and hope. I know there is always something positive just around the bend. I believe it. And I find the mysteries of God to be much more boundless than ever.

After a prolonged period of complete musical silence, I am now writing songs again. Oh, how relieved and grateful I am when each new work channels through me. Perhaps this precious gift will be with me until my days are done? I hope so but I no longer assume anything. I know that every life is full of unexpected twists and turns and I am quite certain I will experience a few more on my journey. I am ready for whatever comes my way. My relationship with God has offered me a new kind of freedom. The freedom to follow with faith and allow my life to unfold. That doesn't mean I can get lazy and do nothing. It simply means I can trust the path. I can trust new pursuits and new objectives. And most of all I can trust myself.

The music may change, the lyrics may change, my voice may be lower and my style may be less flamboyant. But there is one thing that I do know with all my heart: I will always have a reason to sing.

Epilogue

The End

**Reason To Sing** ♫

# Acknowledgments

Vickie van Dyke, without you, I'm not certain when I would have finished this challenging project! Your dedication as an editor surpassed all my expectations and I am sincerely thankful for your creative input, unwavering support, love and patience.

A big thank you to all of the readers who accompanied me on this literary journey and offered honest feedback and a whole lot of love: Arlene, Athena, Beverley, Brenda, Carrie, Craig, Deborah, Gord, Jacqui, Joy, Juliet, Kath, Kathryn, Kristen, Linda, Linda F, Lizzie, Margo, Michelle, Patsy, Susan and Trudy.

Deep gratitude to my cherished spiritual mother and friend, Michelle Sim. Your unwavering belief in me, your boundless support, and your love have meant the world. With all my heart, I love you!

A sincere thank you to my many friends but especially my girlfriends, from childhood to present day, for your gift of friendship and loving support. You have helped me through so much.

Blessed gratitude to the prayer warriors around the world who have prayed for and supported me. You have meant more than you'll know.

Junny Photography-for your strikingly beautiful cover artwork that captured this book perfectly, thank you.

# Acknowledgments

I owe immense gratitude to Kelly Savalle for adding your creativity to the photography and designs of the book and CD covers. And for all the video shoots! You're so gifted.

Denise Grant-my favourite photographer, thank you for all the years of working together.

Thank you Sara, for your creativity in assisting me on my social media platforms.

Thank you Dave and Angel for making the audio book process so comfortable and easy for me.

I am grateful to you Greg for helping me get to the final stages of publication.

Thank you to my counsellors for allowing me a safe place to work through my trauma.

I am most grateful to the teachers and professors who recognized my talents and encouraged me to pursue them, especially John Hill and Jim Shields.

A big thank you to the many gifted musicians, songwriters, producers and engineers I have collaborated with throughout my career. And especially Gord, our years of musical partnership have been inspiring.

To the many churches and organizations I have worked with over the years, who invited me to tell my story and where my family found a home, I am thankful.

To the Canadian Christian Music community, thank you for embracing this country singer!

I applaud with fondness the Canadian Country Music community. Your support in my early years was invaluable.

And for giving me the opportunity to be heard and seen, thank you to TV, radio, media, record labels, publishing companies, concert promoters and especially my fans around the world. Your support and enthusiasm for me and my music have always given me a reason to sing.

Keldon, your heartfelt encouragement for me to cross this finish line means the world to me (as do you). Thank you for inspiring your mother to share her true self, flaws and all. I love you and the relationship we have.

Kelly, your genuine desire for authenticity and your championing of me and my true story mean the world to me. I am proud to call you my daughter.

And to my dearest Gord, thank you for your enduring love and support throughout this arduous and often painful writing process. But most of all, for your grace in letting me share such intimate details of our story, I am forever grateful.

In closing, I express my deepest gratitude to the One who granted me my first breath, bestowed upon me the gift of music, and infused my life with boundless hope, unwavering faith, and profound love. Thank you, from the depths of my heart.

2 Corinthians 12:9-10

# Author Biography

Kelita is an award-winning singer/songwriter, comedian, inspirational speaker, life coach and now ... author. Originally from Alberta, Canada, she has lived in Toronto and Vancouver and performed all over the world. She and her husband currently make their home in Nuevo Vallarta, Mexico where she practices yoga, golf and watching sunsets.

To learn more visit - www.kelita.com
YouTube - kelitalive

Stay connected with Kelita:
Facebook - @kelitalive
Instagram - @kelitahaverland

To keep in touch with Kelita sign up for her newsletter at info@kelita.com

## Book Club Questions

1. What do you think of the subtitle of Kelita's book?

**Are you honestly inspired by someone's journey through trauma, abuse and betrayal or would you rather read a different type of inspirational saga ... like climbing a mountain with a disability or forging a new life after divorce?**

2. Is there any specific incident or scene in Kelita's memoir that resonates with you?

**Which traumatic situation in Kelita's book - incest, suicide, death, divorce, adultery, emotional abuse - resonated with you most? Why?**

3. What are some of the themes in the memoir? ( Resilience, shame, trauma, infidelity...)

**Did you find it incredulous that so many traumatic events could happen to one person in one lifetime? Did you find the 'true story' completely believable?**

4. How could Jimmy, (Kelita's brother who sexually assaulted her) be her "favourite"? ( innocence, trust, nature of abusive relationships?)

**Why do you think it was possible for Jimmy, who sexually molested Kelita as a child, to still be her favourite brother?**

## Book Club Questions

5. Discuss the structure of the memoir. (First person, present tense, chronological "voice of the age Kelita was at in the moment". Prologue "How did I get here?"

**How did you find the memoir's structure, from the initial voice of an innocent child to the ultimate voice of a mature woman? Did the 'present tense' narrative help you feel more connected to the story?**

6. Through her lifetime, what were some of Kelita's reasons to sing? How is music a relief, escape, healing?

**How could music be a release, escape or healing tool for someone who is not a musician? What other forms of expression could produce the same result?**

7. Can you personally relate to the author's life or any of the events in her life? Explain.

**How many (if any) of the events in the author's life could you relate to? Was it interesting to read about the 'road life' of a traveling musician? Or did you prefer the 'real life' stories?**

8. What was the most disturbing chapter in the memoir?

**And were you able to understand its merit in the narrative journey?**

9. What was most uplifting to you in the memoir?

**Were you able to immediately log on to Kelita's decision to forgive her husband's adultery or did you feel she was too merciful?**

10. How did secrecy play a huge role in the trauma of the author's life?

**And do you feel there is ever benefit or a good reason to keep "big" secrets? Especially from a child?**

11. What value do you think exposing all the "dirty laundry" of her life will have for the author?

**What value does it have for the reader?**

12. What is the greatest value for you in reading memoirs that are raw and brutally honest?

**Do you prefer memoirs that are raw and brutally honest or perhaps something juicy but less blunt?**

13. How did faith play a role in Kelita's life and what are your thoughts?

**Did Kelita's 'journey of faith' resonate with you, especially if you are a non-religious person? Do you think that a non-believer can still find value in the author's theological odyssey?**

Made in United States
Troutdale, OR
12/16/2024